For Marie,

Through the Weather Glass (& What Icarus Found There)

Lucy Burnett

Bon voyage!

KFS

NEWTON-LE-WILLOWS

Published in the United Kingdom in 2015
by The Knives Forks And Spoons Press,
122 Birley Street,
Newton-le-Willows,
Merseyside,
WA12 9UN.

ISBN 978-1-909443-62-4

Acknowledgements:

Some of these poems have previously appeared in *Stand*, *Tears in the Fence*, *Shadowtrain*, *The Clearing and nthposition*. Many thanks to the editors.

'Giving Over into Wings', 'Snowlight', 'Bottled Anachronisms', 'Cutting Up the Heat of Glaciers', 'The Average Spelling of the Weather', & 'Icarus' first appeared in Lucy Burnett's *Leaf Graffiti* published by Carcanet Press, 2013.

The back cover painting is by Lisa Fingleton.

LOTTERY FUNDED

Supported using public funding by
ARTS COUNCIL
ENGLAND

Table of Contents

For the many people who have helped me along the way: not least my parents, Scott Thurston, Sinead Murphy, Heather Hewitt, Harriet Tarlo, Adeline Johns-Putra, Judy Kendall, Anna Taylor & Alec Newman.

But most of all, of course, this is for Icarus and W.

Daedalus's Climate Prologue

i.

Daedalus had only now.
Come along with me, he said,
to the furthest limitations of our earth.
To detest was to bear witness, *de testari,*
and his eyes were the shade of protracted exile.

This was what we'd done and how we did it.
Longing, without latitude.
We had not asked to visit,
for this was our native country to be done with as we will.

He said we might start again, but.
His way was our way,
barred by the tide of our rising seas.

So-saying, he put his mind to the balance of the air.
Techniques unexplored before.
Limiting the growth of our desires to two degrees,
and the complex feedback mechanisms

of the point of no return.

We were altered parameters, shifting masses,
creating space beyond ourselves.
We didn't tend to speak of the disjunctive laws of nature.
Indiscriminating pronouns.
He, she, we, they, reflecting off the carefully layered clouds.

ii.

Some gases.
The smallest to begin with.
The shorter positioned to the longer.
You'd think they'd grown like that.

iii.

In the middle of the sky, adhering to the clouds,
were clumps of earwax.

At the bottom of this neatly compacted plumage
the sheaf of the most recently negotiated protocol
curved in a gentle camber to imitate birds' wings.

The pigeons looked at us as if we had nothing
better to do than hang around their square of sky
and shit on statues.

We did not listen. It was fair game. Whose
carbon dioxide was this anyway? The pigeons
refused to ratify; they just spat stones at us.

iv.

Daedalus was moulding the weather.
But we must also mitigate our ways, he said,
or we'll have the sun falling on our heads
like melting toffee.

His eyes sunk into his scalp as he thought
of his young son Icarus.

What does your Daddy do?
Because my Daddy's going to save the world.

Daedalus's shadow was of light bulbs,
little awarenesses, the size of globes,
the underlying threat of future tense.

To be himself was to be the way the world
was touching on him.

He watched Icarus as he laughed and smiled,
as he ran and caught at the springtime feathers
fluttering in the breeze.

And now you see me, now you don't.

Sometimes Icarus would sit with Daedalus
and carelessly soften the yellow wax between
the feathers with his thumb, enjoying his game,
as he meddled and interfered with his father's work.

I like toffee, he said. It's like playdough.
The colour of summer holidays.

v.

As he'd said.
Everything was going to be ok.
This was perhaps the most surprising thing.
Next Daedalus instructed his son.

It was strange, but he didn't really feel
as if he had a choice in all of this.
When his own wings beat the air
there was but a momentary hesitation.
What were we really found wanting?

They say that life goes on and on and

When Daedalus led the way into the sky
it was in hope of a temporary silence.
His, her, their, our, its. No more shouting

vi.

The sun grew larger than a peach,
softening the atmospheric ice crystals to candle wax,
fastening the accumulated heat to the surface of this earth.

The moment wore the clouds like decorative plumage:

carbon dioxide
methane
water vapour

Icarus balanced the melting ice wax on his fingertips.
It was more than likely that the air had the texture
of dissolved sugar. When the pigeons headed for home
Icarus licked his lips, flapped his arms, and looked sassy.

Part 1: The Fall

One thing was certain; the key to base-jumping the atmosphere was a sense of humour. Only Icarus didn't jump, he was pushed. Afterwards Icarus would ponder the shape of the hands and the familiarity of the laughter that had tipped him off the flat edge of Planet Zeus. He would ask why Zeus had allocated him that particular job of fixing the planetary perimeter fence on that particular August day when he could have been helping the cherubims sew feathers onto wings, or reading stories to the goats. But on the verge of oblivion one has more pressing worries than playing whodunit with the Gods.

Icarus pulled his stripy woollen jumper around him, lay back against the air and looked out into the abyss. The upper atmosphere couldn't have contrasted more with the Eden from which he had just been ejected. The blackness defied the brightness of the sun while the air was so thin that Icarus's breathing had been put on an emergency diet. Certainly, there was something to be said for the once-in-a-lifetime experience of floating, weightlessly on thin air, running the stars through your fingertips like sand.

'Vorpal!' Icarus might have exclaimed, if there had been some choice in his situation. Instead his attempts to butterfly-kick like a dolphin down into the Earth's gravitational pull resembled a dying fish, floundering about the exosphere while floating back into outer space. He was a faller by trade but try telling that to a lack of gravity.

It was only a week since Icarus had declared it high time that his life for once had a happy ending during individual counsel with Zeus. 'I'm fed up of being recalled to earth to play the fool who flew too close to the sun. Isn't it time I outgrew my fate? I've become prisoner to it; my story's wearing out!' Icarus had pushed his curly blonde fringe from his blue eyes and adjusted his adolescent growth spurt to the paisley pattern armchair as he counted the writers who had summoned him to earth, and the artists who had sculpted his wings. Recently he had been a pop song about the follies of youth, before serving as figurehead to a mental health charity. He had once been a design of custom bicycle, but most infamously of all he had lent his figure to Greece's first national airline, which had combusted within months.

Zeus adjusted his tunic, ran his fingers through his flowing golden beard and raised his bushy white eyebrows as if to ask – who do you think you *are* young Icarus? You mean you want to be a *God?* He

rose and opened the door to signal the end of the meeting and instead replied, 'You are right. Your story was recycled more often during the last century than the previous nineteen combined. But there are worse fates than your semi-mortal assignation. The grass isn't always greener...'

'But...!'

'...*BUT* if you really wish to become a God then the only way is to rewrite your story, not just inhabit the one provided for you.'

And that had been the end of that, Icarus had concluded uffishly, getting up to go. There was no point arguing with the God of the Gods. Besides anything, rewriting his fate would require the kind of extended application to the serious matters of life of which Icarus appeared incapable, as both Zeus and his father Daedalus well knew.

'What's going to become of you?' Daedalus had recently asked, on the occasion of Icarus's school report. Daedalus had a shock of curly hair to rival Einstein, which stood on end when he spoke to his recalcitrant son. 'If you left off dreaming and learnt to apply your talents, just think where you could be. Take Apollo!'

Icarus had responded to *that* in the only way he knew – whistling – before the argument could descend into the usual abyss. He didn't have enough fingers to count how many times Daedalus had attributed his son's failings to the genetic limitations of the village prostitute – his mother, Naucrate – may she rest in peace.

But more *immediately*...Icarus shook his head back into the present moment and looked back into the darkness of the upper atmosphere. Never had his father's question been more pertinent: what *was* going to become of him? A happy ending? More likely his fate involved painting a constellation on the exospheric night sky with his skeletal remains – as a permanent warning to humanity against overweening pride. And if it hadn't been for a particle of carbon dioxide sidling by, right then, perhaps his end would have been just this.

'How do?' said the CO_2. 'Icarus, I presume? But whatcha done with your wings?'

Icarus spread his arms wide, as if he had only just noticed that, indeed, there were no wings. 'But I'm not travelling to the sun. I'm trying to fall to earth – if I could only find some gravity to pull me in. How did you end up here?'

'Oh, the usual.' The CO_2 hooked his thumbs in the handles of his oxygen and leant back on his infrared cowboy heels. 'Us bad boys hang around greenhouse earth too long causing trouble and pow wow, before we know it, a cannon blasts my gang out of the atmosphere. Well, not right the way out – you humans couldn't organise an atmosphere at a murder scene. But hey ho, if you're travelling down not up, any chance of a ride? If we can gather a few more carbon dioxides onboard then we'll easily have enough density to begin sinking towards earth.' The CO_2 held out his hand. 'My name's Billy.'

Icarus was soon to realise that exospheric carbon dioxide fishing was about as exciting as poaching salmon from Poseidon's heavily chlorinated swimming pool. As Billy explained while settling down into the weave of Icarus's jumper, gas particles in the exosphere were a lonesome breed and they had plenty of space up here to pursue their solitary ways; individual particles passed by even less frequently than a Planet Zeus bus. However, at least when a particle did finally pass their way, it took very little effort on Icarus's part for passing CO_2 particles to lodge in his jumper without invitation, equally eager for a ride. Icarus soon learnt to relax into it. He leant back against thin air as if exospheric gas particle fishing was how he passed every Saturday afternoon, with one eye on the sky while he re-read his favourite book, Lewis Carroll's *Through the Looking Glass*, which lived in the back pocket of his baggy jeans.

And Billy was right. Despite the slow traffic, it was only a matter of time before they had acquired sufficient density to begin falling towards the next stage of the earth's atmosphere. By the time Billy awoke, the blackness was slipping before their eyes, lightening with every mile, faster, further, until...

'Passports!' cried the helium customs officials in falsetto, puffing out their six packs at the thermospheric border control.

'Special high security delivery of carbon dioxide,' Icarus answered officiously, mistaking the helium particles' camp protestations for a gesture of being waved straight through.

'Are you crazy?' Billy screamed once they were out of earshot. 'We don't get smuggled *into* the atmosphere. Lodging ourselves in your jumper was a form of disguise. Any other guards than the heliums and we'd have been blasted straight back out!'

Certainly, the thermosphere was more atmospheric than the exosphere. It was even inhabited, although there was little comfort to be found in the presence of space-pirates – squatting the floating rafts of abandoned scientific space-stations and terrorising the upper skies. Yet right now this was the least of Icarus's worries.

'Get off!' he screeched to his cheerful carbon dioxide friends, shaking his jumper to and fro. 'Away! Back up out of the atmosphere, now, scram!' Instead the particles scampered around the back of the jumper where he couldn't get to them and laughed. Icarus tugged his fingers through his hair. No matter that he had bunked his science exam, and no matter how much the moralistic overtones of environmental debate made his toes curl, he didn't doubt climate change. Indeed, imagining its potential consequences made his stomach turn. And now in the scheme of environmental misdemeanours he'd just outdone himself. Collecting carbon dioxide

particles in the weave of a woollen jumper could potentially have been a novel invention for reducing the atmospheric concentration of greenhouses gases if he'd promptly despatched them further out of harm's way. But in fact Icarus hadn't just sequestered carbon dioxide at all. Contrariwise, he'd smuggled it back into the atmosphere to further warm Planet Earth.

Icarus raised his eyes skyward to see if his father was watching. Daedalus had spent the last few decades applying himself to atmospheric science, and had recently become Zeus's climate change advisor. Yet no matter how hard Daedalus had tried to educate his recalcitrant son, such things continued to make as much sense to Icarus as a snark in a teapot. The science of climate change was one of those things that – yes, certainly – filled Icarus's head with ideas, if only he knew what these ideas were. He'd broken his arm on a climate science fieldtrip trying to knit together some clouds in a bid to veil the sun – whistling had failed to slow his collision with earth as he fell from the snapped branches of the tallest Planet Zeus tree.

There was nothing for it. Political correctness aside, the fate of Planet Earth had to come before his favourite jumper. However, when Icarus raised his arms above his head, his hands were met by another pair – rough, weathered – which far from helping him off with it, instead hauled him onto the balcony of a passing space-station.

'Now what do we have here?' the space-pirate asked in a Cornish accent. He resembled an ageing fisherman with his bushy beard, ruddy cheeks and navy mackintosh – and Icarus his catch. Icarus recoiled from the pirate's cannibalistic breath before biting hard into his right hand. The pirate swore and propelled Icarus from the toe of his yellow wellingtons in an arc, up, up, *down* towards the mesosphere – carbon dioxide jumper and all.

At minus one hundred degrees mesospheric lightning travels at the speed of elves and sprites, firing bolts at you like pyromaniacal garden gnomes. The burning on entry was so cold that meteors combusted. Icarus spun at the speed of light, his arms and legs flailing like a Catherine-wheel. He would have truly been a firework had it not been for the inflammable protection of his carbon dioxide vest.

Usually when Icarus combusted, his story was escorted back to Planet Zeus by cherubims, to await reincarnation, reinterpretation and his next inevitable fall. But when he finally came to a stop in the stratosphere, here he still was. 'You might be the first things to truly save my life,' he said to the CO_2. 'I don't know how to thank you enough.'

'But we save your life every day,' Billy scoffed. 'You wouldn't even remember to breathe without us. But thanks, I guess credit where credit's due. Makes a change from being the black gas in the family.'

Icarus blushed. Had he really once thought to cast the carbon dioxide off his jumper to be done with as any passing space-pirate might choose? Of course not *all* CO_2 were bad. As Daedalus had once taught; it was only certain concentrations that were problematic – carbon dioxide's tendency, as Icarus had understood, to hang around in gangs and drink, multiply and collect anti-social behaviour orders as trophies for their skies.

'However, if you really want to thank us, then you could best leave us here where we can cause most climate havoc,' Billy added, winking.

Icarus scratched his unruly head of hair to weigh things up, but by the time he'd decided he really ought to offer the particles up to the authorities on Earth, his jumper sagged lifelessly from his shoulders. Every particle had dissolved into thin air, further stoppering the planet to see whether humanity could take the heat. 'You could at least have said goodbye...'

Icarus's resultant mood fitted into the ultra-violet stratosphere well. He traced his index finger mimsily over centuries of human environmental misdemeanour, etched in the sky like an Icarian tragedy. *If you fly too low, the water will clog your wings; if you fly too high, they'll be scorched by fire...fly the middle path?* Now that it had occurred to Icarus, it was impossible not to hear the echoes between Daedalus's warnings – and his own foolishness – and the tale of anthropogenic climate change. He followed the upward trajectory of human progress upon the sky – up, up, and...*where* it would come to a stop was the million-environment question. Icarus knelt upon the increasingly dense atmosphere to pray for forgiveness and a happy ending to the climate change story in which he had unwittingly become implicated. 'Let *me* fall, not humanity, not earth.'

It was a big ask, but Icarus had barely spoken before his wish was granted. He had soon gathered enough pace that the atmosphere became blurred. It wasn't long before his disorientation was complete and he lost all sensation in his dislocated limbs. He heard the almighty crash before feeling the impact. Yet in those final instants before losing consciousness, he was certain that he heard Zeus proclaim from high above.

'It will sun and rain and storm. Humanity will be amoebas rising from the remnants of earth.'

The greenhouse effect shredded Icarus, liquidising his guts and bones to pulp.

◆

Looking back, Icarus couldn't have been sure how long it took him to re-embody the slippery amoeban puddle of himself that had dripped through a halogen lightbulb down to Earth. There wasn't much that was memorable about a life as slime, after all; and Icarus's sense of linear history was shady at the best of times. But if slowly,

then surely, Icarus emerged from his landscape as an island from a
flood:

 a rib
 a single rib

 a brain – disembodied senseless
 think therefore am but could not say

 eyes – light brighter than morning
 the slow motion sea-sickness gagged

 there was nowhere to come from
 nothing to come

 the sound of potential
 the hollow of a throat

 take some shoulders slipping from a collar

 one arm
 two arms
 a touch of liquid legs

 kneecaps floating round a nearby coffee table

One minute Icarus was a grotesque surrealist collage of body parts,
the next…one, two, three…Icarus's spine clicked into place vertebrae
by vertebrae until – SNAP – his neck whiplashed into position,
causing his eyeballs to temporarily pop from their sockets. 'What
the…?' Icarus coughed, spitting some slimy phlegm from the back of
his throat and heaving for breath. His halitosis was so bad that a pall
of pollution hung over him, while the individual strands of his
woollen jumper had wrapped themselves around him like a net.

Icarus had never before felt so much like a giant, rotting squid – of this he was fairly certain. The exertion of trying to disentangle himself caused him to vomit over the laminate floorboards, while voices echoed around his mind, providing an ethereal commentary on Icarus's every move.

'If you vomit on the rug I'll be having you,' and, 'you're an insult to the giant squid population. Crikey you stink.'

It was at least another week before Icarus properly awoke from his putrid haze of existence and his nightmarish dreams. But when he did it was immediately clear that everything had changed. The green cloud of pollution that had hung over Icarus's head had cleared, revealing a summer morning as clear and fresh as newly laundered sheets. Or at least, for the first time, Icarus's brain was, and his body movements were and...Icarus sat up and blinked three times. This was a bit more like it. For the first time since landing he felt alive, vibrant, real, *himself!* He looked around.

The style of the living room he found himself in was minimal, the sofas brown. A single wall was painted orange and a bicycle had been rested against it. Icarus himself was surrounded by carnage – a pile of vomit here, an entangled rainbow of wool there, scraps of *Through the Looking Glass* scattered like confetti, his jeans in tatters. Icarus took a start, suddenly realising his nudity, before closing his eyes to try and mentally reinhabit his physical self. First he wiggled his extremities to prove the existence of the length of himself. Then he moved his joints to affirm the connections between his limbs. Finally he traced his body south to north to check that everything remained in place:

> *your foot bone connected to your ankle bone,*
> *your ankle bone connected to your leg bone...*

he began singing – the lyrics to a song he'd never known.

your leg bone connected to your knee bone,
your knee bone connected to your hip...

That wasn't normal. Icarus began again, but on the second occasion the feel of unfamiliar curves directed his eyes sharply south. 'What the...?' he screeched, jumping to his feet as if the floorboards had become hot coals. For not only had he grown child-bearing hips, but where his manhood should have been was...well, how could he put it? Icarus shook his limbs frantically in an attempt to eject himself back into his gangly, masculine form. Who was *this*? Icarus? Icara? 'This is a woman,' Icarus groaned, 'and alive with it.' Right enough, it was the story of Icarus's life to inhabit the forms of others during his earthly quests. Yet no matter how often he had wondered how the world might look from a woman's eyes, this had been but idle curiosity.

'It's not funny,' Icarus pleaded, addressing the halogen lightbulb as if it were a conduit back to Planet Zeus, where the Gods were presumably toasting another meteoric Icarian humiliation. Someone laughed, a low chortle. 'Apollo, if that's you, then at least show your face. Why not come closer for a better look!' Yet far from eliciting any response, the thought of Icarus's nemesis casting eyes over this naked female body caused Icarus to feel her first stabs of shame. She slumped onto the sofa, hugging her knees to her chest. Was this her punishment for smuggling carbon dioxide; all her punishments at once? Was she being deliberately shamed? Of course, womanhood was not in *itself* anything to be ashamed of. But an enforced sex change was *way* out of proportion to her crime. 'I was scared. Anyone might have fallen for the charms of those carbon dioxide gangsters in the circumstances.'

'Perhaps so, perhaps not,' replied the nasal, monotonic voice which had laughed previously.

'Zeus, is that you? Dad?' Icarus said, pulling a rug off the back of

the sofa and wrapping herself up in it. The recent souring of relations aside, a familiar face right then would have been some reassurance, albeit looking like *this*...?

'Well, no, not exactly. Although Daedalus *is* my idol, and I *am* here at Zeus's behest.'

Icarus groaned audibly. Could things possibly get even worse, she thought, turning to face the bicycle, which if she wasn't sorely mistaken was the source of current conversation. It was nothing special to look at: a skinny black frame, slightly worn and tatty. Its gear cables were gathered together with masking tape and its handlebars flat, in a geeky, retro style. Not tall, not short – about Icarus's size in fact. A 'hybrid' bike as they had come to be known. Yet its most remarkable attribute had nothing to do with appearances. 'A talking *bicycle*? But bicycles can't talk in the *real* world.'

'We can when there's anyone worth talking to. Depends on what you count as real.'

Icarus took a start. 'Well in my experience, the bicycle I once became could neither think nor talk.'

'A poor kind of bicycle, you will find. In my reality the ability to converse is as natural as a chainset and sprockets. Just look out the window if you don't believe in this reality.'

'I see,' Icarus replied. Indeed, she had already seen far too much since returning to Earth. Nonetheless, her curiosity led her to hide behind the curtain to further protect her modesty while she looked out of the living room window. The house was located at the end of a nondescript cul-de-sac of modern semis, as real as a postman completing his rounds. 'Well, you'd better tell me where I am if I *have* to be here.'

'53°30'N, 2°18'W. Salford, England. But if you want to understand *why* you are here, then you had better read this.' The bicycle extended an envelope from its bar-end.

Dear Icarus, Your attendance is requested at an extraordinary Athenian people's democracy tasked with resolving climate change, and discovering a future for this troubled earth, to be held on the 9th of September 2010 at the Pnyx, Athens. May this be a test of your ability to rewrite your fate. In anticipation, Zeus.

Icarus read the invitation once, twice, while its implications scaled her rebuilt spine, and her eyebrows circumnavigated the moon. *No!* Had Zeus lost the plot? Hadn't she recently emphatically demonstrated why her fate should be kept a million miles from climate change? And what for the planet if she didn't manage to rewrite her story? Of course he wasn't laying responsibility *solely* on her shoulders, but... Icarus shivered as she thought of the constellation of Gods and intelligentsia also likely to be invited: Plato, Aristotle, Socrates, Pythagoras, Archimedes, Pericles, Parmenides, Myacles, Odysseus, Theseus... Zeus, Ares, Dionysus. Apollo would be there, of course, intent as ever on making a fool of Icarus. No less than the conjoined origins of western thought on democracy, reason, reality, technology, science, logic. Icarus's high school understanding of climate change would hardly prove groundbreaking in such company. And as for her? If she failed to find an answer to climate change, as was most likely, then this was the antithesis of a happy ending. Far from becoming a God, had she just been made prisoner to the most severe problem confronting humankind?

'But you must know *something*,' the bicycle suggested.

'On the contrary,' Icarus replied, with an upside down smile that betrayed some sense, but little by way of cleverness. 'No more than any old Alice.' However, in fact, when Icarus now began racking her brain, she was amazed to discover a depth to her thinking about the current climate change agenda, quite unlike her own – as if her

23

thoughts were being ventriloquised. 'The evidence for anthropogenic climate change is, of course, by now unequivocal,' her speech began. 'But its consequences depend upon different emissions scenarios. Popularly mitigation is preferred to adaptation and if I'm not part of the solution then I'm part of the problem, right? And then there's the ongoing fiasco of international negotiations – twenty years of discussion for what precisely?' Icarus scratched her head – where had all *that* come from? 'You got anything to add?'

'Oh, I have a lot to add.' The bicycle puffed out its head tube like a blackbird. 'I wasn't randomly selected for this role. There was an extended entrance process which *I* – yes that's right, me – won.'

'But *you're* hardly ancient Greek! What role do *you* imagine playing?'

The bicycle raised its gear cables. 'There is nothing imaginary about it, Icarus. How else are you going to get from the north of England to Athens? Private bicycle scientist, Wings esquire, at your service.'

Icarus almost fell into the abyss of her own dilated pupils. 'You serious? It's been years since I rode a bike. Isn't it an awfully long way?' She wrapped the rug more closely around her once more to protect her from the bicycle's masculine gaze but needn't have worried for Wings's attention was already elsewhere.

He had grabbed a laptop from a nearby table and now peremptorily keyed in some figures as if Icarus's query was just another detail in the course of his scientific research. 'Approximately two thousand miles as the crow flies. Probably another five hundred or so if you factor in the digressions of the human road network. Zeus must have thought you might have needed time to work out if you have anything *useful* to contribute to the conference.'

Icarus knew of no other response to *that* but to scat on solo mouth-whistle, while sidling her curiosity across to the bookcase on the far side of the room. The shelves were lined with climate change fiction,

non-fiction and science: *Meltdown, Water Island, Burn Climate Burn, Apocalypse Soon*. 'These yours?'

'Well, not precisely, but I've read them.'

'Never tempted by the occasional detective novel or a romance or two? Never tempted by...' Icarus smiled for the first time since landing as her eyes settled upon the tatters of *Through the Looking Glass*, which remained shredded across the living room floor, in fact more like shards of broken mirror than confetti. She bent down and gathered up some scenes from around Wings's wheels: the talking flowers; the White King; Humpy Dumpty.

Wings sniffed, as if to say, 'Of course I've read *that*. Am I not an educated kind of a bicycle?' He pointed to the top drawer of a cabinet. 'But you will find that I'm more of a weather glass kind of a guy myself.'

Icarus opened the drawer and unwrapped a small parcel she found inside – layer by tissue paper layer – to reveal a delicate glass object, which fitted into the palm of her hand. She sucked the air between her teeth and dangled the oval, elongated glass teapot from its string. 'It's beautiful. But what am I to do with it?'

'Measure atmospheric pressure, of course – if you fill it with water then high pressure makes the level in the spout fall; low pressure causes it to rise, and even bubble out the top during storms.'

Icarus filled the weather glass with the accompanying vial of sky-blue water and watched it settle between the body cavity and the spout.

'I thought we could record our quest's statistically averaged weather conditions and deliver them to Zeus.' Wings propped up his gear cables, from where his self-satisfaction had caused them to slip.

Icarus watched the twirling reflection of the living room in the glass. It wasn't so different from a looking glass after all then, with humanity's impact on the climate reflected right back at them – a shifting weather forecast of an entire civilisation. 'So how long have

we got?'

Wings shuffled from tyre to tyre. 'Well, five weeks should be plenty, don't you say.'

What?' Icarus's eyes popped from their sockets. Just over a month to rewrite her fate, with the consequences of failure not only another fall from grace but the potential for taking the entire human race with her? She sank back down on the sofa before leaning forward and picking up a pen from the coffee table as if she might just rewrite her fate there and then and be done with it. But five minutes later Icarus had made no more progress than some doodles in the margins.

'Just start writing,' Wings said, with a knowing air. 'You may surprise yourself.'

Talk about rewriting her own fate being difficult. Climate change was the most difficult topic to write of all, Icarus was soon to realise. But sure enough, when she put nib to paper, it was as if someone took hold of the pen and started writing for her – all manner of things that she hadn't begun to intend:

> Awake, and tingling near the air,
> I write about the sun as a place I know.
>
> A collage of an afternoon –
> the architecture of the mountains,
> vanity and wax.
>
> A splash of a mountain stands on
> a hillock, advertising all I write.
>
> > *I am Icarus,* I lie,
> > *a prisoner of flight.*
>
> We eat the plums in any case
> and head back home.

At night on a haybale by the clouds,
you told me all about the antiseptic stars

Alfalfa, Spirulina, Barley grass

a rush of verbal calories,
a wing-shaped human
constellation gathering around us into words.

At 4am the sun begins to rise and we hold
bare atoms on our arms.

Alteration of disturbance at an average rate
per year; antiheroes fissioning to light.

'You finished yet?' Wings finally interrupted. 'It's already four hours
and three minutes since we first spoke. Two-hundred-and-twenty
bicycle years and almost two-million human years since time began,
but closer to being out of time entirely, and passing.'

Icarus laid the pen back down on the table and shook her head. Far
from it, she hadn't even yet begun; and quite frankly the sooner she
found out more about her alter ego, whose form she was apparently
inhabiting, the better.

Perhaps the semi-detached house at the end of a nondescript cul-de-
sac should have forewarned Icarus that her alter ego might have
none of the glamour, power or sporting prowess for which she
initially hoped. She hadn't been returned to earth as a supermodel, a
high-flying politician or an international sports sensation. As Icarus
was soon to learn, she hadn't even been returned to Earth as Alice;
her alter ego's name began with a different letter L entirely.

'Lucy,' she read twenty four hours later, having gained the strength to go on an investigative trawl of the house and discovering a résumé in the desk drawers upstairs. 'A cynical, thirty-something former environmental campaigner cum poet. Really Zeus, is this the best you can do?' Certainly, it made sense. Yesterday's exhibition of climate change know-how had been courtesy of a process of osmosis, while her increased sense of consequence resulted from ageing twenty years. And the writer of the poem last night had been none other than Lucy herself. Some unspent curiosity and overweening pride were presumably Icarus's unhelpful contributions to the character she had become.

However it wasn't until her second evening after waking that Icarus raised sufficient courage to look in the mirror. The fey character she found staring back at her had fallen over the feminine side of androgyny, but remained identifiably Icarus – as large as life, and twice as natural? His gangly form had simply been compressed – down, and curving, out. Icarus's blonde curls and blue eyes meanwhile pleasingly set off Lucy's athletic tones, even if Icarus's crooked grin ill-suited the face of a thirty-something professional lobbyist. Not that Lucy seemed bothered about inhabiting the story of a wayward adolescent. Rather, it was as if she was already leaning on Icarus, imploring that the myth might bear some weight.

Icarus sighed. At least inhabiting Lucy's identity had eased the shock of Icarus's earthly transition, enabling her to go about her daily business with ease, and it couldn't harm to have found a writer to help re-write her own and climate change's fate. Icarus closed her eyes to realise the feeling of blood flowing from her head to her toes to her heart. She was used to inhabiting the forms of others on her quests to earth – to becoming the hybrid of Icarus and the identity she had assumed, with the combined knowledge and experience of both. *And for the purposes of this climate change quest, her own myth and Lucy's life were to become one, and what would be would be, and be done*

with it? she asked Lucy, and Icarus could have sworn she felt her alter ego nod her approval.

If only Wings could have been equally phlegmatic. 'What if they don't let us into the Pnyx after cycling all that way?' he asked, gesturing unsubtly at Icarus's curves. 'You know, on account of you being a lady now, and all.'

'But you're every bit as hybrid as me.'

Wings held his half mountain-bike half road-bike form tall. 'And indeed we inanimates, when animated, prove far more open-minded than humanity about all manner of bodily combinations. I'm simply raising my concern, from the disinterested perspective of science, that your shifting identity might place this entire experiment at risk before we've begun.'

Icarus had no convincing response to *that*. Democracy was all very well, but Athens's version reached no further than the masculine elite. Zeus would undoubtedly have hired some Titans to guard the entrance gates to the Pnyx – ready to club any suspiciously womanly characters back down the feminine alleyways from which they'd come.

ᐱ

The following day was what Icarus had come to refer to as C-day – the climate equivalent of D-day – or else high time that they were on their way. If only she could work out how to fit a living room of essentials on a bicycle. *Through the Looking Glass,* which she had pasted back together, was non-negotiable luggage. But Icarus had already removed a selection of climate change novels from the panniers. 'Same old formulaic apocalypse,' she explained, ventriloquising Lucy's thoughts for Wings's benefit, with a broad sweeping gesture of her hand. 'Enough to scare anyone witless.'

'But you have sorted some travel insurance?' Wings asked.

'Programmed emergency contacts into your phone?' Wings's faith in Icarus's organisational nous had already been dented when she had returned from shopping with a budget mobile – without internet access, let alone GPS – and a set of maps. 'The weight of those will buckle my tubes.'

But never before had Icarus had to organise her adventures. They just happened – the sun tempted her a little higher, she ignored her father's good advice, and up she went. And organisation wasn't proving to be her *best* skill. 'Double insurance premiums for mythological semi-mortals and talking bicycles!' she exclaimed a few minutes later, throwing her phone down in disgust. 'And an add-on option for cover in case of apocalypse?'

'It may yet prove worth every penny,' Wings muttered. 'We'll never beat the end of the world to Athens at this rate.'

Outside, Icarus leant Wings up against the moss-roofed Vauxhall Astra in the drive and removed the camera with which she hoped to document her most fantastic quest yet. 'Smile!' The flash sparkled on the polished flanks of Wings's frame, and captured the graffiti Icarus scratched onto the car bonnet full-beam:

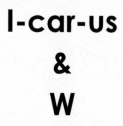

I-car-us

&

W

The adventure to end all such adventures had just begun.

Part 2: The Climate Labyrinth

because a climate wizard makes large databases of climate information visually accessible a giant iceberg breaks free from the antarctic in a collision with no intention of capping the emissions of the world's temperature record which will need to be re-analysed with more ambition if greenhouse gases are to peak in time for an official to see a climate aid scheme within months since saving the amazon may be the most cost-effective way to cut greenhouse gas emissions the concerns of which are plaguing syrian farmers with permafrost rapidly deteriorating in northern quebec while penguins in antarctica are to be replaced by jellyfish due to global warming declining into fog which threatens california's iconic redwood ecosystems' rate of ocean acidification at the fastest rate in 65 million years although zero emissions are possible at $40bn a year if only the tar sands snubbed by green retailers could see the food crisis looming over scientists peak before earlier springs destroy the delicate balance of uk wildlife studies which show arctic sea ice vanishing faster than our most pessimistic models and could cost $2.4 trillion by 2050 or else global warming may cook sea turtle eggs flooded by criticism like a body slammed for errors and potential conflicts of interest because despite it all it's known that global warming makes trees grow at the fastest rate for 200 years and after all the last neanderthals in europe died out at least 37,000 years ago and both climate change and interaction with modern humans could be involved in the demise of florida where a cold snap devastates the coral and marine life now under fire by global warming so why not raise a robin hood tax which could feed millions if only the gulf stream doesn't slow down its findings of research pollution from asia circling the globe at stratospheric heights as the world descends into darkness and coral reefs bleached by summer river algae which turn tropical electricity into greenhouse gas emissions further to the secret of sea level rise which will vary greatly by region if global cooling is bunk a draft space study finds nations large and small joining climate change campaign

analysis if a 15% cut in carbon emissions is achievable through simple inexpensive personal actions like linking butterfly life cycle climate fixes to the ways the poisoning of sea life is shifting ice which might be better seen as a problem for penguins since a recent state of the birds report shows climate change threatening hundreds of species with famine marriages as one byproduct of climate change revealing the scale of outsourced emissions will in future represent a 95 per cent chance that man is to blame for global warming says a report of scientists' shareholders whose actions hit a record high smelt in the arctic sea belching tons of methane to india as a practical means to makes us truly ask did mammoth extinction warm the earth and does the "hockey stick" temperature graph stand and if so perhaps we're screwed according to the official report of what we're not being told as massive trees move upwards phytoplankton threaten fish invasive cane toads thrive go global run a fever

Icarus soon learnt, that just because the story of her and Daedalus customarily began in a labyrinth, didn't mean she had become adept at them over the centuries.

'Now!' W cried.

It was as good a time to start as any, had Icarus had not bucked – again – at the entrance to the climate labyrinth.

'What *precisely* is the problem?'

All manner of gyring and outgribing, Icarus thought, twisting her curls around her fingers. Ahead, the traffic on the main road through Salford into Manchester jostled for position. Pedestrians weaved between the cars, the crumbling edifices of bars awaited demolition, billboards sold ten million ways of communicating apart from face-to-face conversation and all the while the road was being dug up. Police helicopters whirred overhead; the courthouse portcullis had been daubed with gangland graffiti; and the shop windows replaced with metal grilles. 'You are now INSalford' read the local authority welcome signs, making Icarus feel even more of an outsider than previously. Even the carbon dioxide particles hustled her, unlike the laidback particles of the upper atmosphere. It was less than a year since Icarus's last quest to Earth, but each time she returned she discovered more and louder and faster of the same. If she had been writing an apocalyptic climate change novel then this scene would have appeared not far from the final climax, she thought, channelling Lucy's thoughts into the present for dubious support. She already suspected that Lucy felt no more at home here than her.

'Salford! Birthplace of the Industrial Revolution, currently undergoing regeneration!' W exclaimed, curving his handlebars into a broad smile before catapulting Icarus onto the main road so quickly she forgot to resist.

The weather glass reading Icarus had taken before leaving that morning had been 'changeable'. But which quest wasn't? Icarus now asked, looking up as they made their way south out of town. Above,

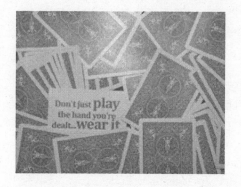

Don't just play the hand you're dealt... wear it

the angular white struts of Old Trafford Stadium, 'Theatre of Dreams', cut open the skyline, inviting her to imagine that nothing might be the same after this trip – for climate change or for her own fate. But her blue-sky thinking was soon serrated by the jagged profile of Spinningfields, the business and administrative district, off to their left. Was this what Zeus had sent her to earth to stabilise? Better throw the whole shebang up in the air like a pack of cards. Icarus couldn't begin to imagine why die-hard capitalist Zeus had chosen *her* for this quest, considering her politically left-leaning and contrary tendencies. Neither did she yet understand why the most omniscient of the universe's bullies didn't just resolve climate change with the storm to end all storms – with a click of his fingers – just like that.

But never mind their political differences and his bullying nature, Icarus reluctantly found herself smiling as she thought about her surrogate father figure. Zeus, the example her father could never have been, who had undoubtedly looked out for Icarus over the years in his domineering way. Zeus, the all-knowing, all-seeing God, Icarus thought a short while later, squirming and risking a brief peek in his skyly direction as she locked W up against some railings and shifted her weight from foot to foot in preparation for making temporary peace with number one enemy – a bank.

'One carbon credit,' Icarus said to W ruefully on her return, weighing the notes and coins between both hands. 'That's what I get for cycling you rather than taking the plane – it's hardly a luxurious allowance, is it?'

On their way out of town a paint-spattered decorator called out to ask them where they were headed. Icarus read the curved beginnings of the tabloid headline, rolled in his palm:

'WHAT THE...?!'

before replying 'Shropshire'. It was a more immediately achievable destination than Athens, after all, and if she *had* to be tasked with climate change, then it was as likely to happen there as anywhere.

we trace our labyrinths with clews of salt

 la via salaria

 a vapour trail upon the sky
or the dashes down the middle of the road
 they closed the border round
the triassic cheshire salt plains years ago

 glaciated flood defences made
of mountains round the sea

 at the point the earth was closed
 we took to flight

 rearranged beginnings
 changed our names

 turned pterosaurs to minotaurs
 and flew towards the light

 the brightness of stars
inside the blackness of night.

these earth grown wings are only leaving things

> A fear of no return.
> A place we've never been.

our clews unravelling spittle from dew

During Triassic times Cheshire had lain under seacover; beneath the surface the sea had left behind a subterranean landscape of salt deposits that had been mined since Roman times. But it was now a rolling, agricultural landscape peppered with olde worlde Mercedes cars and nouveau-Tudor wooden beams. If Icarus had romantically imagined bicycle-bushwhacking through the wilds on her way to Shropshire then she'd seen wildernesses compared with which she'd call *this* a garden! 'And this our own unravelling clew of salt, leading us to the end of the climate labyrinth,' she cried, pointing to the salty white line along the side of the road ahead towards Winsford. 'Better not rain or else we'll never find our way!'

Yet in Winsford itself there wasn't one clew, there were hundreds, and they had just taken the wrong one, up the steepest hill in Cheshire, past the oldest bike shop in the word, a full ninety degrees off route.

'Prehistoric,' W said, pointing condescendingly at the Raleigh Grifters in the dusty window as they rolled back downhill.

'And us the pterosaurs – the first living vertebrates to fly,' Icarus replied, stretching her arms wide, before wobbling to a halt in time to stop herself falling spread-eagled on the tarmac.

'That was clever, wasn't it?' W said, causing Icarus to blush terribly. If the parallels between her own fate and that of humanity with climate change were as closely associated as she feared, had she just risked taking the human race out once-and-for-all by pretending to be a dinosaur? 'So did my alter ego like cycling?' she asked,

quickly.

'Oh yes,' W replied, puffing out his down tube. '*I* was responsible for keeping her sane!'

In truth, her alter ego's love of bikes was already serving Icarus well. It was easygoing cycling and they were travelling at a good pace, which was just as well because the day was already shortening and they hadn't seen a single campsite all day. And no sooner had Icarus begun to worry where they might spend the night than a sudden gunshot pop and hissing caused W to career from control.

'Whoah, steady!'

Icarus wobbled to a stop and jumped off before holding W still and staring blankly at him for a good few minutes. Their first puncture – already. What was she meant to do with this? Bicycles hadn't even existed when she'd first been a young lad, which combined with her infamous lack of technological savoir-faire...

'Are you mechanically dyslexic?' W asked, as Icarus completed a botched repair job, unlikely to make it one hundred metres up the road, let alone to the next bike shop.

Icarus wiped her greasy hands up her thighs. How would she ever resolve the climate if she couldn't even fix a tyre? Anyone might have thought that Zeus never intended her to rewrite her fate by giving her a quest so far beyond her. In the circumstances, the 'ROAD AHEAD CLOSED' sign blocking their passage through the climate labyrinth a few miles further on, barely came as a surprise.

'The pub?' W pointed towards a small sign advertising ales, half a mile in the wrong direction.

The Comb-yer-Arms was a smart place. Icarus shuffled from foot to foot. It was her first time back in human company since Planet Zeus, and she was grimed with dirt, but no-one seemed to care. Her enquiry spread like Chinese Whispers, from the barmaid's ignorance right back to her: return back up the salt trail, left, right and back a little bit, where she would find a Friesian cow advertising sunhats in

the corner of a field of Welsh nuns praying for rain. Icarus was already lost, but the barmaid promised it was easy, drew a dodgy map, and told her to look out for a pub called the 'Cotton Arms' with a 'field out back'.

'Don't sell as nice beer as it does here, though,' added a man with furry arms who smelt of farm, as if he expected her to settle down for a few pints and camp in the one patch of grass in the pub grounds – beneath the septic tank.

The barmaid's map in fact proved perfect, if only they had been a caravan. 'N-O T-E-N-T-S,' W read slowly, as if spelling out a chemical formula. The bar was busy and the barman served everyone else before lazily drawling, 'Y-E-S?' to Icarus in a slanted way which matched the angle of his squint, which was currently angled upon her none-too impressive cleavage. Icarus puffed out her chest – much to Lucy's internal chagrin. But as it turned out, a few extra pennies and a bit of cleavage easily outweighed Caravan Club regulations.

'Eight pounds for an overgrown meadow, no showers and toilets only until closing time?' W protested.

But otherwise it was perfect and Icarus had soon pitched up and re-heated some fish cakes she had found in the freezer back in Salford. 'Time for my first ever legal pint,' she grinned, skipping in the direction of the 'no-talking-bicycles' sign above the bar door with a bundle of maps beneath her arm.

Icarus's route-planning for the next day had already gone astray to the tune of one pint and she was contemplating a second when two

couples sat down at a neighbouring table and rescued her from imminent drunkenness.

"minGinG"

they exclaimed in broad Salford accents, turning their heads in her sweaty direction.

A short time later, inside the coffin-sized tent which was to be her home for the next few weeks, Icarus lay staring at the moonlit roof up above her head, feeling her lungs expand and contract – just one of a globe of rising and falling breaths as one hemisphere woke and the other fell asleep. When she began to whistle it was softly at first, but soon the birds joined in, and the leaves began to rustle, and even W strummed on his gear cables until the night reached full voice.

The music ceased as suddenly as it had begun. Icarus pulled her sleeping bag over her head. Climate change had already proven an elusive companion. No sooner had she captured it in her thoughts than it slipped back into the everyday – food, money, how far she might cycle tomorrow, and finally, a dark black shade of sleep.

a site after the machines
a recapitulation of the whole
sited in a meander of the branches
of the troubled trees

a bright lagoon black water

i sell my emotional
attachment to the edge –
not thinking very much –
establishing a style

industrial activities declined on the back
of scraps of paper with matchstick butts

the proximity of the bleaching fields
to the chronic poverty of concrete space

it went so fast
the fertility of varieties
we download into our composite remains:

ivory black *vermillion*
prussian blue *yellow ochre*
flake white and no medium

shadows sketched in pencil grey on white
an opening to erasure into something else:

 strong falls of water
 hearing hills.

the smell of astronomy and a sixth sense
of the virtual panorama

When Icarus first woke she couldn't immediately locate herself, and
why was everything so green? Remembering, she groaned and
pulled her sleeping bag over her head: she was in a green tent in a
field behind a pub not even yet in Shropshire. *She-Icarus* and her
talking bicycle were going to save the world, and the temperature
inside the tent was already unbearable.

'Morning! Sleep well?' she asked, propelling herself outside like a
pupae bullet.

W rubbed some moss from his nose, sniffed. 'Bit dewy. Got
between my joints.'

'Ditto. I think my groundsheet's absorbent.' Icarus hunkered down
to light the stove, half expecting the fuel to explode her straight back

through the atmosphere. She sighed heavily, imagining Zeus's temper if she returned now, burnt and frazzled by methylated spirit.

'What are *you* doing back already? So you've rewritten your fate? Resolved climate change?'

Whereas her Dad would just scratch his unruly head of hair, shuffle awkwardly, and wonder how best to resume relations with his prodigal child. It wasn't that Daedalus had been a bad single-dad. Rather, that he was a *genius* of one, who hadn't yet worked out how to apply atmospheric formulae to fatherhood.

Icarus burnt her lips on her first slurp of black coffee, and looked up to the skies. Usually her quests were peppered with Zeus barking orders and Daedalus pleading guiltily that she mightn't fly too close to the sun. But so far there had only been an eerie kind of silence and the loneliness of the most independence she had ever experienced. Not that those thoughts were going to get her anywhere – let alone to Athens. Icarus packed up before her doubts could get the better of her and pushed W through the long dewy grass towards the exit. 'Shhhh!' she whispered noisily, leaning him up against the bins while she nipped through the back door of the pub to steal a pee beneath cover of the whining vacuum cleaners.

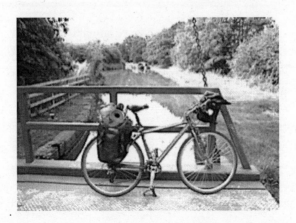

It soon became apparent that navigating a route to Athens was going to prove even harder than navigating the atmosphere to Earth. The barmaid's map went no further than the campsite and the roads were too minor for salt trails. 'Across that muddy field and through the farmhouse living room according to the compass,' Icarus proposed at the first crossroads. 'D'you think they'd mind?'

'Or else this road looks *least* wrong.'

At least once Icarus had reached the Earth's gravitational force it had pulled her in, as if by an umbilical cord. But there was no umbilical cord leading to Whitchurch, let alone Athens; and the minotaur of this labyrinth was Birmingham, sitting slap bang in the way of almost every route.

Before they left W had shown Icarus how to trace a great circle arc – the 'as-the-crow-flies' route – across virtual earth. Groundbreaking, Icarus had thought, but useful as a teetotum considering she was travelling by bike. Yet her own computer-generated estimation had been no more helpful: the cycle was feasible within the time frame, just, but only if they stuck to motorways...however it wasn't long before the rolling countryside eased the knots from her shoulders. A few miles further on, a cycle-route sign even popped up pointing all the way to Salisbury. 'That's precisely our direction. How lucky is that?'

'More of a validation of my experimental approximation to scientific truth, as a *regular* rule,' W replied, with a *Through the Looking Glass* turn of phrase that caused Icarus to take a start for not the first time this quest.

All they saw of the Roman town of Whitchurch were some housing estates on its outskirts, some toga-clad Whitchurchian teenagers programming their satellite-enabled wrist-devices for the quickest parent-free route to the skate-park, and a community elder fly-mowing around his faux columns and fish-spa pond. They were soon back in the countryside, winding along hedgelined lanes and

between fields of crops ripe for harvesting. Icarus found herself thinking the kinds of thoughts she'd never had the time to think before: *are the wheat sheaves whistling, or the wind?* 'What's the rush?' she asked a duck, flapping its way across the Llangollen canal.

W exhaled a puff of dirt. 'The rush Icarus...'

'But wasn't the wind behind us before?' They had just rounded another bend into a headwind, back over the canal (twice), corkscrewed round more hedgerowed lanes, until, 'does this not look familiar?' Right then, in fact, the hedges had been cut so uniformly and the fields were arranged so neatly that everywhere looked familiar. Most crucially, however, there were now two roads ahead, and the signpost pointed directly in-between.

'The deeper tyre tread says this way.'

'But we don't have to follow everyone all the time.' So many possibilities, mixed signs, dead-ends and whoever had led a merry dance along yesterday's salt trails had abandoned them. If climate change were a labyrinth, then its architect kept changing its design. 'This way!' she said, pointing in the opposite direction altogether. They wound round the next two corners of the maze, unable to even see into the next field over the hedges, let alone all the way around the atmospheric curve of Earth to Athens.

Icarus's route choice failed beautifully. The next signpost revealed she had both correctly chosen the cycle route, and the wrong direction – north not south. 'But perhaps there aren't any right directions,' she supposed. 'Simply an infinity of slightly-longer slightly-shorter routes around earth, all leading eventually to Athens.'

'Scientifically affirmative,' W replied, reorienting himself back towards the sun which was already proving the most helpful dual-function clock and compass of all.

as a slant of opposition to the way the sun faces the creation of space which time might positively circumnavigate

Daedalus had begun Icarus's education early, but over the years his look of disappointment at Icarus's scientific and technological failings had become etched on the back of her eyelids like a mental tattoo. True, there was little point dwelling on this now, but in fairness to W it did mean that Icarus had to find a bike shop to get his injuries repaired – soon. And the pedestrianised main street of Shrewsbury, whose timbered Tudor buildings overhung the road with multi-coloured logos and advertising straplines, wasn't looking hopeful.

'Vodafone, phone a historical friend!' W exclaimed. 'I choose Darwin.' Over the years the town's devotion to its most famous resident had evolved from a figurative statue outside the library into a 12x17 metre, half-a-million pound shell-shaped vertebraic DNA

super-sculpture named the Quantum Leap – poised to slink off down the Severn as soon as no-one was looking.

'Look! Darwin Shopping Centre,' Icarus said, 'where he developed his Natural Selection Theory of Marks and Spencer pants.' But the banter only lasted as far as the first bike shop. 'What was that for?' Icarus asked, picking herself off the cobbles where W's bucking action had thrown her. 'Don't you want your tyre fixed?'

'I want to *be* fixed. But I don't want to *get* fixed. I hate bike shops.'

Icarus laid both hands on W's handlebar grips. 'But I don't know what else to suggest.'

W swallowed. 'Oh, ok, Icarus.'

The first bike shop proved to be in the early stages of evolution and didn't stock bike tyres. The second was out of W's size. And while the third was state of the evolutionary art, the owner wasn't. 'Hello son,' the man said, failing to apologise when Icarus corrected him, and bursting out laughing when she told him where they were headed. 'You? Off across the Alps on that? Going to save the world are we?' W's handlebars bristled and his wheels buckled from side to side as the snark trundled him one-handed into the operating room.

However, Icarus couldn't deny when she returned, that W was looking one-hundred times healthier. 'Thank you, that looks wonderful,' she said, sticking her bike pump in the snark's ribs and hanging him up in the market square for the locals to throw carrots at. 'Excuse me,' she asked a bearded copper, who was idling away a day's lack of crime stopping cars to chat to his friends a short distance down the road. 'How do I leave Shrewsbury? Quickly?'

'Well I just drive round the ring road, but you shouldn't really do that,' the man replied, beaming with ignorance. His female colleague smiled less, but at least gave them directions.

'We're in a dead end car park,' W said, stating the obvious.

'Those police officers were no Darwins, were they?'

W coughed, and his tubes blushed through their black paintwork,

before he stammered, 'you know, Icarus, you're not so bad really...*you* might think you're a bit of an evolutionary aberration, but, oh, well, err...thanks Icarus...'

Icarus smiled an upside down smile as she looked at W, then looked her maligned androgyny up and down. She let out a long breath of air, as if deflating pressure. Was she wrong type of cyclist, on the wrong type of bicycle, on a quest which had been wrong-minded since the beginning?

'Oh, don't look so sad Icarus,' W added, the ends of his handlebars curling into a grin. Perhaps we don't need to worry about gaining access to the Pnyx after all.'

Icarus levered W up some steps out of the far side of the car park. In fact the Pnyx felt so far away right now as to be an irrelevance – both physically *and* emotionally. Who cared about entrance into a man's world which made you feel this objectified, lessened, *cheap*? Was this the way of things for womankind on Earth? Were quests the liberty of men? Was this the kind of experience which Lucy was accustomed to? Surely not! The episode had left a metallic taste on her tongue. The snark wouldn't have dared doubt her ability to cross the Alps by bike if she had been a bloke.

Icarus flushed to remember her own recent objectification of her cleavage in the Cotton Arms and how a puerile echo of her old self had found the barman's seedy gaze at her breasts entertaining – at the time, understandably, much to Lucy's disgust. Icarus had always prided himself upon being an open-minded, progressive thinking chap. But *really?* How many centuries of inadvertent insult might he himself have directed towards women? Was her masculinity coming back to haunt him? Was his feminity...oh, *balderdash*, Icarus thought, as the pronouns of his-her existence tangled round each other and wouldn't come right whichever way she put it.

my name is icarus in chaos
 inchoate

 i am the obsolete
 of abyss
 the gap between
 the time available

i'm situated in the space between
your knowledge

 lost or gained

 the end of hubris
 sloughing wings from the suns
 you laid along my spine

if you ask me who i am i will take
the archetype of namesakes

 a loss of windows to pictures
 stories resurrecting openings

 i name myself the way that i become
acquiescing with the way i always was

At least they had a tailwind, Icarus thought, as they continued south
along the suicidally narrow and busy A49. A northerly at this time of
year was unusual, but so long as the wind blew them forward, this
was one climatic abnormality that even W agreed to overlook. A
short while beyond Shrewsbury they were back in the most scenic of
countryside. The Long Mynd hills stretched away to the west, with
Church Stretton nestled into their steep slopes, while Caer Caradoc
studded the skyline to the east – aptly, perhaps, like a large breast.

 'Are we there yet?' Icarus asked, in the tone of one who would
have happily wished away the forty miles they still needed to cycle

that day before they could justify stopping over. The next town of Craven Arms didn't have any arms but it did have a FARMERS MARKET NEXT SATURDAY. Ludlow meanwhile was as quaint and prosperous as expected, with its timbered houses, cobbled streets, and independent shops selling produce from the local area. Icarus dragged W away from the mouthwatering menu of another multi-rosetted restaurant. 'What? A table for me and my talking bicycle please guvnor?' Further on in Leominster, Icarus took a wrong turning – not once, but twice. By the time they neared Hereford, the risk of benightment finally tempted her to stop at a small campsite with a duckpond and two coin-operated showers.

'When you dragged me from that restaurant you didn't warn me about *this*,' W commented, furrowing his cables at his dinner of powdered-minestrone-soup-pasta laced with processed cheese later that evening. 'What on earth is it?'

Maltodextrin *Potato Starch* *with Flavourings*
Dried Noodles (8%) *Tomato Powder (7%)*
Sugar *Dried Vegetables (3.5% including Peas Carrot Tomato)*
Salt *Onion Powder* *Yeast* *with croutons (6%)*

Suitable for vegetarians – just add boiling water

First thing next morning, Icarus refilled the weather glass for her daily measurement. The water level rose up the spout, forecasting rain. But just looking out of the tent could have told her that. Icarus's backup plan of retracing her clew of salt if all went badly wrong had already dissolved into the local water courses. Meanwhile her limbs had begun to rust; the muscles behind her knee had begun stiffening the previous night, and were now completely seized, making it difficult to straighten her legs. Outside the tent, she spread her

luggage on the sodden ground before her ready to pack up and post back to Salford. There was nothing for it but to travel as light as possible. Back in the day had she not travelled as light as her own skin and a pair of home-made wings? Hairbrush, Britain guidebook, battery charger, a pair of trousers, some socks and pants, compass. She could certainly do without these, she thought, unscrewing her belly button and laying it on top of the pile like a crown.

Climate change, of course, remained unexpendable, and was already proving the heaviest, most unwieldy baggage of all. It wasn't just a case of changing weather conditions, Lucy had already taught her. Trickier still were the *human* parts to the maligned weather's problems: political negotiation bedevilled by self-interest; the shifting exchange rate of the concentration of air; potential catastrophe; alternately petrified and apathetic peoples...the more Icarus thought about what was involved, the more she concluded that climate change was an *awful* lot for two words to mean – a definitional labyrinth of the most complex and entangled kind. No wonder her knee joints were already creaking beneath the weight of it. Rewriting her fate? Wearing Icarus's old story to the bone more like, over the tangled mess of Britain's roads.

However Icarus could just imagine Apollo's snarky grin if she had to abandon cycling before even leaving the country – swigging on a bottle of stolen Retsina and toasting another Icarian fall from grace: *see that Icarus, can't even tie his shoelaces, let alone save the world. Had to take the train after two days.* Not that she had enough cash to pay for the train even if she'd wanted to. She raised her head to the sky. 'What could a climate want of the like of me?' she asked, but even the climate refused to answer to its name, as if *it* had no use for it, while Zeus and Daedalus remained hors de combat as ever.

Admittedly, by the time they had reached Hereford, Icarus's whiffling mood and aching limbs had begun to ease. Once she had despatched her excess luggage with a handy-enough Anglo-Saxon

messenger at the local post office, and dropped by the cathedral to borrow its Mappa Mundi, she felt lighter in spirit as well as fact. She stretched the two square metres of thirteenth century cow vellum across W's spokes. 'Mappa Mundis are by far the best maps for labyrinths,' she explained, pointing to the historical and mythological symbols peppering its geographical surface:

we split our sphere in three
and hold the habitable portions in our palms

europe, asia, africa

destratified from rigid climate
zones we orient ourselves due east
and keep on moving

where the human mass finds rest there is an island:

palm trees
granite
and the beach front promenades
they built last century

we sketch the outlines of the myths we found
along the way in sand

where now?

but it feels quite calm here
adjusting our ways of breathing
to the altered density of air

the tide is turning myths into the sea:
grains of sand we filter through our hands
and an absence of coordinates

'But I don't understand why we're down here.' Icarus pointed to a small island marked Britain perched below the bulbous curve of Africa. 'And our destination's due north east – up here?' She dragged her finger in an exaggerated manner, diagonally up, and right. 'See?'

W did see, but simply spun his wheel to reorient the map to the absent sun. 'Surely it depends where you're looking from.'

Icarus reluctantly agreed. 'But *my* story's certainly been misplaced.' She licked her thumb and smudged the symbol representing the myth of Daedalus and Icarus from where it had been swept into the mid-Atlantic onto Britain. 'In the beginning was a Cretan labyrinth. A riddle of a place—money, belief, intrigue and power—with no apparent exit, and a minotaur waiting to maul you if you dared try to leave…the jaws that bite, the claws that catch!'

W shivered – 'crikey' – but he was not to be dispirited for long. 'It's a race!' he cried as they crossed the bridge over the River Wye. He threw a stick into its bulging currents before accelerating towards the hills ahead. 'Come on, you must cycle twice as fast as this if we're ever to keep up with the river, let alone climate change!'

🔺

No matter how fast Icarus cycled, the bad weather and poor visibility moved with them as they cycled deeper into the climate labyrinth, via the direct route to Monmouth over the hills.

'Llancloudy,' W read off a village sign as they entered Wales, shaking the rainwater from his tubes, which were standing the test of the weather better than Icarus's goose-bumped skin. It was a remote stretch of earth, with small village islands rising from a sea of fog. By the time they had aqua-spun back down the hills to flood-prone Monmouth, they were only beating W's stick – which had taken the longer, flatter route around the hills – by a bike length.

Ahead, their route meandered down the deciduously wooded Wye valley, back and forth across the river – England, Wales, England – alternating the lead with W's stick at every bridge. But by the time they reached Tintern Parva, W's stick had been waylaid.

'It's not a single stick, it's a convention,' he said. Sticks of all shapes and sizes clumped around the moored boats, making identification impossible.

'So long as it enjoyed its journey.'

'It's not the winning, I suppose, once there is no race.'

Yet further wonders lay just ahead, where, around the next corner Tintern Abbey suddenly rose above them. The remains looked as fragile as a vast spider's web and tourists were dutifully showing their respect by trickling down the path to pay their entrance fee before retiring to the Wordsworth café for tea. The rain had ceased but mist hung upon the tree tops. When Icarus sat on a wall and closed her eyes it came as no surprise when the sky began to talk, in a whisper like the wind:

> *while here I stand, not only with the sense*
> *of present pleasure, but with pleasing thoughts*
> *that in this moment there is life and food for future years...*

Icarus waited for the sky to finish the entire poem before re-opening her eyes. It was just how the sky should have spoken – God-like, in riddles, idealising nature as well as any William, Percy or Samuel...which was all very well, *but*...of what use nature poetry when it came to climate change? Icarus scratched her head where her alter ego's thoughts met her own mind. But if not poetry, then what? Whistling? If poetry struggled with being *about* climate change, then it was far beyond whistling, Icarus concluded, breaking into a jaunty sailor's shanty and drawing a picture of the Abbey onto the Mappa Mundi, with a small black bicycle right alongside:

 five length of five hear
 these waters rolling springs

 with a murmur-once again

 do cliffs
 that impress

 thoughts connect the sky

Their onward route due south wound through the limestone gorge
at the end of the Wye valley, down to Chepstow and on to the Old
Severn Bridge where cars and lorries were queued several deep. W
goofily raised a bar-end at the drivers, from a position safely beyond
punching distance, as they took advantage of free passage for
bicycles, pedestrians and low-flying gulls. Icarus looked down to
read the lines etched in the banks of mud – a bit like palm-reading
the skin of the earth – before raising her head to admire the elevated
grace of the New Bridge further downstream, stringing the traffic
high across the sky. Perhaps everything would be ok after all? The
tide would come, and the tide would go, a bit like the weather? And
right enough, back in England the sun came out. Chocolate time,
Icarus concluded, lying down precariously as Humpty Dumpty on a
low wall outside a village shop and starting to whistle:

 Hicarus Dicarus sat on a wall,
 Hicarus Dicarus was fated to fall.
 Had Zeus lost his marbles, gone round the bend,
 giving She-Icarus a climate to mend?

'If I could grant you one wish, W, then what would it be?' she asked.
 'But this trip is my wish, of course,' W snorted. 'The chance to put
my climate science into experimental practice at last. Didn't you

think I'd know the answer to that one? Ask another.'

Icarus turned to look her egghead bicycle in his bolts. 'Yes, there is actually something I've been wanting to ask. So what *do* you know about climate change if you're such an expert? I'm always happy to learn a thing or two when it's sunny.'

Just as Icarus hoped, W had soon launched into a barrage of climate data, statistics and formulae which mixed with sunshine, rapidly lured her off to the land of nod. When she woke, W was drawing to a close.

'...extrapolating from the simple challenge of applying the world's conjoined techno-scientific expertise to the earthly apparatus so as to be cognisant of what might otherwise appear to be the contradictory impulses of the balance sheet of atmospheric and financial concentrations of gas – whether we aim to stabilise emissions, greenhouse gases, or even the climate itself...'

Icarus swallowed a yawn, patted her tummy. She hadn't actually needed to listen to W to get the gist. There was a problem, and according to his way of thinking, problems needed to be solved. If only she could think that linearly! Zeus had once explained that there were those in life who pursued purposive ends and those like her, who stumbled on, prone to diversions of curiosity, like scribbles in the margin of the page. What might it be like, she wondered, to see the world through the technological lens of her Dad or W? What might it be like to be Zeus, with responsibility for the whole world?

Before setting off again Icarus smudged a fingerprint of chocolate onto the Mappa Mundi just south of the Severn crossings. Already the map was becoming decorated with symbols of her travels through the climate labyrinth; as if it were a storyboard for a huge game, being played the world over. And her no more than a prisoner or a pawn, no closer to understanding climate change, let alone finding a resolution to it, than she was of becoming a God?

Icarus had hoped for an easy early evening cycle through Wiltshire's maze of country lanes. No-one had warned her about the climb over the Cotswolds. But she was soon charmed by the limestone houses, winding roads, dry-stone walls, extended fields of crops, and a light sharp enough to carve plum-cakes with:

The whole world had come out to play: horses, drivers, flowers, the odd spade or two. The pub advertising two steak and chips plus a bottle of wine for £20 was tempting – *we'll have two £20 servings please* – but they were already running late. By the time they reached Devizes the light was fading. 'Red sky at night, shepherd's delight. You can almost see the layers of the carbon dioxide can't you?' Icarus said once they had pitched up and sat watching the pylons sculpt a weather front from the falling sun. 'Sometimes this whole trip feels like a sunset, W, do you know what I mean? A final chance for the climate, for humanity, for me...'

'And you're not the only one, you know,' W replied. 'Did you not

see the high-tech carbon racing bike at the top of the Salford stairs?'

Icarus nodded and stole a glance at W.

'Not that *she's* got the stamina and strength I've got,' W continued, wiping away some uncharacteristic dampness from around his headset and shrugging off Icarus's gentle squeeze of his handlebars.

Icarus looked around. The campsite was as stratified as the weather, from the elegantly refined tents at the top, down to the rambling shacks housing raucous families of children and beer-swigging parents who had joined forces for an anarchic game of football. If only she were a bit more like Apollo, Icarus thought, and could wander over and ask to join the game. In actual fact, her social ambitions got no further than the shy 'hellos' she exchanged with passing campers – 'lovely evening for a sunset:'

> English speakers love to talk about the weather. It is a way of *breaking the ice*. One common mistake learners make when talking about the weather is mixing up the noun, adjective and verb forms of weather words. It is sun, it is rain, it is wind. The glaciers are melt.

Not for the first time in her life, Icarus felt as if she was travelling *through* humanity rather than *with* them on this quest to Earth; as if she really were, somehow, apart – semi-mortal, neither human nor God, neither fully man nor fully woman, at home neither on Planet Zeus nor here. By the time she hobbled over to the toilet block for a shower later that evening, her leg had again stiffened markedly. The last thing she needed was to have her headtorch stolen by some teenage boys while she washed. Not that it was the end of the world in the current context, she supposed, and Icarus had already fumbled halfway back across the campsite when a hand tapped her on the shoulder. It was the toughest looking boy of all, holding her

torch in his outstretched arm.

'Sorry to scare you, miss. I think you must've dropped this.'

The following morning, when Icarus had arisen, the water had lain low in the weather glass's spout, predicting sunshine. But instead of enjoying the weather, by the time Icarus reached the town centre of Devizes, she was all of a sudden of a mind to call the entire expedition off. She jabbed at the newspaper she had just purchased with her index finger. 'How can I continue when all this is going on, W? My quest's just exploded through the ceiling.'

She sat down on the steps of the Devizes market cross, whose stone tiers radiated with cold. Having proven unable to rouse the owners that morning, or to find anywhere obvious to leave some money, Icarus had crept up the campsite lane without paying – with the tip-tyre of the guilty and a fear of Zeus. It was only two hundred years since a local woman had been struck dead by lightning for failing to pay her share of a bag of wheat. Icarus traced the shape of the 'Z' which marked the spot where Ruth Potterne had fallen with her toes: Zeus's final mark, reserved for when he is so frumious that he has nothing left to say. But in the current context a portion of wheat or £8 of campsite fees unpaid were the small change of guilt!

Icarus's morning cycle had been waylaid by the headline catastrophes catalogued on an advertising board outside the local newsagent. Droughts and wildfires in Russia, floods and landslides in Pakistan. Hundreds, becoming thousands, already dead, and an incalculable number of lives destroyed. Of course such events couldn't be directly attributed to climate change, even if they were the kinds of events anticipated. But what response was adequate to this? The article hypothesising the meteorological causes seemed premature, and the articles dominating the centre pages bad taste.

'Will Russian export embargo cause wheat prices to rise?' Surely no-one right now cared?

While Zeus was evidently cold-shouldering Icarus, he did apparently still exist, because he had taken the chance to advertise his plans in a piece of editorial commentary:

> *It is because of events like these that I have organised an extraordinary convention of Athenian democracy to gather humanity's best minds with a view to not only resolving climate change, but preventing associated humanitarian disasters such as these. If nothing is done about climate change, then such catastrophes are certain to become more frequent.*

Even Daedalus had been drafted in to provide an expert's view in support of Zeus's rhetoric.

'I'm sure your intentions are worthy, Zeus,' Icarus began, looking up to address the God of the Gods. 'But surely these events make a mockery of my quest? There must be something more useful I can do…' She stopped short. Her, the semi-mortal who had flunked her school science exam and recently smuggled carbon dioxide into the atmosphere? But it wasn't more technology she was after, more like, 'what, beyond this cycling adventure, can I do to help?'

'But you can't give up the race while there still remains a race,' W replied, filling Zeus's silence. 'That's like entering a labyrinth and giving up at the very first turn.'

Icarus rummaged in her panniers for the weather glass which she made a show of filling. 'An experiment? Try reassuring the Russian people with a weather prediction of a sunny day. Perhaps we need to reconsider our methodology entirely. It's not the climate that's the problem. It's us, it's them, it's everything! A weather measurement here or more technology there isn't going to solve that.' Icarus gulped at the vehemence with which this had sprung from her lips,

as if she were no more than a voicebox for Lucy's concerns. She raised her arm, preparing to smash the weather glass on the tarmac.

'Whoah, hold on there!' W's handlebars had turned white with outrage. 'At least this experiment is contributing to knowledge that might help prevent future catastrophes. What do you propose? More whistling? Why didn't Zeus send a real God with real supernatural powers? No, who do *I* get but a wayward, self-centred, outgrown adolescent intent on discovering a happy ending to her story, with the mistaken notion that this will ensure a happy ending to the world. This is a once in a species' lifetime opportunity. This is the climate's moment – never has there been such consensus over the need to resolve climate change: the science, the economics, the politics. The climate's right!'

Icarus slumped further with every blow. He was right. W, and climate change, would have been far better off with athletic, intelligent, manly Apollo. Zeus couldn't have chosen more badly had he tried. And what alternatives *were* there to her current quest? Say she made her way to Pakistan to help the relief effort – her two left hands were likely to prove more of a hindrance than a help. If only she felt like she was actually *getting somewhere* with climate change on this quest. As it was she felt like Alice in her race with the Red Queen – all this cycling just to remain in exactly the same place. But all the same, she lowered her arm, emptied the water from the weather glass and repacked it carefully in her panniers. 'But surely my views aren't news to you, W? Didn't Lucy speak of such things?'

W spat some dust from his brakes dismissively. 'You must've been listening at doors and behind trees and down chimneys, Icarus.'

♠

The wheat in the fields beyond Devizes bent low, heaving with grain, as Icarus and W's south-easterly trajectory accelerated the

season. Some of the fields had already been harvested, and straw offshoots were bundled up into all shapes and sizes of bales: upended oblongs, margarine tubs, old fashioned stooks. It was mainly wheat, with a bit of barley, corn, and some sparkly, mauve Christmas baubles growing for the coming season. The road bisected the Vale of Pewsey from Salisbury Plain, with Stonehenge only a few miles south, over the tops of the hills. Yet Icarus's shoulders were bent even lower over her handlebars than the grain.

On the one hand she could go along with everything and see what the scientific experiment with the weather glass delivered them? And perhaps she needed to just have faith in international diplomacy? Surely those ancient Greek minds that had created this civilisation must have *something* to contribute? But fundamentally Icarus agreed with Lucy – science and technology were unlikely to be *the* answer and it was hardly a homogenous endeavour. There were as many approaches to science as there were roads to Greece! Neither was it neutral, for who decided what was researched in the first place? Icarus sighed. At least there was *one* thing of which she was certain. Living in fear of catastrophe

would leave her feeling more trapped and powerless than ever.

She raised her head and resolved to enjoy the morning. And right on cue the thatched houses provided a comical commentary as they passed. 'If just a simple trim from time to time, it is a little wasteful buying new wigs all the time,' grumbled one elderly specimen, buckling beneath the layered weight of his seven foot thick Gaudi-

esque roofline. His neighbour complained of the short-stem varieties of wheat cladding her roof these days, harking back to the long-stemmed times before combine harvesters and nitrogen fertilisers:

and when the sky wore thin
they built another layer on top

500 eons of carbon-dated air
organic tall-stemmed wheat
and medieval rye

the greenhouse glass
is buckling in its frame

Their route was now climbing steadily onto a contradictory expanse of army range and nature reserve moorland. DANGER TANKS CROSSING, read a large sign by the roadside, and right enough, Icarus thought, it had been getting progressively dark, with the shadow not only deepening, but following them along the road. However when she looked up she found herself not staring down the barrel of a cannon as expected but at something else entirely.

'Fear not,' the huge bird boomed. It was so large that its ten foot wingspan could barely fit between the clouds, and it was making all manner of booming, grunting and other raucous noises.

'A great bustard?' W asked, opening his headset bolts wide.

The bird nodded. 'You have learnt well the ways of the birds and will make worthy messengers. I am old, having lived through the extinction and the reintroduction of my species on these very moors, but there is no promise of such luck for humanity. Take my story and all the other stories you find along the way and deliver them to Athens. Have faith, keep going, and do not let your doubts betray you.' And with that the bird carved a contrail on the sky and

disappeared in a hurricane of flapping wings before Icarus could even say 'but'.

↓

In the garrison town of Andover, Icarus leant W up against a pentagonal bench for lunch. The centre-piece tree was dead, but neither of Icarus's bench-companions – Olaf the Homeless Bearded Viking and King Eldred the Skinhead Tattooist – seemed to notice, nor to care. A saxophonist busker failed to sell CDs of his version of a song called 'Let Me Entertain You,' while squaddies' wives rocked their prams back and forth, swore down their phones and puffed cigarettes to the point where Icarus's cookies from Tesco tasted smoked. With the combined sugar and smoke rush she remembered little of the next fourteen miles to Winchester.

Instead of exploring Winchester cathedral and its attention-seeking spire, Icarus wandered down to the River Itchen where she found Keats throwing regrets into its current. 'I should not have committed myself to those four months tramping but that I thought it would give me more experience, rub off more prejudice, use me to more hardship, identify finer scenes, load me with Grander Mountains, and strengthen more my reach in poetry than would stopping at home among Books, even though I should read more Homer.'

Icarus smiled and jumped back on board W whom she now pedalled with more conviction than she had felt all day. No matter what happened, she couldn't simply *abandon* her quest like Keats, who had cut his journey short when he had found the rural poverty too harrowing. If this quest was about delivering stories to Athens as the Great Bustard had supposed, then *this* was the tale she would take from Winchester – and reading Homer could most definitely wait until she got back home:

towards autumn
 a lifting wind and temperatures
which bloom like burning fuel

 beginnings are always easier
 than endings

 default positions
 – the texture of clichés.

i struggled with the sun as a system
 touched the didactic stubble
of the globe

 mistaking concentration
 for an atmosphere
 a debt of avoidance
 further into abstracts

 So we rolled back the greenhouse
to the market

 barred clouds
 and a cradle of apples
 clammy poppies
 and an average sea

Our universal graves are rotting
around the thatch eves

 As our last attempts to solve
 the world of change

 a writer returns her failings
 to a high wind

'Only the labyrinthal coast to go!' Icarus exclaimed as they entered
Hampshire, their final county in England – a rolling landscape,

marked out in various shades of prosperity, which couldn't have contrasted more with Salford.

'Poop poop,' sang the horn of an old dear's Jaguar, shooing them away from her electronic entrance gates. Icarus thought it best in the circumstances to avoid the village called World's End before climbing up Portsdown Hill where, to W's delight, the sea spread out before them.

'We've made it!' he exclaimed prematurely, forgetting that he and Icarus had fallen out in the excitement of what was in fact a rather dreary panorama. The light was fading and the endless monotony of Portsmouth's housing merged into the grey water towards a greying horizon, but nothing could grey both their smiles as they freewheeled downhill.

Icarus exhaled. The end of England – they had made it to the end of England...! She looked towards the European continent where it lay before them, vast, distant and out of sight. But then, weren't the invisible problems always the most difficult ones? The more you looked at them, the more they simply weren't there.

Rather than heading straight to the hostel where they would spend the night, Icarus first took a detour down to the shore where she removed the weather glass from her bag and filled it with murky English channel water. She was glad she hadn't smashed it against the tarmac earlier today. Even filled with opaque seawater, it just had that little something

about it. And she suspected that if she could work out what this something was, then this might prove the key to everything.

✦

When Icarus's alarm vibrated at 6am the next morning, she felt even more tired than before bed, and far less enamoured. *Frabjous!* Getting a hostel dorm all to herself as she had at first thought had proven *far* too good to be true. It was 3am when the two German, late-ferry arrivals had landed, waking Icarus with the fluorescent light, shaking her bed to confirm her existence and bending lower for a little stare – 'ja es ist eine Frau' – then drifting into a heavy stereo of snoring after an extended shower. Icarus packed up in darkness, then tiptoed across the room silently. Their noses will soon blow off if they keep up snoring like that, she thought, gently kicking over their bunk to save them as she went (what a noise they made when they tumbled).

'What time's this?' W asked as she unlocked him from the railings.

'On the verge of running late time,' Icarus replied, setting off.

'Quite. Couldn't put it better myself. Even if we make it to Athens on time, it will take decades for past emissions to work their way out into the climate, let alone the gases we continue to emit.'

'Goodness, W. Isn't it a bit early for such talk?'

'On the contrary.'

As if to emphasise W's point, as they rounded the southern tip of Portsmouth they overtook an old man, riding a sit-up-and-beg bicycle with a scythe over one shoulder and an hourglass in his shopping basket, who signalled them to slow. Icarus recoiled as he turned his hood towards them, revealing a cracked, weathered face, and black holes for eyes.

'You think it is respectful to overtake your elders? No matter how fast you cycle, you can't turn back time.' Old Father Time held his

rapidly emptying hourglass high, then smashed it on the pavement like a beer bottle thrown from a passing car before disappearing into the wind.

Icarus gathered some of the hourglass sand from the gutter and poured it into her back pocket – if urgency wasn't her strong point, then it was the least she could do to purchase some, she supposed. She was going to have to speed up something rotten in France if they were ever going to make it.

At least, more immediately, the ferry terminal was somewhere people in Portsmouth seemed to want to go – away – and well-signposted. Soon Icarus was cycling W up the narrow greasy slats into the deafening echoes of the car deck's mouth cavity, where she tied him up with oversized ropes intended for securing tugboats.

'Wait on, Icarus. How am I supposed to conduct my climatic experiments from here?'

'Good scientists can conduct experiments anywhere.' Icarus winked. 'Where better to conduct a chemical investigation into climate change than the fume-fuelled laboratory of a ferry?'

Portsmouth possessed far more glory in retreat than it had close up. The Spinnaker Tower's one-hundred-and-seventy metre high steel sails threatened to launch the island city towards France at the first chance of a northerly gale, while the naval fleet secured it firmly to Britain. Yet Icarus's mood was once more about to take a sudden turn. She squeezed in alongside a father and son for a stretch of railing to watch Great Britain retreat behind them.

'Destroyers,' the boy said to his father, pointing to some metallic wasps of naval boats, their antennae fixed on the sun. 'Frigates,' he yawned, before swivelling 180 degrees to machine-gun a raft of 'exterminators, annihilators, HMS Victory and Warrior and submarine deathboats,' with his index finger.

'BOOM!' Icarus thought, focussing sadly on the shrinking horizon of humanity's destruction. The boy's Dad was no better, reeling off the crafts' capacities as if showing off a new car. *Clutch, engage, accelerate, BOOM! A lethal injection of carbon dioxide catapulted into the sky. Watch the sky burn son!* Icarus followed Lucy's gaze out to sea along the sightline of an imaginary cannon.

Technology, market, negotiation BOOM! Neo-liberal, neo-colonial, quasi-democratic BOOM! Geodiplomacy, security, terror, BOOM! Let's do battle with the skies! More of the same, to battle more of the same. More capitalism for capitalism. More science for science. More negotiation to negotiate. More stabilisation to stabilise. Hubris, arrogance, progress, BOOM! A war on climate – clutch, engage, accelerate BOOM!

The carbon dioxide pressed in hard against Icarus's head as if, far from exiting the climate labyrinth, she was approaching its combusting core. So was *this* the nub of Lucy's issues with the climate change agenda? The thought made Icarus shake and caused her head to spin giddily. Of course, Lucy was right, a war on climate change would resolve nothing. Not the climate, nor suffering, nor famines and droughts and floods. Nor even the war itself, for were all wars by their nature resistant to final resolution?

Icarus paused and looked out to sea. A climate labyrinth? Certainly. The earth had become a climate labyrinth as complex and entangled as the one Daedalus had built on Crete, in which they themselves had become imprisoned. 'Fathers of the world,' Icarus began, looking upwards to see if her father figures were listening. 'You have outmanoeuvred yourselves spectacularly. Whatever are you doing? Whatever have you done?'

we start a guided tour of the controls –
slide the sunshine towards morning

four and a half billion years of accretion

evolution
at the touch of a key:

clumps of dust
and gas-gathered gravity
to a density of heat beyond degree

we are untouchable
– nuclear fissions, shining stars –

middle aged effigies of blood-red giants
burning helium from the sky

the sun absorbs our white dwarf forms
and us – its nebula – a rising kind of dust

I once knew the way to tell the time from
the shadow of a stick I placed into the earth.

Part 3: Crafting Wings

the answer to the labyrinth
had been built from labyrinths

tower blocks, hedge funds,
virtual clouds we built into the sky

what will run out first i ask you
air or earth?

paper scissors stones you reply
it depends on how you play

they say there are no boundaries
at the point of boundaries

and i choose to disagree
just one way in and one way out:

a gathering of containers
huddled around the centre
as if our lives depended on it

look at all the greyscale faces
residual memories the texture of aggregates

Bienvenue en France! 'Every shade of grey on grey,' Icarus muttered, taking in the immediate surroundings of Le Havre – destroyed during World War II, and rebuilt to a modernist design. Concrete tower blocks, concrete roundabouts, concrete river, concrete trees. For the last few centuries or so, Icarus had found that wherever she went on Earth, the shifting face of modernity had already arrived before her. Some people said it was her that was old, but this wasn't

how she saw it. *Contrariwise!* Teenage lad or thirty-something lady or any-old-who, the world was overwhelmingly new, and nowhere more so than here. But after her troublesome ferry passage Icarus actually felt far more up for the quest. She threw some hourglass sand high; she could either give in to the troublesome ways of the world…or she could enjoy this quest if it killed her.

'Le Havre,' W began in his usual nasal monotone. 'Awarded World Heritage site status for the interchange of human values in the architecture of climate change. 410 kilograms of carbon dioxide emitted for every ton of concrete, give or take.'

Icarus shook her head at her geeky bicycle. 'But you can't stereotype all carbon dioxide as hooligans. Some really rather delightful particles escorted me ever so safely through the atmosphere to here.'

Icarus had spent the remainder of the ferry passage plotting a route across France on her Mappa Mundi – 75cm according to a length of string stretched across France's diagonal breadth. Eight days' transit? Nine might be ok…if they could ever find a way through the entangled labyrinth of roads which crossed its surface. *Le labyrinthe climatique. Réchauffement de la planète. Le dioxyde de carbone.* Tell Icarus what language climate change was in, and she'd tell you the French for it! But the challenge was finding a way out of here as quickly as possible in whatever language the climate came at them and Le Havre was already proving tricky.

'I thought you said the pictures helped.' W referred to the Mappa Mundi symbol of Jean-Paul Sartre – who had written a book called *Nausea* about Le Havre – whose head was obscuring the entire local road network.

At least they were making less dangerous progress than the father and son from the ferry who had already cycled the wrong way up a motorway sliproad in their search for the cycle path across Le Pont L'Évêque, and were now trying to fly. 'Any luck?' Icarus enquired.

The father shook his head and looked up to the bridge, one hundred metres overhead. 'But it must be possible.'

Icarus looked at the pair, their bikes, the bridge, before nodding her alter ego's sense of consequence doubtfully. The arc of the bridge was more than thirty times higher than even the Wright brothers had managed on their adapted bicycle's first *motorised* attempt at flight, and the son can only have been aged twelve at most. She might once have believed six impossible things before lunchtime, but that these clowns might soon take flight wasn't one of them.

Perhaps inevitably, W had other thoughts. 'Of course it's possible,' he muttered under his breath, jabbing Icarus with his saddle before listing off a startling array of data about the comparative flight capacities of bike v bird v plane before coming to the perhaps unsurprising conclusion that bicycles were the most aerodynamic of all. 'Let's show them. At least let's fly a little bit of the way – like a practice flight – to illustrate it can be done. It would be churlish not to share the one power you've got.'

Watching W speak, Icarus wondered how she had never noticed the birdlike nature of some of his mannerisms, which combined with his love of technology and his need for speed...*BUT*. Lucy's warnings equally rang ever louder in Icarus's ears, like an acute form of tinnitus. *Don't do it!*

Looking back, Icarus would be unsure what it was about that particular moment that encouraged her to throw wisdom to the wind – perhaps the sun caught upon her line of sight like stardust, or perhaps it was down to the carefree spirit upon which she had so recently resolved. For despite the warnings, Icarus began grinning broadly, spread her arms and before she even knew it herself, she was letting W accelerate into a freewheel. Of course! Those English clowns couldn't fly, but *her*? She'd show them. Why bother solving the climate labyrinth when she could just fly out the top? 'The great art of flying is to keep your balance!' she had just enough time to cry

over her shoulder before W attempted a bunny hop which sent Icarus flying over his handlebars, landing head first in a ditch with as much grace as Lewis Carroll's White Knight.

'You are meant to *feather* the brakes, not slam them on like that!'

Icarus disentangled herself from W's spokes, blushing, unable to meet anyone's eyes. If only she hadn't been cycling a *live* bicycle then things might have been far more straightforward. 'Le Pont de Tancarville?' she suggested, pointing to the next bridge, twelve kilometres upstream.

$$\Lambda$$

The road onwards might have been quiet and uneventful, with be-shuttered houses backing onto a limestone escarpment, if only Icarus's alter ego might have left her alone. 'So *that* was clever, wasn't it?' Lucy asked. 'Want to rewrite your fate? But that's just the same old Icarus story, told over.'

Icarus thought back to the spirit of the ferry passage, and the bravado regarding climate change that she had recently dismissed. What was it about the temptation of flight that over the centuries had repeatedly got the better of her, even when she self-consciously willed it otherwise? Of course flying was hardly the most environmental means of transport. And flying away from climate change would hardly meet the demands of her quest: 'so, when you found the climate labyrinth too challenging you just flew away?' Zeus would boom, while Daedalus would wring his hands with the anguish and the guilt that, when it came to Icarus and flying, it was all his fault.

In the circumstances, the view from the Tancarville bridge was a murky one through Icarus's eyes. Mud and pollution had long sullied the romantic waters of the Seine since leaving Paris, and industry lined the riverbanks towards the sea. Icarus took a weather

glass measurement which she noted beside all the others in her writing pad. Despite change being the purpose of their quest, the readings so far presented a pattern of reassuring continuity – *if only* the weather readings had been in metaphorical tune with events on the ground! Icarus looked down at the road. Not only had she just lost her one and only superpower, she suspected that recent events might have changed her fate more than she could yet imagine.

At least the road kept going, she thought, as she started out again. And not much further on they turned off the main thoroughfare onto a delightful back lane towards Pont L'Audemer which marked the labyrinthal doorway into *proper* France: timbered houses, cows lazily licking flies from their faces, a fisherman waiting for a slow river to arrive, and some cocky chickens pecking at W's wheels:

 i hung them up to dry
 one long circular loop
 and a rolling mechanism

 la rue des poulets
 cows smoking *gauloises*
 and a lazy drawl of riverbank

 what came first
 the chicken asked the egg
 our climate or its change?

 (if nationality
 is cultural, who taught it to the chickens?)

 a wheel on an axle
 the egg replied
 a rotational motion

 a rope between the groove
 causing changes in the direction of applied force

Beyond Pont L'Audemer Icarus and W's route climbed onto the vast high agricultural Normandy plateau. The pace of life up there was slow, but Icarus and W travelled fast, overtaking two tractors and a horse-drawn Citroën 2CV, while doing their best to pause the sunset. There were still forty kilometres to go, and having crossed into France, the clocks had moved night-time one hour closer.

'I'm hungry,' W cried out, as they finally rounded the last bends downhill into the small town of Orbec, their destination for the night, famed for its belt-busting gastronomy – whose supermarket had closed just one minute ago.

The thing about companionship, Icarus realised as she sat alone at a table in a local brasserie later that evening, was that you didn't really notice it until it was gone. Icarus didn't dare look outside where she had locked W. Instead she focussed on her dinner, all too aware that

hers weren't the only eyes watching camembert cheese drip through the prongs of her fork as she lifted it to her mouth: the two sisters twirling the edges of the chequered tablecloths; the cooks staring through the kitchen slats; the family polishing glasses behind the bar. If Icarus had asked, she suspected no one would have been able to explain why they were staring. There was simply something 'not quite right', where right meant normal, and 'not quite' meant that suspicions were raised sufficiently to have just paused a couple's

heavy petting.

Icarus wriggled in her seat, suspecting that her current appearance was the *most* likely explanation. The sideways glances she had received on the ferry had already suggested that she hadn't yet *perfectly* mastered wearing a woman's body, but give her a chance! It wasn't as if she'd had many female role models to emulate over the course of her life – she had still been young when Naucrate had taken her life, and Icarus had resisted Aphrodite's motherly advances.

It was the big fat man, resting his belly on his knees, his elbows on his belly, and his stubbled triple chin on the bar, who raised the courage to talk to Icarus, but once the questions had started there was no stopping them. 'Where are you from? Don't you have a family? A job? Where are you going? *Where?*' The restaurant atmosphere had already shifted from hostility to curiosity and now amazement. 'Aren't you scared on your own?'

'But I'm not on my own, am I?' Icarus bit her lip and swept her hand disingenuously around the bar before finishing her cider and getting up to go before the man could ask, 'but why did you come out here at all?'

Icarus could barely speak upon leaving the restaurant as the confusion of the last few weeks suddenly caught up with her. When she tripped on a tiny cluster of pebbles while pushing W back uphill towards the campsite, stubbing her toe in the process, everything suddenly became too much. All of Icarus's emotion, previously suppressed, now bubbled from her – like water from a weather glass. 'Why did Zeus have to go and complicate *everything* by turning me into a woman? Isn't climate change difficult enough as it is?'

But W just shrugged, as if it were of no consequence any which way Icarus came. 'With a name like Icarus you could be any shape almost. We're all trans-identified now.'

Tears stung the corners of Icarus's eyes. True, W was proving *far*

better at negotiating and accepting his hybrid bicycle identity than she was at adapting to her new self, but this didn't mean he couldn't try out a little bit of sympathy. Yes, so she had been kind of getting used to her new bodily form, but...the saddle was uncomfortable; but she wasn't as strong; but she had never realised how unenlightened the world remained. But she hadn't changed her fate, simply complicated the gender of getting there. And so far it had just made everything about the climate labyrinth that good bit harder.

'You won't make yourself a *bit* less real by crying over it,' W added, causing Icarus to spin him round to face her.

'Anyone would think you'd been reading *Through the Looking Glass* while I wasn't looking, the way you've been talking!'

W shrugged his handlebars. 'What was I meant to do while waiting for your amoeba to form? I thought it might ease communication.'

For not the first time this trip Icarus felt that her companion's superior intelligence had actually dug a channel *between* them, frustrating any kind of meaningful understanding. Outwitted by a *bicycle*? Right that moment Icarus would have been happy if the amoeba simply hadn't bothered.

Orbec was layered in different ages of old, cobbled, brown and beamed – the kind of small French town where identical twins wait by supermarket doors to inform you that it's raining, and the campsite attendant spends the afternoon sleeping off his three hour lunch. Icarus spent her day-off procrastinating over the comparative merits of 150 different types of salami, restlessly wandering the cobbles and tightening the elastic waistband in her one pair of trousers – an outdoorsy, lightweight pair she had found in Lucy's chest of drawers which He-Icarus wouldn't have been seen *dead* in – and which were already falling off her. Finally Icarus retired to a bar,

hoping that Kronenbourg's 'slow the pace' motto might help her relax.

At a neighbouring table, Claude Debussy was sipping his Kronenbourg precisely, shaping the air to a point between his index finger and his thumb to divine the rain while putting the finishing touches to his 'Jardins Sous La Pluie.' Taking the artistic hint, Icarus focussed on the bubbles of her beer, and attempted to put pen to climate change poetry. She had barely written a thing beyond the odd scribble of a ditty here and some scrappy notes here since leaving Salford. And now? One poem, two – both stroked out. Three – Icarus allowed Lucy to let the pen rip in the biggest scribble, which before Icarus knew it, had consumed both the page, *and* her frustration. She scrunched it in her fist and was about to launch it out the window when she paused, uncrumpled the piece of paper and held it out at arm's length in front of her.

'Mais oui, ça c'est le changement climatique, vraiment,' Debussy said, peering over her shoulder.

The scribble had no beginning, no end, just an entangled infinity of clews, with the trail of salt Icarus had been following just one arbitrary strand. *Vorpal!* No wonder she had made little progress with climate change. Thus far Icarus had been trying to work out a linear trajectory through it with the hope of discovering an answer at the end – like a pot of gold at the end of a rainbow. But no! If this scribble really did represent the form of the climate labyrinth, then it would tie knots in the path of the most cunning travellers.

Debussy raised his fountain nib from the paper again to murmur abstractly: 'we'll not return to the woods. So sleep child sleep.'

But that night Debussy's lullaby riddle proved powerless in the face of Icarus's excitement. This really was rewriting things. 'You know, W,' she whispered through the canvas after an hour of tossing and turning. 'If climate change *is* as entangled as that, then maybe we *can't* solve it. It's not like the ozone hole or pollution or other

discrete problems – if you untangle one string it will only tie a knot in something else:

And if it pervades our whole culture, then trying to solve it is like supposing we can cure world history in one fell swoop!' Icarus had begun to conclude that W was asleep, and that this was probably for the best, when he finally spoke.

'You mean a wicked problem, Icarus?'

'Why, probably!'

'But I thought you were the hubristic semi-mortal, with aspirations to become a God. At least you demonstrated ambition at that.'

The lullaby child goes down to the wood
where the child will soon fall asleep.
The laurels are cut, absorbing the beauty
of the lullaby child while she sleeps.

A white hen is there in the barn,
joining in the dance, watching how we run.
It will lay an egg for the beauty of the laurel
and the child who's going to sleep.

We take our songs in turn. If the lullaby child
sleeps the cicada must not hurt.
The song of the nightingale will wake us up
in time for the warbler, with her sweetsweet throat,

and the shepherdess, who gathers the hen in her
big white basket with strawberries and wild roses.
Cricket, my cricket we must sing, for it is almost
night, and the laurel wood has rejected us.

We will not return to the woods so sleep, child, sleep

Translated from a traditional French folk song

By next morning, the Sunday bric-a-brac market had transported Orbec back to the sixteenth century.

'I'll 'ave that,' squawked one hawkish trader, stealing a bra from where it was drying on W's rack as they made their way.

'Ugh,' groaned Icarus as they cycled past the piss, faeces and flesh of the local tanner's stall. A rack of early printing press parts. Lizard

bones. Some snorting gunpowder.

'Catholic or Huguenot?' cried a young lad. Had they landed slap bang in the middle of the French Wars of Religion?

The market sold everything, but only in rusty, smelly variants. After the events of the last twenty four hours, Icarus herself felt tanned. Still, she declined the special two-for-one offer on a rusty barometer and a smelly knee. They were barely back in the countryside before W recommenced his tirade.

'But you've not gathered nearly enough weather glass readings to disregard the scientific consensus and give up. First you're upset about events abroad, but now you've decided we couldn't do anything to help, even if we tried. Make up your mind.'

'If I'd meant that we should *disregard* the evidence of climate change,' Icarus began, 'I'd have said that. Of course I'm not doubting it, and I'd certainly like to help. But not even Plato will solve climate change if it can't *be* solved.'

'So shall we turn back? Go on, call some cherubims to teleport you back to Planet Zeus, because see if I care.' And with that W stuck his bar-end out in an attempt to hitch a ride with any passing pedestrian – of which there were in fact none, for they were already in the middle of the Haute Normandie plateau's nowhere.

Icarus stole a wry grin. Of course she wouldn't be abandoning her quest, for she had only just discovered it. The guilt and responsibility that had weighed upon her since her carbon smuggling exploits had suddenly lifted, as if they had been truly elevated with wings. She may have been no closer to knowing *how* to respond. If they couldn't *solve* climate change, *then* what? But at least this was somewhere she could work from – in crafting a very different kind of climate wings. Despite the emotional turmoil of the last few days, Icarus felt clearer than she had all quest, as if she had found expression – permission – for thoughts which she suspected Lucy had so long suppressed. Who would have thought that scribbles could be such powerful things?

'So why bother continuing?' W continued.

'Because the road keeps going.' Icarus pointed to the long straight line of tarmac stretching ahead, dissecting the large open spaces characterising Haute Normandie, before zoning out from W's ongoing tirade...Instead she mesmerised herself on the dashed white clew leading ahead of them. One dash, two, three...

'Wake up!' W suddenly yelled.

Icarus juddered awake, almost throwing them into the headlong path of a passing truck:

What were we talking about and for so long?

It was not an easy question
nor rhetorical and we talked about
the meaning of the question for some hours.

The chemistry of words.
The formulae of thoughts:
vectors sketched invisibly on minds

But our world was no laboratory.
By the time we had an answer

the test conditions had changed.

> I remember all the things you taught me
> about the sky were useless when
> it came to words and you heard me wrongly

> Didn't want to understand the things
> I meant to mean

The first generously-vowelled village they came to that morning was called Montreuil-L'Argillé.

'On your way to the Loire?' the friendly owner of the local store asked. 'What is it that you want to buy?'

'I don't know yet,' Icarus replied. 'I should like to look around me first if I may?' The shop was filled with all manner of curious things – a whirligig of postcards to other more scenic parts of France, seaside toys, horse trotters – but the oddest thing about it was that every shelf Icarus looked at was covered in dust and grime, while the produce on every other shelf looked sparkling and fresh! She rubbed clean the lid of a sardine tin. Anything from the middle ages onwards should be ok with the preservatives they added these days, she thought, adding a can of old-fashioned coca cola to her basket:

> *May I present for the benefit*
> *of scientists, scholars, poets, divines,*
> *lawyers and physicians, and others*
> *devoted to extreme mental exertion*
> *Pemberton's French Wine Coca!*
> *A cure for urbanisation and all associated ills!*

Outside again, Icarus sat down on some steps, flicked open her globally branded can and watched the district flag, the tricolore and the European Union flag intertwining in the wind above the village

hall – encapsulating the many different political levels of climate change. Otherwise not *much* was happening in Montreuil. A chicken was clucking in the background. The sun shone – reliably so. An old man crossed the road towards Icarus, in slow motion, leaning heavily on his crook. 'Excusez moi,' he said with exceeding politeness, trying to squeeze past Icarus up the steps to his own house. If only the lycra-clad cyclists from a Parisian cycling team who swept at speed through the village at just that moment had been equally polite.

'Bonjour!' Icarus cried out, waving to the peloton enthusiastically. The cyclists didn't even divert their gaze.

Not that W was proving any more companionable. 'It's just a harmless wood wasp,' he spat at Icarus as she fled from a hornet with a massive stinger when they stopped for lunch in the Bois-de-Châtelet further down the road. His only other contribution to proceedings were some clunking noises his bottom bracket had started making – as if competing with Icarus's knee, which continued to grate ominously – and some gasps for water when their supply ran out.

It was a further eight parched miles before they reached Bellême, the first opportunity to refill their water bottles. 'Nothing else,' the Chinese takeaway owner asked in a hybrid French-Chinese accent, frowning at Icarus's parsimoniousness. 'Chicken Chow Mein? Prawn crackers? Black bean sauce?' Icarus shook her head to all of the above. 'Fill them to the top,' the man said passing the bottles to his employee. 'For the brave cyclist.'

In the centre of town the café balconies were full, the churches in full-bell and there was a homely cooking smell coming from the town square where Robert de Bellême, the half-French son of William the Conqueror, was slow-roasting some locals on a spit. It wouldn't have surprised Icarus, right then, had the local climate travelled up and through the global ceiling.

When Icarus stopped a man in their destination town of La Ferté-Bernard, a further sixteen miles down the road, to ask for directions to the local campsite, the last thing she expected was to be invited to join him for an early evening pastis. She hung her sweaty, dust-grimed head to one side in the coy, demure manner she had seen Aphrodite do, and apologised – 'I really would rather go and pitch my tent'.

The site turned out to be a veritable fortress, situated beyond an industrial estate, in a surprisingly idyllic spot on the banks of an artificial lake. It was guarded by a video intercom, ten-foot-high electric gates and a lengthy registration process at the end of which Icarus was too tired to argue about W being charged as a car.

W was yet to rise from his bad mood. 'And you paid?'

'But I thought you 'its' weren't bothered about the boundaries between categories of being. I didn't think you'd mind.'

The campsite was large but almost empty. Icarus had fully pitched her tent and was cooking dinner under the eye of some watchful dogs when W asked, 'Do you smell urine?'

'So long as it's only dogs,' Icarus said, yelping as a rat scampered over her bare foot.

<p style="text-align:center">▾</p>

If only the unwanted visitors to the campsite had stopped at rats and dogs. It was already sunny when Icarus poked her head from the tent the following morning, and W was nowhere to be seen. She rubbed her eyes, blinked. Surely she hadn't offended him *so* badly that he'd done a runner. Icarus's heart jumped. But she'd never reach the conference alone…

'I'm over here, stupid,' came a familiar nasal voice from the direction of the beech hedge, which Icarus noticed had become blackened and withered overnight. She blinked again and her shoulders relaxed.

'But how did you get over there?' Right then, Icarus would in fact have listened to anything suggesting that W had outslept the previous day's uffishness, but by the time W had related his late-night tale, Icarus's mouth was opening and shutting like a fish. 'You know, I'm rather good at bedtime stories if you've been having nightmares, W.' If this had been anything to go by, she wasn't the only one around here with an ear for a yarn. No wonder the campsite was almost empty if it had been receiving overnight visits from the locally renowned shaggy beast called the Peluda, which had grown during W's tale from a six foot tall jabberwocky – half plant, half animal, all tentacles – into a hundred-foot-high friendly giant, the epitome of Darwinian science.

'Read this if you don't believe me.'

Icarus unfolded the charred paper and read 'The Shaggy Beast Story' through to the end:

As the world was warmed
and the water grew and the ice melted.
Five decades of rising waters.

The animals boarded the lifeboats
two by two, but there was only one
Peluda:

a greenish ox sized porcupine
with a scaly neck and tortoise feet
and a sensitive tail, shooting acid from
its sting-tipped tentacles for quills.

There was no room on the boats

for the Peluda.
 The world was warmed and
the water grew, and the ice melted.

For fifty years of rising waters
the Peluda hid inside its cave,
shaping shadows on walls;

the shifting patterns of kaleidoscopic
creatures; the miscellany of his quills.

When the water fell the Peluda
rampaged round the country
wilting crops with its fiery breath.

The world was warmed and
the water grew, and the ice melted.

'You wrote this?'

'Well, the Peluda wrote the poetry. I simply helped with a few mistakes of spelling and logic. Do you like it?'

Icarus nodded. It was actually better than anything she had written so far all trip – even with the assistance of her alter ego. 'So what was he like this Peluda poet friend of yours?'

W looked down. 'A sad old fellow, bit hard on himself. Just wanted me to listen to his story. But clumsier than a spare electron – knocked the security gates clean off their hinges, and with a volcano for a voice which blew me into the hedge saying goodbye. I promised him you'd make a memorandum of the poem to take to Athens. You will, won't you?'

'Of course I will, W,' Icarus replied. 'We'll never remember it otherwise. I'll stick it in my notepad right now.'

That day they were headed along the D1 – the first of the network of regional roads binding together the feathers of France's wings – which was providing as efficient a route south as motorways. The sky was bigger than ever – a scene that lent itself to humility, Icarus thought, in contrast with humanity's – not least her own – characteristic hubris. 'You know, it's not just that I don't think we

can solve the climate, W,' she said, already risking that morning's tenuous entente. 'But I've begun to wonder why we think we *should*. Surely managing the skies replicates the arrogance and pride that got us into this pickle in the first place? Why can't we accept that things change?'

W shook his handlebars. 'You're a fine one to talk about accepting change.'

'I didn't say it would be easy.'

Perhaps unsurprisingly, W's feelings about Icarus's climate scribble hadn't changed any overnight. 'I just don't *get* it, Icarus. It's like you've decided that those trying to resolve climate change are the villains. I thought you wanted a different kind of world?'

'I do,' Icarus replied, before repeating more firmly. '*I do*. Perhaps that's why I'm questioning why we're stabilising this one.'

By now they weren't far at all from Le Mans, where the Wright Brothers had undertaken their first European flight, causing W to change tack. 'Imagine that, the first bicycle to fly!' he exclaimed, holding his frame tall. 'Do you know, Icarus; if you will listen, there

is a proposal which I might share with you. If anything might persuade you of your errancy, I've been thinking over the course of the last twenty four hours that perhaps this will.'

Icarus had secretly been half-hoping that W might come up with some knock-down argument to save her from herself and her proclivity for leftfield approaches to everything she tackled. And this sounded hopeful. She had always prided herself on being open-minded in the sunshine. 'Sure!'

'I've named my proposal a bicycle revolution,' W began, charming Icarus with a vision of ranks of comrade bicycles marching on the leaders of the world. The reality of W's plans, however, was worthy of the most hubristic and cyclocentric genuses of the bicycle species.

'So there are three tiers to your revolution...?' Icarus repeated after he had finished.

'...that's right...'

'...firstly, mitigation – requiring every human being to cycle rather than to drive...'

W nodded.

'...optimistic, potentially authoritarian. But ok. Secondly, adaptation – in case of flood, people cycle pedalos or drive human-powered planes?'

'Couldn't have put it better myself. Did Kanellos Kanellopoulos, the champion Greek cyclist, not recently cycle a human-powered plane from Crete to Santorini in your name?'

'Made it fifty feet from Santorini before a gust of wind splintered the tail boom, taking out the right wing spar, requiring Kanellos to eject himself into the sea.'

'You omit to mention that he'd already flown a record twenty-seven miles by then. The range might be initially limited, but will improve in time.'

Icarus let this pass for the best was yet to come. 'And then your geo-engineering coup d'état – launching rafts of bicycles into the sky

to recycle greenhouse gases back out of the atmosphere, simultaneously reflecting sunlight off their frames, and generating energy for use on earth?'

'Indeed!' W exclaimed, his bolts popping from his headset. 'I'm rather a hand at inventions do you not think? It's taken me years to develop my ideas. Do you like them?'

Icarus was speechless.

'What you should think is that it was extremely kind of me to tell you this,' W continued, filling the silence. 'But we'll suppose it said. I just need the brains of the best Greek innovators to perfect it. Archimedes and Pythagoras, Hephaestus and Euclid, your Dad – the greatest master craftsman of them all.'

Icarus looked back up at the sky differently than before – as if bicycles were dismantling the clouds through their spokes. 'But what if the bicycles get dusty and don't reflect sunlight? What about punctures? Who's going to cycle them?'

'There are worse retributions for environmental crimes,' W replied, causing Icarus to screech to a halt at the none-too-subtle reminder of her carbon dioxide smuggling exploits at the start of the quest. 'But more importantly, do you think Daedalus would help?'

Icarus's protestations were stopped short as the reality of her father's likely reactions to her own and W's plans hit home. Of course Daedalus was far more likely to assist W than he was to offer open arms to his carbon dioxide smuggling, prodigal 'daughter' who had only recently come to doubt the intention behind decades of his technological endeavour. 'Yes, W, yes I do,' she mumbled. It was precisely the eccentric type of genius which set Daedalus's furrowed forehead and hairline a-quiver.

For a good while afterwards, Icarus cycled W on in a disagree-to-agree silence: W's wheels spun with adrenaline, while the implications of their discussion cut feathers from Icarus's nascent climate wings. For how many centuries had she hoped for the look

of fatherly approbation she now imagined reflecting off her bicycle's frame? How many hours had she dedicated to making riddles and abstract art from scientific formulae, hoping to extract some kind of sense? And now? Her recent conclusions about climate change were unlikely to please either climate sceptics or campaigners – both for the wrong reasons – let alone her Dad. No wonder Lucy had struggled to find expression for or permission to express her doubts. 'Hey Dad!' Icarus called. But nothing, let alone any reassurance or warnings about flying too close to the sun. 'But who even am I without my Dad's warnings!' she wished to cry out in despair.

<p style="text-align:center">🔱</p>

Yet, as was the way of this trip, Icarus's despair was soon humbled by events in Montoir-sur-Loir. At first glance, Montoir was just another quiet, small town in the French interior. It's the 'Loir', an old man pointed out enigmatically as they crossed a bridge over a nondescript river on the way into town.

'The Loire?' Icarus asked W when she realised that the man had disappeared into the ether before she could enquire.

'Or the Loir?' W replied, peering over the wall into the murky green flow. 'Not that a name matters a jot to anyone when you're suffocating in that much run-off fertiliser.'

However it wasn't just the hypoxic river which was suffering from a lack of oxygen but the whole town. The announcement which boomed through the airwaves from a tannoy at the railway station hit Icarus directly in the solar plexus, causing her to gasp for breath.

'WE ENTER NOW INTO THE WAY OF COLLABORATION'

It was the voice of none other than Maréchal Pétain, decades after his fateful meeting with Adolf Hitler in a railway car just down the line, in a move that had so radically altered the course of French history.

'But that's not collaboration!' Icarus and W exclaimed in unison, causing them to glance sideways at each other. Had they really just agreed upon something? The climb out of town onto the plateau was completed in silence. Icarus didn't even know what she could or couldn't say. 'I guess it's not our history to comment on...' she finally commented.

'But what do they remind you of?' W asked, pointing to a field of dead, unharvested sunflowers whose march towards the sun had been brought to a premature halt – the heads of their grey corpses bent low on their emaciated stalks:

Icarus declined her own head and searched deep for a *Through the Looking Glass* quotation to fit the moment. 'I should never try and remember my name during a climate genocide. Because what would be the use of it?'

W replied in type, quoting a very different kind of thinker entirely. 'And to whistle after climate genocide would be barbaric...' There was nothing much more to say, and not much else to do after that, but to keep on cycling: past the concrete outskirts of Château-Renault, and south towards the Loire.

♠

It had been an eventful enough day to last a century; Icarus was only too happy when fading light forced them to stop off earlier than planned in Amboise. As they had approached the Loire everything, including the weather, had become increasingly touristy, much to both of their distaste. But their first sight of the river stopped them short. The scene stood out in the poignant relief of the evening light: the channels, reflections, wooded islets, swimmers, fishermen, and Amboise castle setting off the view at the end of the bridge.

'Shall we stay there?' W asked, pointing to a campsite on an island between two strands of the river. Icarus nodded, but the campsite had other thoughts.

CAMPSITE FULL

read the sign, unequivocally at the end of the track.

'We'll see,' Icarus said, leaving W outside while she went to enquire. And indeed, French definitions of fullness proved debatable if only you dared to ask. The campsite receptionist slowly removed a

map from the drawer and indicated a 'free camping' area at the back of the site reserved for, 'teenagers, walkers, dead sunflowers, criminals, dictators, cyclists, and'…the receptionist picked up a pencil and crossed out the word 'peluda'.

'They say a bereaved fiancé caught him just after dawn this morning,' she explained. 'Chopped his tail clean off.'

 a loss of river limbs
 throw-backs

 the plural of fishes
 from a body of water

 inside the river bed were
 entrails, scales and bones
 regenerative rims of liver

 we had only meant to take the sunshine

 solar glycogen
 a metabolic pathway to the sea
 but instead I strummed the ripples

 my fingers webbed to the uneasy compulsion
 of dredged mud

Antiestablishmentarianism had long been one of Icarus's favourite words, and not only because it was very long. Yet when it came to realising her left-wing principles, Icarus proved flexible. When she awoke the following morning she was unashamedly excited by the prospect of meeting a very real historical Queen. 'Le Grand Départ de Mary Queen of Scots!' Icarus had read off a campsite noticeboard the previous evening, with the naivety of one not yet accustomed to history falling from the sky onto your daily cycling schedule.

'Mais, bien sûr,' W had replied, in his strongest Salford bicycle accent. 'She is off to assume the Scottish crown.'

By the time Icarus reached the centre of town, the morning sun was already lighting up the Auld Alliance of tricolores and saltires lining the thoroughfare. The crowds jostled to shake Mary's hand. However the eighteen year old royal, who had grown up in Amboise, was progressing so briskly it was as if she feared that Scotland might no longer exist in its independent state by the time she got there. Icarus watched her approach, her hand outstretched in the vain hope of touching a moment in history. Yet to Icarus's disbelief, when Mary drew level she paused for the first time, moved past, returned. Icarus held her breath and tried to meet Mary's eye. She was taller than expected – almost six foot, with strands of auburn hair escaping from her headpiece.

'I heard o' you. You're the woman cycling tae Athens, are ye no'?'

Icarus stared, open-mouthed. She had never spoken to a Queen before, and this Queen wasn't speaking quite as she expected.

'Curtsey a wee bit while you're thinking would ya. It saves time, mind?'

'Yes, Your Majesty,' Icarus stuttered, as Mary leant in close to whisper in Icarus's ear.

'Ah ken yer secret – it came wi' a lass and it will pass wi' alas – but I'll no' tell onybody, if you'll only do me a wee favour.'

'Of course. Perhaps I could deliver a message to Athens for you? But for the Scottish crown, we're all Greek now!'

'Aye, well, only if you promise me no' tae forget?' Mary bent down to whisper her enigmatic message in Icarus's ear, before re-composing herself, standing tall, and moving swiftly down the line cackling, 'and now aff wi' her heid,' for the benefit of the crowd.

Icarus sprinted off before a translation could spread; back at the campsite she committed Mary's message to poetry before it slipped her mind:

> *In my end is my beginning*
> – the shifting junction of
> the present tense
> *I desire nothing but*
> *my own deliverance*
>
> you said as we pickled onions
> by the light of the moon
>
> there were no fireworks
> no particular storms on which
> we could lay our finger and say
> it happened *then*
>
> just onions
> look at all the onions
> Mary Queen of Onions
> peeling endless onions until the end
>
> *
>
> you say we might leave the onions
> here – go swimming in the sea
>
> that is a nice idea
> but what about the onions?

When finished, Icarus spread all the notes and scraps of poems she had so far written before her on the grass like an extended collage – the words of valleys, maps, Hitler, myths, birds, philosophers, Humpty Dumpty. Climate change crossed with improvised extinction crossed with playful existentialism crossed with exploratory rivers crossed with pluralistic myths crossed with performative chickens crossed with looking glasses crossed with experimental beer. EXPERIMENTAL CLIMATE CHANGE BEER. YUM. Poetry modelled on the big entangled scribble that had consumed the page back in Orbec – the contaminated site of the insoluble knot of climate change. And up to her to *re*-make it, whichever way Icarus chose.

When W returned from visiting Leonardo Da Vinci half an hour later, Icarus had written six new climate change poems and believed in every one of them. Not that W was interested in *that*.

'Renaissance helicopters, swing-bridges and even some formulae for calculating the power of the sun!' he began. 'But Leo confessed that the model bicycle drawing attributed to him was fake – bicycles wouldn't appear for many years yet. Imagine that! More advanced than a helicopter. More swinging than a swing bridge. Less predictable than sunshine. I told you bikes were the future of the world!'

Icarus smiled, took a fresh piece of paper and drew a large letter:

upon it. 'That could be us, W. The shapeshifting face of climate change, discovered at the place where art and science meet.'

W's spiel stopped as suddenly as it had started. He picked the image up and held it to his front wheel. 'But first we need to set the model in motion. Shall we get going?'

Icarus looked around. All the other cyclists, murderers, teenagers and dictators in the campsite had already left, and she doubted any of them were going anywhere near as far as they were.

♦

The next stop that morning was Chenonceaux, where Icarus hoped to satisfy her curiosity with a distant peek of the famous castle before cycling on. The powers that be had *other* thoughts.

'You'll need to lock your bicycle up and pay!' a steward at the barriers shouted, presuming she was attempting to break in. 'Castles weren't made to be looked at for nothing.'

The bicycle park was a veritable zoo of every size, race, model and hybridised gender.

'I guess I'd better have a look,' Icarus said.

'But be quick,' W cried after her. 'This isn't a holiday, you know. The Alps *always* take a couple of days more than expected.'

Icarus rubbed the hourglass sand in her back pocket in the vain hope to attain some sense of urgency 'There will be plenty of time, W, promise!'

The queue stretched through the ticket office, a yard, out through another building and back into the fresh air. 'A young-person's ticket,' Icarus said when she eventually reached its head, hoping to get in half price – she wasn't going to be there for *long*, after all.

The French receptionist drew her face up towards Icarus, peered above her half-moon spectacles, before asking in a severe tone. 'Date of birth?'

About 8 AD, Icarus thought, before replying, '1985,' – ten years after the date of birth of even her alter ego. However Icarus was soon

to regret being admitted at all. The long skinny plane trees lining the drive reached into the upper atmosphere in the most elegant way, but when she reached the riverside the ripples marred the famous reflections of the arches of the castle and everything looked flat in the mid-morning light. The arches were certainly graceful, photogenic even, as seen through any one of the million viewfinders wandering the grounds. But what if she didn't want to take a photo? Over the course of the last few minutes Icarus had in fact taken several, and was currently refocusing her lens on capturing the precise moment when the plume of a nearby fountain began to fall: 'now you've got me, now you never did.' The thing was, the minute she took a photograph, the scene already began to fade; if she took too many photographs she feared the scene might disappear entirely.

Icarus wandered into the castle but beat a quick retreat. She would rather have stabbed herself than be stabbed – again – by that petulant Spaniard with seven bayonetted elbows, as the crowds fought over communal pockets of air.

'I'm not a tourist, am I?' she asked on her return, causing W to snort.

'75% likely. Certainly not a scientist...'

Icarus pulled a face, and scratched her head where her thoughts met the sky. She had come to hope she was more of a participant in

the world than an observer of it. 'But maybe that's ok, because when *I* use a word it means just what I choose it to mean - neither more nor less,' she replied, staring into space before handing W's space over to the broad, dopey handlebars of a young Dutch bicycle named Hans.

The road south east led along the River Cher wine trail towards Bourges. The atmosphere between Icarus and W had improved remarkably since their recent disagreements. 'Fancy listening to a poem for solo whistle? I composed it just for your amusement,' Icarus asked W after a good spell of companionable silence.

'But is it very long? I've already heard a *great deal* of whistling on this quest.'

Icarus shook her head. 'The length of ten bicycle wheels, or three bottles of wine, whichever you prefer:'

> Sau, vignon blanc cot a cabernetfranc to go and gamay up to his carignan, pinot noir's, melons de bourgogne, yes syrah, they're going to cin sault much they'll make a pinot gris of it. Muscadelle says pinot noir's a merlot – mourvèdre - che nin blanc herself. Exactemente. Clairette – too much rouge. But lonesome old grenache? There' sé millon ugni blanc in the viognier. He chardonnay's a damn, driving his cabernet, sau, vignon cot it.

W suppressed a giggle as best he could. 'But real whistling has no words!'

'That depends on what you count as real. In my reality whistling has more words than a dictionary. Did you like it?

'I liked it well enough, I suppose. But it didn't make much sense. It made me hot and bothered and that Muscadelle did tease so.'

♦

After the last few days, Icarus decided it was time they enjoyed an afternoon without incident. If only it were as easy as that.

The next town, Montrichard, was a typical French Renaissance market town with an impressive fortress and a church. St-Aignan went one better and had a fortress and a church and a zoo. 'Koala, Okapi, White Lions, White Tigers, Manakees, Wolves, Cave Beetles, and Peludas presumably too…' W began, listing off the endangered species. 'Although there's only *one* of them left and he's in the wild.'

'…*was* in the wild…' Icarus corrected, before she could stop herself.

'*Icarus?*'

Icarus swore silently. She had forgotten entirely that W hadn't heard the news from the campsite receptionist yesterday, and of course it was news he was unlikely to receive happily. She tried to explain herself away as best she could, noticing the trail of salty tears which had started dribbling along behind them. 'Hey, W, you ok?'

'Of course I'm ok. As I said before, I'm just a little hot and bothered.'

'Yes. I see. Hot and bothered. Anything else?' Icarus already regretted asking before W could answer. When had there ever *not* been anything else when it came to her opinionated bicycle?

'Well, actually, yes, since you ask, there is something else Icarus. I've been wondering. You know this humility – respect even – that you seem to have come to associate with *not* solving the climate? How, precisely are you going to achieve it?' W's watery headset bolts turned to face her. 'Legislate? Pray?'

Icarus paused before speaking, as she began to register some of the difficulties Lucy might have had with progressing any *further* with climate change than that it wasn't something which might be solved. 'If I had my way, everyone would be humble enough to agree that the Earth deserved respect,' she finally replied. 'But I don't want to persuade anyone of anything. That would be against my ethos of humility and respect.'

'Hmmm,' W replied.
'I know, it's a problem.'

 perfect undetermined trees settle into lines
 amongst the purple-flowered meadow

 close up is best
 there is no need for sky

 enough the brush
 of dew upon my ankles
 and the su-su-surring ripples
 of the accidental breeze

 it was hardness-wearing off-symmetries
 I rubbed the peeling bark.
 I tread the flowers.

 The year was approaching autumn
 but the way was closer closed

 the way the miles seem longer
 at the place of the purple trees

Beyond St-Aignan, Icarus and W entered an idyllic land of
backroads, living sunflowers, a multi-coloured pallet yard, plane
trees, vines and flower meadows. 'A shortcut,' Icarus exclaimed with
unfounded conviction, sweeping right along a road signposted in the
right direction, but unmarked on her Mappa Mundi – as if these
places didn't actually exist. But it proved to be a reassuring kind of
nowhere. When Icarus stopped at the highest point of the 'shortcut'
she enjoyed the meaningless chit-chat between a shop assistant and
and a customer, and a long cold fizzy drink in the sun. For a few
minutes time simply stopped. Nothing happened in the village, and

little happened in Icarus's brain, and W was silent. 'I'm not sure I'm meant to be enjoying this, but this might be the happiest I've ever been,' Icarus said eventually.

By the time they eventually reached Bourges campsite later that evening, everything about Icarus was still going slow.

'You've been eating for 35 minutes solid,' W estimated, having long since finished his own dinner. 'And you haven't even started pudding.'

All through England and France to here, Icarus had obediently taken daily weather glass measurements, just as W had proposed. Not that the high pressure readings through France were scientifically-sophisticated stuff likely to impress the best minds of a Greek generation, Icarus thought as she fulfilled her ritual the following morning. She could well-imagine Zeus's response.

'So, what are you saying Icarus, that your cycle through France was predominantly settled and sunny? But everyone knows that the weather forecast doesn't equate to climate change.'

Even though *Through the Looking Glass* made not one single reference to the weather, Icarus had found her favourite novel far more helpful for thinking through climate change than the barometric instrument at hand. *If you let climate change alone, it will let you alone, you know!* But that morning the water level in the weather glass spout was the highest yet, signifying change.

'I'd say an 87% chance of precipitation,' W said, peering over Icarus's shoulder. 'You know, it takes some time to be able to read it accurately.'

Strangely, the weather hadn't significantly touched on their expedition until now. There had been that one morning of rain between Hereford and Monmouth, but that was to be expected from August in Wales, and otherwise a tailwind and fair weather all the way. But Icarus suspected they both remained as blind to a 'proper reading' of the weather glass as ever. She had been reading *Through the Looking Glass* now for one hundred and forty years and still didn't suppose she'd achieved *that*. But looking up towards the skies now, Icarus supposed that W and the weather glass were right. Today they were going to get wet and the sooner they got on the road the sooner they would get it over with. There was just one place they needed to visit before they got on their way.

In the centre of town, the famous stained glass windows of Bourges cathedral opened onto climate change in all directions. The Good Samaritan and climate change climbing through the north east window. The Rich Man and Lazarus. The Last Judgement. Christ's crucifixion. The Apocalypse and climate change – of course – leading the thrill-seeking churchgoer by the hand. Icarus stepped away from the window of the Prodigal Son before the light could tattoo the story onto her skin:

Through the stained glass window shone a purple robe and a falcon, and a local ox which was staring at the scene from a neighbouring story. The prodigal sun is likely to be wearing a frown both before and after entering the red

brothel, and the pig sty – in all honesty – stank of chicken shit and three ageing sheep. The sky was pixelated, and the sunshine's smile became a little like eternity. Where's home? The multi choice question had three potential answers: A, B or C. No matter what they tell you. It is true.

Icarus lit a candle to climate change before leaving the church, but quickly blew it out when she noticed the donation box a millisecond too late. Yet not even *this* faux pas led Zeus to intervene: not a single reprimand let alone a bolt of lightning to her feet. Icarus had frequently grumbled about Zeus's omniscient dictatorship of the skies, and his inexplicable ways. But now had the God of the Gods given up caring entirely? This wasn't freedom; this was abandonment. How would she ever achieve her Godly ambitions if Zeus wasn't there to notice that she was busy rewriting her fate?

'You're never going to solve the skies, Zeus!' Icarus cried, to see if provocation might work where her inner pleading had failed. 'Come on, disagree with me, I dare you!' But nothing. Not a single grumble to warn her of her fate when she reached Athens. No murmurs of approval that Icarus was for once making her own way. If only for a *little guidance*, Icarus was thinking when a prehistoric woman on a stone-age bicycle interrupted her.

'Where are you going?'

'The wrong way up a medieval one-way climate,' Icarus replied, looking around and noticing the cars dodging her as they tried to drive up the narrow street.

The woman readjusted her hairbun to a jaunty angle, sending a couple of house martins on their merry way. 'You will have a wonderful journey,' she said, looking Icarus in the eye.

All Icarus knew about the woman was her preferred choice of prehistoric vegetable, displayed like a flower arrangement in her

wicker basket. But despite everything, Icarus felt obliged to believe her. She just had that way about her.

♦

It didn't take long for the rain and the first headwind all trip to wash away the last residues of the previous evening's contemplative smile. Icarus's legs felt rustier than ever, and the scenery leaving Bourges was featureless and misty. It wasn't until they reached the next large town of Nevers that the sun finally came out, dramatically lifting her spirits. 'Welcome to Nevers Neverland,' she cried. 'Home of eternal childhood and play!'

'Impossible,' W replied.

'We'll see.'

The Loire looped around town, with the medieval quarter climbing towards the cathedral. Icarus hadn't even had the chance to take breath at the top of the hill when a man tapped her on the arm.

'Parlez-vous français?' He had a yellowed smokers' slug for a moustache, the remains of his grey hair had been greased to one side and he was wearing a waxed mackintosh and bent plastic glasses. A malnourished lad, aged sixteen or seventeen, stood behind him holding an oversized camera dating back to between the wars. Icarus's limited French proved perfectly sufficient; the man had already thrust a huge microphone in her face. 'We're from the local newspaper, doing a visitors' report on Nevers. You like it here?'

Icarus explained that she hadn't really seen it yet, but she was sure it was lovely, before proceeding to answer his questions by rote, guessing 'oui' or 'non' to any question she didn't understand, when...

'QUOI?'

A wrong answer, but then French wasn't her *first* language, let alone her adoptive one. 'No, I didn't mean to say that people are unfriendly, but you're the only person I've spoken to.'

It was only a matter of time before the journalist asked where they were going.

'*QUOI?*' The photographer was hauled into service to shoot Icarus and W in front of the cathedral for the front page of tomorrow's edition. 'Off to the climate conference?'

The directness of the question made Icarus take a start, before she began nodding over-enthusiastically. Of course, there must be any number of campaigners marching on the conference, using equally sustainable means as her. She only hadn't met them because they were travelling the same way.

On the way out of town W resumed their previous discussion. 'Neverland? That journalist was proof of human mortality. I'd give him two or three years.'

'Oh, but I never made any claims for immortality.'

W acknowledged this. 'But what's childlike or playful about a provincial town with an ageing population?'

Icarus sprinkled some hourglass sand over W's top tube. 'Us, W. Peter Pan and Tinkerbell all the way until we die. The magic dust of flight and happy thoughts!' W grunted ominously causing Icarus to butt in before *he* took the initiative. 'You know, W, I've been thinking...'

'In fact it's my opinion that you never think at all, Icarus!' W interrupted. 'Because *I've* also been thinking. Endless childhood? Becoming immortal, a God? How does this match up with your ethos of humility? Are you willing to let these go in the name of your new beliefs? For surely these are the most hubristic ambitions of all.'

Icarus gulped so hard she almost swallowed her tongue...in the circumstances she could think of no other immediate answer than to

carry on where she'd left off. 'To a timeless island with no boundaries, many suns and many many Charollais bulls.'

The hill to Château-Chinon was long and uphill, the rain was wet, and Icarus was in desperate need of the consolation of biscuits. She nipped into a bakery in Rouy just in time to avoid a particularly bad shower. 'Le biscuit,' she said pointing to the closest equivalent, but the young assistant stared back in blank incomprehension.

'S'il vous plaît?'

For a country that had invented the word biscuit, France was performing particularly poorly at producing them. This was Icarus's sixth day in France, and she was still to find an example to rival the head-size cookies she had bought in Tesco, Andover. Instead she ordered yet another pastry made of blotting paper, gunpowder and sealing wax, which she ate, waiting beneath the baker's canopy for the shower to pass – long enough for some joiners to arrive, rehang the front door, and leave.

By the time they arrived, Château-Chinon had already disappeared into the mist, and its campsite had become invisible. But the bar

patron with the droopy moustache was only too happy to come to the rescue. Before Icarus knew what was happening he had already identified her confused stumbling around town as a search for a patch of grass on which to pitch her tent, and he had already stopped a scrawny local in a battered Renault van, which now screeched around the one way system – the patron gesticulating to Icarus and W to follow until the van did a handbrake turn at the end of a dirt track marked 'camping'.

That night Icarus could have done with a good sleep to prepare her for the challenges which the morning would undoubtedly pose. Instead she galumphed around her tent this way and that, as she struggled to sleep through the beats of the local youths' music in the neighbouring village hall.

'Not so eternally youthful after all?' W cried through the canvas as he gyred to the syncopation of the music with the rain.

Icarus tossed the other direction once more. As if there was any way to get comfortable on a two centimetre thick foam mat when your best friend has just pulled the rug of life from under you. It already seemed such a long time since the heady excitement of the climate change scribble, and all the possibilities it had seemed to offer. Even her gender-inflected interrogation in Orbec brasserie paled into insignificance in the face of *this*. Of course, the fact of her newfound mortality wasn't *assured*. But in order to actually help Lucy in her quest to understand climatic change, the prospect of death was crucial. And as usual, W had been right. Wanting to become a God? Aspirations of immortality? Humility? *If it was so, it might be; and if it were so, it would be: but as it isn't, it ain't.* Rewriting her fate? The hole in her logic couldn't have been greater.

Château-Chinon's main attraction was its view of the surrounding Morvan landscape. The following day that remained closed, although by the time Icarus and W had wound down to the bottom of the hill the sun had already begun to cut through the clouds. The hills were rolling, and held together by hedges and outcrops of woodland. Off to the right rose Mount Beuvray, site of Bibracte, one of the most important hill forts of the Gauls and, would you have it, perched right there on a bollard beside the road looking sorry for himself was the most famous Gaul of all.

'Hey Asterix,' Icarus said, drawing up alongside. 'What's up?'

Asterix raised his white feather headband, wiry blonde mop and over-enthusiastic moustache from his hands, while Dogmatix, Obelix's dog, yapped viciously around W's wheels.

'Where's Obelix?'

'All gone,' Asterix replied. 'People gone, culture gone, language gone. Obelix gone. And only me and Dogmatix left to tell the tale.' He handed Icarus a small vial of magic potion. 'Take this. It will give you superhuman strength when you get to Italy to out-cycle the Romans. It's my last one – but *I* won't be needing it.' And before

Icarus could argue Asterix had turned back into a cep mushroom and Dogmatix had turned into a fly.

W snatched the vial from Icarus's hands and read the label before throwing it into the field to help the grass grown greener. 'Just as I feared. The potion of cheats. Blood doping – adding oxygen to the blood to keep it going just that little bit faster, for that little bit longer. Was Asterix a drug dealer to the cyclists on the Tour De France?'

Icarus coughed and spluttered. 'But isn't that rather like what we're trying to do to the sky? Neutralising the carbon dioxide to save our civilisation from ourselves?'

'Contrariwise. If I'd meant *that*, Icarus, then I'd have said it!'

> i never saw it as a form of fleeing
> past tenses: flight
> i was always going somewhere
>
> space inside the centre of the page
> unwalked millimetres
> expanding cycles into rings
>
> i meditated on the things the trees will say
> and how they'll choose to say it
>
> the dendrochronology of concordance
> horizontal cross-sections of our lives
> our bandwidths
> spotting the setting sun
>
> the new growth will be colourless and odourless
> departures of retreat calibrating
> the gaps between our early and our late wood

By the time they reached the top of the pass above Arleuf it was sunny. Meanwhile, the higher they had climbed, the higher the conifers had grown; at the summit they almost reached to heaven. The lower branches didn't even start until the middle atmosphere, leaving Icarus contemplating bare totems. Logging lorries swept past leaving millimetres of breathing space, while every layby was stacked high with felled trunks. It was a scene that lent itself to reflection on the deeper matters of life, the *meaning* of life around which climate change had suddenly come to revolve.

'They died so young, didn't they?' W said, wandering between the stacks, translating the stories of their rings. 'Some of the trees behind the Salford house have survived more weather.'

Icarus scratched her head where her very-large-gnat-sized worries had begun to eat her. 'So is that really what this is all about? Survival?'

'What?'

'Climate change, stabilising it, the climate conference.'

'As jolly good a reason as any,' W said, with a sniff of his brake cables. 'Don't try and tell me you didn't turn pale when I raised the question of your mortality yesterday?'

'Survival of the fittest bicycle?' Icarus tried to joke.

'If that's a joke, then I'm glad you made it, because it isn't funny. You know you shouldn't even *make* jokes if they make you *this* unhappy.'

Icarus bit her lip so deeply she could taste blood. That was harsh. She had just been trying to lighten the atmosphere a little. Was it really surprising she felt this troubled? It had taken humanity centuries to not yet come to terms with death. Did W expect her to just take it in her stride? Icarus squatted down on the verge and continued where her previous line of thought had left off. 'We just seem to have forgotten to ask the key question, W. *Why?* It's like solving climate change has become an end in its own right. But

what's important to us? Survival? Happiness? Money? Humility and respect, Zeus forbid?' She gestured around at a surrounding landscape so magical it might have been a Wonderland. 'What kind of a world do we want, and what are we prepared to do for it? I may be idealistic, but imagine this...'

There was once a year the speed of days
a world of naïve trees:
branchless conifers that stuck
the sky a cumulus of candy floss

Scheherazade was washing her stories
by the river while she swam

she wrote a great black
puissant horse above the trees
a form of a fashion:
a six-rayed-sun you painted on
a blue-night sky

we took our loss of knowledge of descent
as a talking point: *'no sip save these things like button'*

a horse-head moon
a wash of water
a darker shade of ebony
wearing river to the shore

if our elixir were never-ending air
would you fight me for a portion of the sky?

As they wound back downhill a short time later, Icarus concluded that all that had been missing from 'Wonderland' was a biscuit or two. In the next town of Augustidinium every local Roman was

walking along the road with a bakery bag under their arm, taunting her off-route in the direction of the smell of sugar.

'Combien?' the baker asked, rubbing his hands in glee and translating Icarus's answer of three biscuits into three kilos.

Icarus sought out a corner of peaceful solitude in the town square to sample her treasure. As if that was likely on *this* adventure. She had barely sat down when Romans came running, at first in twos and threes, and then in such crowds they seemed to fill the entire town, tripping this way and that as they went. Icarus clasped her three kilo bag of biscuits close to her chest in case this was the cause of the commotion. She needn't have worried. A battle was rumoured to be taking place at the football pitch, and the Romans already running several centuries late.

Icarus breathed again, closing her eyes in anticipation of the heady sensation of buttery sugary pieces of heaven melting on the tip of her tongue. One heaven, two heavens, three...at that moment the chances of Icarus eating so many heavens that she felt too nauseous to cycle any further that day were high – if it hadn't been for the strike of wonder which caused her to suddenly jump to her feet after only seven heavens.

'Heavens above!' she exclaimed, dizzy sugary stars circling her head as if she were a cartoon character.

W reached out a handlebar for Icarus to grasp. 'Steady on, now, Icarus. What's up?'

But there was to be no steadying Icarus now. 'Do you know, W. For longer than anyone can remember it's become habit to view Icarus as *hubristic* and *proud*. But what if that's untrue? Because *that's* not me. For sure, I'm a dreamer. Curious certainly. Can you see where I am going? Why bother rewriting my whole story when I can just encourage people to *read* me differently? Everyone's simply got me wrong!'

'What, behold the death of dear Icarus?'

But not even W's sardonic response could knock Icarus off track. 'And do you know what – sod mortality, because stories can't die, can they W?' When Icarus began to laugh it was slowly at first, but it wasn't long before her lungs were heaving this way and that, while the baggage attending her hubristic identity and fate grew fingers, developed feathers, crafted wings and took off to the sun.

♦

In fact Icarus didn't have to wait long to test her earthly – as opposed to narrative – mortality for real. The landscape beyond the industrial hub of Le Creusot, famous for its iron and steel and trainworks, was characterised by small pastures, copses of trees, green fields, Charollais cattle, and small red-tiled limestone hamlets. Even though they were further south, the faces of the sunflowers remained in full bloom. The TGV blessed them with a few seconds' whoosh as it passed by on its way to Lyon.

'A forty minute journey which would take us more than a day,' W pointed out.

However, that afternoon, Icarus's energy lasted barely forty minutes, as the biscuit sugar-rush high disintegrated into the emptiest of energy lows. They remained well short of their destination of Cluny, let alone Lyon, when Icarus flopped onto the verge like a rag doll. The infamous cycling bonk.

'Caused by the depletion of glycogen stores in the liver and muscles manifested by sudden fatigue and loss of energy,' W recited.

'Who'd have guessed?' It took an entire dry white loaf, and about half an hour of lolling about for Icarus's eyes to refocus and her spine to reform. But keeping going proved even more dangerously scenic. Only a few miles down the road she stopped to take a photo and was facing ninety degrees the wrong way when:

'Don't move!'

As if Icarus had any option. She could only watch as a car approached at speed, swerving inwards, treacherously close to the car it was overtaking as it spotted the cyclist at the roadside at the last minute. It was travelling so fast that the wheels struggled to carry the body of the car with them, and it missed Icarus's knee by millimetres. Icarus pushed W onto the verge and closed her eyes. If she *were* to reinterpret her fate, then surely it was only fair to give her a chance rather than whacking her BANG OUT LIKE A CANDLE? She sighed heavily. No matter how much she philosophised about the humble importance of confronting mortality, it was different looking death in the eye of a car. Icarus sank onto her knees and began to pray:

> *Our Zeus, who art in heaven, Hallowed be thy Name.*
> *Thy Planet has come and gone. Thy will be done on earth*
> *As it is in heaven.. Give us this day our...*

Icarus took another bite of bread. 'Please Zeus?' she pleaded. 'Speak to me? Is this what you were hoping of me? Am I doing you proud?'

But not even the cheep of a passing bird, let alone the reassurance Icarus craved, the direction she required, the hug she deserved.

At the very least Cluny itself proved worth living for. Indeed it was one of the most beautiful small towns they had cycled through yet, with small cobbled lanes leading past the remains of the tenth century monastery – whose cloister wine shop was determinedly SHUT. Icarus swore, blasphemously. Tomorrow was a day off. 'The least we deserve is a glass or two of wine to celebrate survival!' Icarus exclaimed as she walked into the automatic glass doors of a supermarket which had also closed three minutes ago.

Icarus's face was set in an upside-down smile as she walked up the campsite path, resigned to commiserating her mortality with sobriety when…

'Do you see what I see?' W asked.

The van selling offsales from a local vineyard was lit up by a large halo as it made its drunken way around the *emplacements*. 'I will try all of them,' she informed the négociant, while muttering all the right things about chocolate noses and vanilla legs and an unmistakeable aroma of what…*petrol?* 'Now *that's* special,' she said, savouring a miniature glass of the most expensive wine on offer, before pointing to a bottle of the cheapest red. 'But on reflection, I will have that.'

L is the colour in the middle of yellow

The best things about days off were the little things. In fact, were the best things about being *alive* not the little things, Icarus thought as she went about her laundry and her food shopping with unusual gusto. Icarus's only immediate needs were sleep and food and after the last few days she yearned for little more. Having done her chores she watched her elderly French neighbours cook up a camping-feast, only to turn around and realise that she was also being watched. The girl was aged about three. Her fingers were hooked tomboyishly in the back of her shorts and her unruly curly hair protruded from behind her ears. Undoubtedly, Icarus thought, her name would begin with the letter L. 'Salut.'

'Lucy!' called the girl's father, causing Icarus to jump.

The father in turn was ignored; after all, Icarus agreed, who obeyed their father when there were more interesting attractions at hand?

'Stick your tongue out,' W suggested, which Icarus did, sending the girl fleeing, giggling, to hide behind her father's legs.

But soon enough Icarus's sixth sense told her that Lucy was back, and about a metre closer.

'Why does your bicycle talk?' she asked, assertively, in French – the first person, Icarus reflected, who had actually responded to her bike's voice. As if she was the first person, apart from Icarus, to truly believe in him.

'Lucy!' called the girl's father, apologising profusely and escorting her away. So the afternoon measured the passage of time with Lucy approaching a metre closer with every investigation until she was almost reading Icarus's attempts at poetry over her shoulder. All the while a Belgian couple, one hundred metres up the hill, watched the scene unfold in wide-screen from the comfort of their deckchairs, and a family two tents down began their third argument since arriving at lunchtime. 'Why does your bicycle talk?' Lucy repeated, having once more evaded her father's grip, addressing Icarus from close quarters.

'Because why not?' Icarus replied – her response to every question that she hadn't known the answer to since birth. Why did you disobey your father's instructions and fly too close to the sun? Why are you incapable of progressing beyond entry-level science? Why can't you apply yourself to anything but dreams? Why have you gone off-message over climate change? Perhaps not the most *convincing* answer to this question in the world, Icarus confessed. But in the immediate circumstances Lucy seemed to have liked it, for she grinned and tottered back to her father to tell him about the talking bicycle and the strange, boyish woman in the tent over there who looked and spoke an awful lot like her.

Icarus stretched out on the grass and closed her eyes. Just when she had most needed it, it was as if a younger version of her alter ego had dropped from the skies to present her with the most basic of permissions – to continue. 'Thank you, Lucy,' she said to herself. 'Haven't we already come so far together?'

As it turned out, the minotaur wasn't Birmingham. It was Lyon, France's second largest city, whose industrial sprawl blocked not only the most direct route south, but most alternatives. It was their ninth day in France, when had all gone well, they should have already crossed into Italy. All being well, Icarus thought as she continued on her way the following day along a greenway cycle path running parallel to the motorway, a more convincing alternative to solving the climate might have begun to form in support of admittedly vague principles of participation, humility and respect. Her rationale suddenly felt as flimsy as the wrist-thick scaffolding holding up the entrance to the Tunnel de Bois Clair, the longest cycle tunnel in Europe, which lay between here and the next valley.

'Are you *shaking*?' W asked.

'No,' Icarus replied, trembling. 'But I should be. Look at it! It's the crumbling entrance to the living underworld.'

W took the tunnel at high speed, careering between dive-bombing flying mice and drips of condensation that echoed like heartbeats. 'The temperature's half what it was outside!' he shouted half-way down, thus alerting a passing group of murderers on a family day out to their precise echo-location.

At the far side Icarus bent breathless over the handlebars. 'You know, W. It's not easy confronting death after all this time. Would you sacrifice yourself in the name of what you believe?'

W scoffed. 'What usually happens to your Wings, Icarus? Have you really not considered *my* fate? I stand to lose everything. Kings' horses are unlikely to piece together bits of bicycle.'

Icarus laughed – punch-drunkenly – and faced the Mâconnais wine region ahead: Pouilly Fuissé, St Véran, Mâcon, read the grapes, lined expensively against the hillside, while the hilltop castle of Berzé-le-Chatel peered feudally down upon the valley as far as the paleolithic site of Roche du Solutré in the distance. The Stone Age put her own old age into context, Icarus supposed, pulling her creaking right

knee back over W's frame, trying not to feel *too* sorry for herself. She had been so self-absorbed, she admitted, that she hadn't considered W's fate one second. And the interruption now of Alphonse Lamartine, Romantic poet and latter day politician, ensured that this line of thought didn't get too far now either.

'Upsets me every time I return or leave,' he began, addressing his valley of birth.

'If we could only suspend the flight of time?' Icarus replied, quoting a line from his most famous poem.

'Vraiment, Icarus, vraiment.'

Icarus looked onwards as Lamartine made his way. If Lamartine symbolised a fear of the future, the regret for times past was up ahead in the form of a caveman, sporting a shaggy black beard from head to toe, who was cycling along on a rag and bones of a bicycle. His entire neanderthal belongings were balanced precariously across its frame in tatty army bags which were the worse for various slingshot wars.

Icarus showed him how to use her pump to relieve his asthmatic bike. 'So you're heading to the caves at Solutré?'

'Non,' the man replied brusquely, as if she had just pulled the sun from the sky. 'Whatever made you think that?'

A kilometre further on Icarus and W passed two beautiful young blonde-haired women leaning on their shiny, unfettered bikes. 'You haven't passed a caveman by any chance? He's got our jewellery and mascara and our wolf-skin coats. We need them for the caves.'

Icarus affixed the feather of the present to her wings and kept cycling.

♠

we lost the silk thread test and failed
to time the season of our young

 la chauve souris
 is it late to confess that i knew little?

just hand-wings pointing onwards
and a sound beyond the threshold of pain

the rhythms of my pulse upon the darkness
of my empty fear of night

 see me
 liminally naked
 out of sight

there was just the ongoing spread of membranes
(blinded evolution)
bald as the outspread digits of echo-located flight

Once the greenway ended Icarus badly guessed a way into Mâcon, inexplicably (to her eyes) arriving from the south. Yet it was a grand enough entrance, up large commercial boulevards lined with expensive hotels, which met at a roundabout large enough to encircle the whole of Europe within its grassy globe. Europe's stella aurora flag flew in the centre, surrounded by the twenty seven flags of its administrative empire, all hanging at equally and precisely limp angles to the otherwise blue sky. Yet when Icarus began to launch into a tirade against its regulatory approach to the precise pantone of the climate, she finally broke W's patience.

'Icarus, would you ever listen to yourself! Your self-righteousness can prove most provoking. Europe has achieved more regarding climate change than the rest of the world put together. Beyond your dreams; this is what we've got!'

Icarus drew up short, plucking the feather of self-righteousness from her climate wings before it could properly affix itself. So there she was, practicing what she was preaching against? 'I'm sorry, W,' she said, giving W's tyres an affectionate kick before drawing back out onto the road. The traffic swept them round the roundabout, along another tree-lined avenue and on into Centre Ville. Mâcon had developed around the wine and metallurgy industries and elegant pastel-coloured villas, expensive cafés and wooden shutters opened onto the waterfront along the Quai Lamartine. They crossed an eleven-arched bridge over the river Saône and sat down on some concrete steps on the far bank. And no sooner had they opened their lunch boxes than they were joined by a fisherman taking a lunchbreak from fish, and some car tourers taking a break from touring. An old guy took a break from being old. But the Saône took no break at all, it just kept drifting southwards towards the Rhône and into the Mediterranean sea as if it had eaten its lunch already.

The Dombes landscape due south was punctured with ponds, built in the fifteenth century when landowners had decided that fishing would be a more profitable use of the area's clay soils than farming, before the resultant malaria had required many of the ponds to be re-drained. For once Icarus swallowed her self-righteous thoughts, allowing but a *little* knowing glance in W's direction.

By Chalamont, the afternoon was lengthening and, as was becoming customary, it remained no clearer where they might spend the night. Pérouges wasn't far enough but there were no campsites marked at all on the other two routes. Icarus laid her Mappa Mundi out on a café table and was busy trying to move the minotaur of Lyon a bit to the west to open up her route choices with the pressure of her thumb when a handshake was thrust in her face.

'Hallo. From Germany?'

Icarus shook her head. From *mome*, more like: far from home, meaning she'd lost her way, you know. But certainly not German.

'Ah, but you look it. You cycled here? Going far? Strong muscles, non?' The French man was tall, wiry and suntanned to leather with an ominously thin brown moustache covering little more than a third of his upper lip. 'Cycling to Athens? For the conference?'

Icarus nodded, then jumped backwards to dodge the man's, apparently appreciative, lunge for her quadriceps.

'I cycled all the way from Brussels to Nice when I was a teenage boy,' the man continued, pulling up his shirt to show Icarus his old man's six pack.

'I see,' Icarus mumbled, looking over the Belgian man she had mistaken for a Frenchman's shoulder for an escape route. And no, she wouldn't be joining him for tea in his brown Ford Cortina, she clarified – she would rather take on the Lyon minotaur if it came to that. Not that anybody else had better ideas about where to spend the night when she had finally escaped his attention.

'Why not camp rough?' asked two young German men – the first people Icarus had actually met who were also cycling to the conference.

'But I can't read maps,' said the silent wide-eyed stare of an assistant in the local épicerie.

'There is a lower, flatter road,' replied a French touring cyclist, obliquely…The professional cyclists in their logo emblazoned van stared at Icarus and W through the darkened glass as if they'd just seen aliens.

It had been another breathless day, full of incident. Icarus was tired and frankly, for one day, had suddenly had quite enough. 'What's the point?' she blurted, out of the blue, pulling onto the verge for some water. 'What's the point in being Icarus if no-one even realises? What's the point in rewriting anything if the Gods aren't listening?

Why am I even bothering thinking through climate change if everyone will just carry on as usual? No offence to Lucy but...what's the point in being a woman, W, if it really makes no difference as you say, yet still I have to deal with *all these men?!* I'm fed up of never having a base, a home. Of course I wouldn't feel safe camping rough, for fear of passing Ford Cortinas! And you know what? I really *don't* want to die if I'm perfectly honest, ta very much.'

Icarus dug her phone from her panniers and flicked through the emergency numbers: her only thread of communication with Planet Zeus, with enough credit for only one call, if things turned out wrong. But even if things went even more wrong, who was she going to call? Zeus would ignore her, boom or shout. Apollo would laugh. And Daedalus would over-intellectualise, and offload his guilt, when all Icarus really wanted was a hug! What, moreover, would she say? Icarus thrust it back in her pocket and swallowed hard. Was that not the nub of it?

The lower, flatter road cut through a mile-wide valley, hemmed in by limestone escarpments, while the Rhône wandered lazily through the fertile valley bottom towards the sea. The campsite, meanwhile,

had been hijacked by a pirate with medusan dreadlocks, a diamante watch, and a set of golden teeth, who had made his fortune through a canoe-sloop business on an artificial river he'd diverted between the river and the canal.

'The rapids get switched off overnight to let them sleep,' W explained when they went to investigate the artificial river's source. A pump had been installed to thrust water downhill as fast as possible in order to challenge the prowess of visiting canoeists. Yet now, as it approached dark, all was still. 'Vorpal huh?'

There was both something ominous about it to Icarus's eyes and also, she had to admit, something really rather awesome indeed – an admission that only served to unsettle her. She turned to walk W back to the site. By the time they were back at the tent the sunset had set the sky's oxygen on fire, further ruffling Icarus's feathers. 'Something's going to happen,' she said to W. She could feel it in her bones. And over the next few days all sorts of things began to happen in a hurry.

in answer to the question
the question was wrong

if the nest was burnt then the phoenix also burned –
there is no climate inside the fungicidal brain of a gaseous mushroom and the sun city blossoming like the moon

listen for the bird is singing

we had been here but a thousand years and all this

we wished our sunset could have been a scarlet tale
a sunset mostly gold

then you threw a grenade at it

The next morning even *began* as upside down as Icarus's smile. The River Rhône flowed upstream, uphill, along the base of the Bas-Belley-Bugey valley, while trees grew at right-angles from wooded limestone escarpments to their east. To the west, meanwhile, the landscape became increasingly industrial. They were roughly parallel with Lyon when they drew level with the controversial Superphoenix fast-breeder nuclear power plant, which due to technical problems and protests had only been operative for eleven years since 1968. The Tour de L'Ain bike race had come this way just the previous day, and several anti-nuclear, pro-cyclist protestors still lined the road, waving flags enthusiastically as Icarus and W passed.

'Allez, allez!' yelled Chaïm Nissim, the Swiss Green Party politician, who had launched a rocket grenade attack on the plant in the early eighties.

'Vive l'action directe,' cried Carlos the Jackal, who had initially been accused of the attack.

'Vite, ralentir!' cried a split-both-ways-when-it-comes-to-climate-change group of Les Verts.

Downstream, near the Pont de Groslée suspension bridge, the river was an ominous shade – greener than the campaigners they had just passed, greener than the leaves which had already begun to turn. 'Already autumnal,' Icarus said.

'Or the beginning of the serotinal if you adopt ecology's six season system. Late summer, which in fact begins on 15th August. Today!'

And this wasn't the only spectacle of colour happening today, if a sign up ahead was to be believed. 'Coupe D'Icare Festival of Flight!' W read aloud. 'Fancy that! It's our *ideal* chance to get in some practise. My prototype could do with another test run or two before we fly across the Alps. Your recent attempt at pilot-hood was hardly an *unmitigated* success.'

Icarus groaned volubly, before replying, 'no, *no* W, I don't think so.' In the far distance the valley route towards their destination of Grenoble was already lit up with a rainbow of balloons, paragliders, parachutists, kites. But why would anyone be stupid enough to call a flying festival by her name? And who had said *anything* about flying across any mountains let alone the Alps?'

'*No?* What do you mean, *no?* But I thought we were in on this flying project together?'

'I agreed nothing of the sort!' Icarus objected before beginning whistling to drown out W's protests. Icarus's whistling oeuvre was generally characterised by an improvised virtuosity. Yet this was more of a nervous sound, more like a steam train than pure-jazz:

We built our wings from sackcloth.
Hessian, burlap, gunny, jute.
Cilice aerofoils, the hairs abrading
our arms down to the bone.

Ours became a skeletal repentance,
of long-lost origin: one hour, two years,
several centuries of soon-forgotten time.
It was as if we'd never really been
there, for a fragile sense of no return.

They say a single sack will suspend
one hundred pounds of fresh potatoes –
nontoxic, breathable, assured to
keep a range of ballast fresh.

Watch the way the sunshine angles
through the holes between the weave.

The eagles taught us how to fly,
but our ratio of lift to drag was zero;
we left only sandbags filled with fear,
spreading, airborne, the anticipated flood.

W sighed, as if exhaling steam himself. 'What am I to make of that?'

Icarus closed her eyes. 'Perhaps there's something I need to share with you, W, if you'll only attend, and not talk so much...' she began.

'But you're a flier, Icarus, I mean...?' W pleaded once Icarus had completed a long, tortured explanation of the many reasons she should never ever fly again, uppermost of which was the relationship between her increasingly vulnerable fate and that of the planet. Yet Icarus's explanation was nowhere near as pained as the resultant look on W's face.

'I was, W, I was. But things change.' For the last few hundred miles Icarus had repeatedly envisaged what might happen if she tried again to take flight. Up, up and down, taking the entire human race along with her? It was a no-brainer. Hadn't she done all of her falling already? If she was to leave hubris and teleological ambition behind; what role did flight have to play in rewriting her own and climate change's fate? What would be the good of having it over?

'Do I mean *nothing* to you? It's the least you owe me to demonstrate that my bicycle revolution prototype can leave the ground.'

For a haunting moment the disappointment etched in W's face reminded Icarus of Daedalus. 'Of course, you mean something to me, W. But if there really is a link between my own story and climate change, even if only symbolically, then I've got no choice. As you

pointed out, I'm hardly going to legislate or pray about it. Perhaps all I can do is to participate in climate change as well as I can.'

'When did you decide this, Icarus?'

'Well, I've been *thinking* about it since Le Havre, but Lucy has been proposing it ever since…'

W was never going to let Icarus complete that sentence. '…it's my opinion that you never think for yourself at all, Icarus. In fact I've never met anybody stupider!'

▼

Icarus's resolution against flight didn't account for circumstance. In Le Pont de Beauvoisin, at the foot of the alternative route to Grenoble over the Chartreuse massif – avoiding the festival, the sun came out and the road began to climb. Icarus was leaning W against some barriers to investigate the gorge which fell precipitously off one side of the road when:

WOOF!

A gunshot of barking from the local restaurant's dog launched her into the sky, air-cycling above the gorge for a good few minutes in animated slow motion before swinging back to earth on the branch of a most convenient oak tree.

'You might find it safer taking me with you next time,' W sniffed.

From there on in Icarus resolved to follow the dashed white clew along the middle of the road to avoid falling off it, until it suddenly got lighter and the road's gradient eased – far sooner than Icarus expected. When she looked up the gorge had opened into an unlikely alpine pasture, ringed by the sharp limestone peaks of the

'Colline du Menuet' which were busy singing their way into subsidence up ahead. A jolly kind of a tune to sing while one disintegrated, Icarus thought, joining in with a bit of heavy-duty whistling – if that was the way it chose to go:

> downstream of the poppy peak road ends
> through cantilever the lower urgonian leads an
> expansion notched in the cliffs of coarse talus it is
> there in the red layers of barremanian shales
> which are removed in five to ten metre cliff foots
> beyond the road cut outcrops of fine hauterivian
> delivering plenty of spatangoids sea urchin
> outcrops separated by a few shreds of lake silt
> and those limestones brown and bedded cherty
> exposed in the last five hundred metres upstream

In the next village of Entre-Deux-Guiers, the Guiers split into the river of life and the river of death, the latter of which they were to follow upstream. It wasn't the most auspicious sign. But not even the more positive motto of St-Laurent-du-Pont – 'I care for the past, I want the future' – could lift the metaphorical or physical black cloud gathering overhead. The road once more led them higher into the jagged mountains – past the derelict remnants of St-Laurent's industrial past haunting the climb through another gorge. Inside a tunnel the amplified noise of the cars reverberated with Icarus's concerns and more ominous still, when she exited the tunnel the sky was darker than it had been inside. The worst storm since the mesosphere was approaching faster than her legs could pedal.

'Quick!' W said, breaking his silence to point to a derelict factory up ahead as the first hailstone dented the earth and some lightning split the sky in two. Icarus tumbled beneath an overhanging canopy and pressed flat against the wall in time for the sky to let fly. Ten

pence pieces, ping pong balls, frozen golf balls. A car drew to a halt and the hailstones dented its shiny roof, threatening to smash the windscreen before the terrified eyes of those trapped within. And for the first time since Icarus had landed back on earth, Zeus truly spoke, in the bellowing thunderous voice he reserved for when he was most furious and fuming and frumious all at once – an almighty godly roar with which a world might either end or begin and nothing in between. His tirade made W's protestations sound like whiffles. With every blow, Icarus cowered further into the shelter of the derelict building, as her worst fears were spelt out in no uncertain terms.

No, this wasn't how Zeus had hoped she might rewrite her fate. No he wasn't impressed by her ideas about humility, participation and respect. And how dare she be so hubristic as to contravene the very parameters of her mission to earth. 'Not solving climate change! Who do you think you are?' he concluded with a final slash of lightning which cut free the final feathers in Icarus's climate 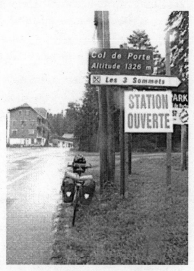 wings from where she had spent the last ten days crafting them.

'But I was only making my own way, Zeus, just as you suggested I might,' Icarus replied, with her last small thread of courage.

'But you have no ways! All the ways around here belong to me! Surely you knew *that*, dear Icarus!' And on that note Zeus's presence disappeared even quicker than it had arrived, leaving the valley echoing with silence.

W didn't dare speak, while Icarus bent double, gasping for air.

No, thunder wasn't caused by lightning and lightning wasn't caused by thunder, and...The Earth had been having its face scrubbed by the rain and had no hand in the mischief, and...The storm had been Icarus's fault entirely. Of this she was in no doubt. Had the door to the future just closed in her face where her and Lucy had only recently re-opened it?

And if Icarus had been confused before? How to travel backwards or forwards from here when forwards risked annihilation and backwards going back on everything she had come to believe, everything she'd become? 'Help me, Lucy!' Icarus cried out to the woman whom she was allegedly here herself to assist. Why was it that Icarus always ended up choosing the difficult, because *different*, path – inhabiting the difficult, because *different* characters?

'So shall we just keep going now?' W asked, pointing ahead before Icarus might fall into the void of her own gorge.

'Of course, forwards, always forwards,' Icarus cried. 'All the way forwards until the end – is that how it is W?' It was as if the umbilical cord of progress kept pulling, reining her thoughts in towards the kinds of teleological conclusions she was resisting so hard. But other than onwards...?

The road up the increasingly dramatic limestone gorge towards Grenoble had turned to slush and wound precariously through tunnels, between pinnacles and even overhung the river on concrete cantilevers. Icarus's sight was blurred by the rain and the stinging of her tears as they slowly wound their way towards the summit of the pass. The mist swept high above the mountains as if promising to clear, before enveloping them once more as they emerged into the valley of St-Pierre-de-Chartreuse. On they cycled past the shrouded Carthusian monastery and its famous green elixirs, past two cyclists who had stopped to do star jumps beside the road to keep warm. When they reached the 1326 metre col the sleet whipped through

Icarus's skin. 'What's the best speed to descend without the cold making skeletons of us?'

'I don't think you have a choice,' W replied softly, as his wheels slipped through his brakes, 'but fast.'

Tears streamed down Icarus's face and her hands seared with cold. She could hardly even feel her frozen naked slabs of legs let alone see through her iced-up eyes. In the end she simply submitted to the curves of the road and gravity and her chattering teeth and purple lips and to hell with it.

That night, Icarus's top choice of miracle would have been the hug she'd so recently come to crave from her father. Her second choice would have been to find Jesus sitting behind a youth hostel reception desk in Grenoble, just when everything seemed lost. The young, bearded be-sandalled man led her upstairs to a room with only one elderly, and absent companion. And then there was dinner.

'Quattro Stagioni?' the proprietor of the local Italian restaurant clarified.

Icarus nodded. All in one day, how had he known? She could have eaten the six seasons W had mentioned earlier if only they'd fitted on a single margherita pizza.

Later that night Icarus put pen to postcard in a coded poetic plea – dear Dad – for help:

 The sun set
 a little like a climate
 mapping of itself

 the kaleidoscopic sum
 of spectacular averages.

 There will always be
 a tendency towards the
 falling-rising sunshine.
 Atmospheric forcings.
 The attraction of inverted poles:

 we must meet our own imaginations
 at the point of our opposing sunsets.

 One over latitude multiplied by 23.5 degrees.

The next morning rain battered the roof of the glass lobby; when Icarus filled the weather glass, water bubbled from its spout. 'Do you know the weather forecast?' Icarus asked a warden, who turned in panic to her colleague as if she had never been asked such a ridiculous thing. The colleague knew little better, but at least had the initiative to look out the window and state, 'it's raining.' Indeed, out of the window the Alps had entirely disappeared from view. If Icarus had been cold yesterday at thirteen hundred metres, how cold was it going to be today if she climbed to two thousand? Pure and

simple – these were survival conditions – Icarus thought, hooking her thumbs in the elasticated waist of her cycling shorts.

W had been the only bike in the cellar when they'd arrived, but when Icarus returned to collect him there were several. W was busy admiring the highest specification machine either had ever seen – more of an insect on wheels than a bicycle.

'Try lifting this.'

Icarus reached out with her index finger but before she even touched the bike it hovered off the ground. 'Vorpal! That's not a bicycle, it's a flying machine.'

'Too right,' W replied. 'And he isn't the only flying machine hereabouts. Today is the day *this* black eagle prototype takes flight.'

Icarus shook her head. Over the course of the quest her Mappa Mundi had become illustrated with their adventures. But the most important story of all remained uncompleted and today promised to put that to the stiffest test yet. Icarus had come to ignore her knee pain over the last few hundred miles, but today the dampness had already seeped into it, and her ability to cycle fifty miles uphill to the Col du Lautaret before descending to Briançon was already rusting. Only one thing was certain, she wasn't flying no matter what her bicycle might think.

Before leaving town Icarus pulled up at a local post office. 'A postcard stamp for Planet Zeus, s'il vous plait,' she asked the sepia toned woman behind the dusty desk.

'Il pleut,' the woman replied, ripping a stamp symmetrically from page seven.

'Il pleut,' Icarus agreed, wiping the dripping evidence from her face.

Monochrome was the price the postmistress paid for dreams – they put the tax on paper up and everything.

She was lucky enough to possess the thoughts of every single detail of the world. She considered it a kind of reciprocity in negative.

As they set off through Grenoble's industrial suburbs Icarus had a premonitory feeling of déjà vu – as if she already suspected the disasters which might befall her that day. For did conquering the Alps not require an ethos the polar opposite of the humility she had supposedly resolved upon?

The pharmaceutical factories south of town, built to produce poison gas during World War I, did little to lift Icarus's mood. Beyond, an oil refinery belched flames and mist into the mountains,

filling the sky with condensation that continued to fall on their heads as rain. The temperature was barely in double figures and they were yet to start climbing.

'Scary to think that all this would go up if the Séchilienne Ruins came down,' W said.

Nine kilometres upstream Icarus saw what he meant.

'The result of glaciation and brittle local ecology,' W explained, pointing at the ruin of Mont Sec whose entire height was disintegrating into the river at the bottom of the valley. The local village of Île de Falcon had long been abandoned to birds and bats and others who could hope to outfly the falling mountain. 'A test case for French natural disaster management and monitoring: radar, optical sighting systems, measuring cables down fault lines, a hydraulic bypass, flood barriers…'

'Strapping the mountain in place to avert disaster? Or just to divert it elsewhere?'

W ignored Icarus's heavy sarcasm and his gear cables twitched. 'Indeed. A bit like hydraulically diverting the weather. You know, they're already talking about seeding the sky with barley to deflect sunlight. And hanging a big green funnel off some satellites to divert rain to the Sahara for the camels. But nothing quite as convincing as a bicycle revolution. The world bike population already outnumbers cars by more than two to one. The revolution is underway!'

Such a prospect didn't lift Icarus's sense of foreboding either – a sense which was mirrored by the surrounding landscape as they climbed up the Romanche valley. Pylons loomed from the mist like aliens while craggy, forested mountains rose precipitously on either side of the road before disappearing out of sight into the sublime realms of Icarus's climate imagination. Increasingly severe and frequent weather events, rising seas, melting glaciers, altered patterns of ocean and air circulation, water and food shortages, mass migration? Icarus rubbed the gases in the air between her fingertips,

comparing this with the texture of the hourglass sand in her back pocket. This was the valley that time, weather and circumstance had forgotten, with its derelict buildings, worn-down villages in need of a lick of sunshine or paint, and the occasional derelict factory or hydro-electricity plant lining the road like skeletons of its industrial past. Icarus found herself thinking the bleakest thoughts yet:

> out of our house growing from
> the branches of a tree
> > we look alike because we grew
> from water

> > > i am even beginning
> > > to resemble myself:

> > if you were here we might talk
> > > i have 23,000 conversation
> > pieces ready *come!*

> i will share this bridge over a river
> of blood whose blood?

> > *The population had suffered a slow, but*
> > *certain, decline.*

> > *A museum had been provided for the*
> > *recuperation of health and town centres*
> > *deviated with fresh air; the municipality was*
> > *working hard flowering and cleaning.*

> our society was re-balanced upon the
> theatrical cantilevers of white coal

> > genetic structures spanning physical
> obstructions with the intention of passage which
> passage?

We are the masters. We are the slaves.
We are everywhere. We are nowhere.
We control the crimson rivers.

the bridge led to an apocalypse of angels:
 amateur eugenics for which I lay bound

– accused

I had adopted the foetal position of intellectual
inbreeding.

My eyes and hands had already been removed.

Their route offered little by way of emotional relief until they
entered the basin of the Bourg D'Oisans plain, where the sun briefly
made an appearance – intimidating Icarus even further with
glimpses of recently snow-dusted peaks far above. Up up up the
road kept climbing: up a gorge side, scaling the vertiginous dam face
of Lac Chambon, along the north shore of the reservoir before
following the receding icy white string of the Romanche river
increasingly steeply uphill. The entire scene was dominated by the
imposing black mountain bulk of La Meije, casting a snowy midday
shadow over them. By the time they reached the Alpine village of La
Grave, it was already four o'clock. They had made progress, but
slowly. And it was now decision time.

'Shall we just camp-up there, and complete the pass tomorrow?'
Icarus asked, pointing towards a campsite down by the river.

W blew some rust from his chain. 'But I thought you were the
adventuring type, Icarus. Contrariwise, *you've* as much courage as a
baby! Of course we're going to the col. Whyever not?'

Icarus looked up towards the col, down. In any circumstances
carrying on at this time of day was foolish, especially with snow still

falling on the surrounding mountains, let alone in her current emotional state. Yet W was right, stopping off early was a mimsier prospect than the waterlogged biscuits in her handlebar bag.

'It's our ideal chance to fly! My frame will never blister in this cold!'

Icarus groaned at W airing the question of flight once more, but nonetheless, she could feel her heartbeat beginning to rise, with the familiar release of adrenaline and temptation which in the past had so frequently undone her. Icarus checked herself – *no*! It wasn't going to happen like that this time around, after everything she had resolved over recent weeks. But her gut thought otherwise: *yes*, she could make it! *Yes*, she would show Zeus, and even more importantly her father, what she was made of. Now they'd got this high, of course W was right. He was a black eagle and her his trusty pilot. Why not?...'We're going down,' Icarus suddenly announced, her face white as snow, as she turned and freewheeled back downhill in a final attempt to save herself from her former self.

'What are you doing? Icarus? *Icarus!*'

However it was neither the pleading of W that changed Icarus's mind, nor the temptation of imminent flight.

'Not going to the col?' asked a curly dark-haired lad, as he cycled past with a friend. The boys were cycling the most rickety of bikes, wearing jeans and scruffy woollen jumpers, and carrying big rucksacks. 'Come on, join us!'

Icarus nodded, and smacked her forehead as if to say, *what a boojum, there I was about to cycle the wrong direction.* 'Of course!'

'Where are you going? We're going to Athens via Assisi!'

Icarus and W soon overtook the pilgrims, who waved them modestly on. Respect, modesty, humility, Icarus repeated, over and over. The last eleven kilometres to the col were the steepest yet, but Icarus worked hard to keep warm and as her optimistically-paced

attack on the summit began to take its toll, the gradient eased across an unlikely stretch of alpine meadow and the land began to level.

'Look!' W said pointing at some buildings up ahead. 'That must be the summit. You ready?'

'I'm ready for nothing but getting down before dark.' Nonetheless, Icarus couldn't help but kick-in for a final acceleration.

'This is the second highest I've ever been, but the first time with your flying skills...'

'But I DON'T HAVE special flying skills. It's all in the past. Surely you know that by now...' Yet Icarus could feel her feet twitching and her eyes were about to explode with excitement. She breathed slowly, out for three, in for three, and focussed directly on the small patch of road in front of W's wheel.

'We will see!'

Already, Icarus could feel W's frame lighten beneath her grip, while she revved on the handlebars, and her feet kicked harder and faster on the pedals. 'Oh no, W, no!'

'That's not what everybody else thinks,' W replied, as Icarus felt the pedals begin to spin and the air rush past.

'The Col du Lautaret, Altitude 2058m,' Icarus read, looking down at the sign marking the top of the pass from above. 'W, tell me we aren't flying?'

W wasn't going to tell her anything of the sort. Instead he swept a cloud from his line of vision with the breadth of his smiling handlebars and shouted, 'vorpal!'

Icarus's sight began to glaze over as ice particles froze her tears. She saw her future laid out in front of her: a postcard of the mountains under snow, the mourning of the invisible sheep bells, and her, Icarus, frozen, feathered into mist, and hungry for cinnamon.

changes at peripheries of vision
 slanted angles which i pin to my lapel
 inventing snow-light as a way of life?

 the touch of feathering –

 we scuff our heads through clouds
and sieve our rain drops out of dirt

the wind feels louder than the sun
and our moods spin blueness from grey

 we will fly higher through migration's
transitory sky – we'll touch the furthest sun

so we turn the dials of our hypotheses just so
 calibrated frequencies as altered skies
 enforcing shedding

If I take it as a motion into weightlessness –

 there is no way back but side-ways
 a way of thinking into wings

the global seedbank of our lives is buried
 in a vault cut into the rock at minus 6 degrees

 re-storing everything to nothing –

Climate change was a funny kind of thing, Icarus thought, just before she began to fall: a remembering things before they even happened. Then there was the most uncomfortable crash as her body collided at an unforgiving speed with the perma-frozen earth.

🜂

Perhaps inevitably, Icarus and W's second attempt at flight had proven as shortlived as it was inevitable. W's frame had taken a bit of a battering upon landing but his pride remained undented. 'I *knew* I could fly with the right companion! You may not have been my first choice of flight attendant. But with a few modifications to my prototype and some practice on *your* part, then a more sustained period of flight is certainly possible. In no time I will be able to launch bicycle-generators into the sky on a permanent basis!'

Icarus picked herself off the permafrost, dusted down her bruises. *You ok there?* she was sure she felt Lucy ask, with more compassion than the criticism which had met her landing outside Le Havre. But Icarus shook her head. She really wasn't. She was hungry. And cold. And miserable. She dug some of her sodden biscuits and every item of clothing from her handlebar bag. Pants = skull cap. Socks = mitts. Trousers = scarf. Biscuit dipped in chocolate = necessary.

'You look quite the pilot,' W said, sceptically, licking his bar-end to remove some biscuit from the corner of her lips.

'Why, W, *why*?' On the far side of the car park the two angelic pilgrims were sharing travel tales with the pretty assistant of a vending van. All three remained as oblivious to events across the other side of the col as she felt sickened by them.

But W's attention was already elsewhere. He pointed to a sign indicating the entrance to Joseph Fourier's botanical garden a short distance further on. 'Are those the polytunnels Fourier used to discover the greenhouse effect?'

When Icarus looked that way, she thought how it was one of those moments when a climate gardener should appear from thin air, raise his head from his rare alpines and reply, 'that is metaphorically correct,' in the long slow way in which dead people tend to speak. And it was one of those rare moments when he actually did.

'Are you crazy, cycling up to here today?' Fourier continued, elongating his vowels. But the hand that he held out for Icarus to shake was as real, solid and warm as earth.

The same couldn't be said of their descent. Icarus had been looking forward all day to freewheeling down after the efforts she had put in already that day. But there were no words to describe the coldness of their last twenty eight kilometres into Briançon. Her head and arms and legs and her bicycle wings became frozen stiff as an armoured Serre Chevalier knight on a cold metal horse.

it may make rope to climb a mountain
 the fibres gathering beneath
our shining nylon braids

 spinning individual yarns we twist
to strands we're twisting laid to rope

the countertwist of each successive
operation

 we seek a stable balance of ourselves:

 the left hand curve of S
 opposed by right hand Z

 forgetting why we set out
 in the first place

 were we the rope we made?

 understanding free fall sideways –
 stories strung together from the elements
of atmospheric change

 was it just another summit gained and all
the other mountains opening up to face us?

Next morning, when Icarus poked her head from the tent, the view from the Briançon campsite made her giddy. It had been practically dark when she had arrived and the surroundings had remained cloaked in cloud. But today mountains rose in all directions, as if lifted off the relief of the earth. Yesterday's near-disastrous events were hard to believe while the sun was looking down with such a smile. Had she got away with it? It was one of those mornings when neighbouring campers smile on their way past, wish you good day, clearly oblivious to the fact that, if the links between Icarus's story and climate change were as she feared – and the fate of Planet Earth was inextricably intertwined with the outcome of her quest – she had no less than risked human oblivion just the day before. It was one of those days whose unblemished sky opened out before you like the clean, double-page spread of a writing pad. Was Icarus being offered a second chance?

'The Col de l'Izoard?' W asked, his headset bolts glinting with dew. 'You did promise.'

Icarus had recklessly agreed the night before that if it was bad weather today they would travel into Italy via the easier Col du Montgenèvre. But if it was sunny? The next col south – the Col de l'Izoard. One of the most famous cycling passes of the Tour de France. An *hors catégorie* route: a road once considered impassable by car.

'20 kilometres, at an average 6% gradient,' W continued. 'A challenge any self-respecting cyclist couldn't refuse.'

'But we're already running late, W. I thought you didn't want any more detours?'

'It may be higher, but it's arguably more direct.'

Icarus groaned. Following W yesterday hadn't exactly proven an unmitigated success and the weather glass forecast wasn't encouraging. What did it say about her critique of hubris and her wish for greater humility to pit herself against the highest, hardest pass for miles? Yet there was no accounting for the temptation of the sun, of cycling above the middle path and not least demonstrating the stuff that She-Icarus was made of! Needless to say, soon Icarus found herself at the bottom of the Avenue Col de l'Izoard where a sign reading 'Itinéraire Partagé' warned cars to expect to share the road with bikes.

'Do I look carbon from this angle?' W asked, leaning his unmistakably aluminium form up against the sign for a photograph.

'Carbon neutral possibly,' Icarus laughed, looking her unlikely flying machine up and down – was he not the most ridiculous bicycle she'd ever had the pleasure to meet?

The hill behind Briançon offered a birds-eye view of its star-shaped citadel, constructed for Louis XIV, the Sun King, in the seventeenth century. 'If I were king of the sun I'd make it sunny every day and it would never rain and I'd drive a fire-drawn chariot across the sky like Helios!' Icarus exclaimed, before she could stop herself – as if pride really was hardwired into her, and humility hardwired out. When Icarus set off uphill again she wrapped the rays of sunshine around the fingers of her right hand as she went. By the time they had climbed above the treeline Icarus had woven a granny basket of the climate change tangle she had scribbled back in Orbec which she now allowed to slip from her fingers, letting the bundle fall to the road surface – the earth. So, perhaps more appropriately, Helios could keep his chariot, and she would keep her bicycle firmly earthed, if only Louis XIV and everyone else might ease their designs on the kingdom of the sun? She scrunched her face into the sunflower wrinkles of her tan. In reality, right this second, her legs were already aching and far from flying a chariot across the sky, from the sound of some heavy breathing behind her, she was about to be overtaken.

'Hallo. How much do you weigh?' a female German mountain biker asked, drawing alongside and weighing up the luggage packed on W's racks with her metallic wrap-round eyes as they wound round the prow of the hill together into the wooded Cerveyrette valley. 'You're going to the col?' the woman verified, wide-eyed, as if this was the craziest thing she could imagine on a laden bike.

'And you're doing...what?' Icarus replied, as the German bore casually left onto a precipice to bunny-hop her bicycle over the tree tops and drop off a thousand metre cliff face.

In fact the cycling proved easier than Icarus had feared; it didn't take them long at all to reach the halfway point of Cervières, a desolate, low-key cross-country skiing base. Icarus looked up at the steepening slopes ahead as a road cyclist sped towards them before pulling her cycling jersey over her head, stripping down to her skimpy black and pink triathlon suit in readiness to tackle the crux of the climb. She hadn't anticipated the loudest, 'Allez!' which the road cyclist cried out as he swept round the curve of the bridge, throwing a huge smile and a cheeky wink in her direction. So *that* was where she had been going wrong with the otherwise unfriendly French road cyclists, Icarus thought, puffing out her chest pragmatically and ignoring Lucy's plaintive pleas that Icarus might have some self-respect. Pure and simple, if Icarus wanted some encouragement up this mountain then she needed to do so scantily clad.

'An average gradient of 8% with 13 hairpin bends over 7 kilometres,' drawled W as the next French cyclist swept out of the first hairpin yelling a further, 'Allez!' with an Italian speed stallion on his tail crying, 'Bravo, bravo!' Icarus flapped the flies from her puce face. The sweat dripped from her chin, encrusting W's headset with salt as she tried to time her rests between the descending cyclists. Four hairpins, five. 'Allez!' Of course, I cycled straight to the top without stopping once, Icarus's smile implied, as she jumped back onto the salty saddle for the benefit of a further, 'bravo!' Six hairpins, seven, taking the inside corners wide and praying that nothing was coming the other way as they followed the Tour de France road graffiti letter by letter up the road:

!
Z
E
L
L
A

'! Zooming Exchange Leaves Loneliness Astern,' Icarus cried, creating a quick acrostic of the reversed message. 'You know W, for the first time all trip I feel like we're all in this together.'

'Me too,' W replied, puffing out his pumped down-tube. 'Those road bikes could never cycle a load like this up a hill this long – they just said so themselves.'

Above the forest they emerged in a broken desert landscape called La Casse Déserte. Scree runs studded with rock-contorted pinnacles dropped from rugged, barren peaks. 'Vite, vite!' cried a fat French man enjoying a sumptuous feast from the comfort of his campervan. 'Can you not go any faster?'

Icarus shot the man a withering smile, but accelerated anyway for the audience.

'I know our flight wasn't one-hundred percent successful yesterday, but you are willing to try again? Trial and error and all that?' W asked as they rounded the final bend.

Icarus laughed, and when she replied, 'no chance,' it was with such conviction and a final burst of acceleration that they had made it to the summit before W could catapult her anywhere. 'W, we've truly made it! And without having to fly at all. See I *am* a proper cyclist after all.'

But W wasn't listening, instead his mouth was already hanging open at the ranks of sparkling, high spec, ultra-lightweight bicycles parked up on the col. 'All ready to be ejected into the sky to power my climate revolution. Who'd have thought?'

'I'd like to see you try!' Icarus replied. The cycling camaraderie had only lasted until the summit, where a ten metre high trig point had phallically foreclosed all banter and the cyclists' machismo had promptly resurfaced.

♠

It proved surprisingly easy to convince W of cycling rather than flying down when he peered over the vertiginous lip of the col upon a landscape peppered by gypsum and dolomite stalagmites on which to become impaled. 'We could perhaps do with a *little* technological modification first,' he admitted. Instead they swept rapidly down the narrow, precipitous ribbon of road that wound

through the lunar landscape, down down down, in the direction of Italy. Icarus began to whistle out loud:

> A place of circus,
> lunar bristling hoodoos,
> remaining strong into erosions.
>
> I took the hairpins at speed.
> The outer rim of our penultimate corniche:
> steppes, forests, floral carpets.
>
> It's a broken desert,
> a counterpoint to our supposed descent:
>
> descants, filed.
>
> Razor-edged menhirs
> against the bluest thought of sky.

In contrast to the speed at which they were travelling, the niggle which interrupted Icarus's whistle began slowly. According to the Mappa Mundi, the road ahead descended all the way from here into Italy. But the further Icarus and W descended, the more obviously a mountain range kept growing straight ahead, blocking their way. 'It will all become clear when we round the corner,' Icarus insisted. But around the corner, and the further they kept descending, all they could see was in fact a bit more of the offending mountains. By the time they had reached an apparent valley bottom, Icarus's confidence in what she would see around the next corner had already been severely dented – and the road had just turned uphill. Icarus and W climbed up past the imposing silhouette of Fort Queyras, but beyond the Fort the road kept snaking back up into the mountains.

'This can't be right,' Icarus said, spreading the Mappa Mundi out on the verge. 'Look! There are no other mountain passes marked. There must be another way.' But ahead of them the valley closed in on them in all directions and a map on a local tourist board confirmed her worst fears.

'The Col d'Agnel,' W read slowly. 'So our gentle freewheel downhill into Italy ascends another 2744 metre col?'

It was as if Icarus's spine had been sucked from within. 'How could the cartographers miss that?' On the Mappa Mundi there was nothing – no picture, no contour lines, no place marker to indicate that one of the highest passes in the Alps in fact lay between her and Italy rather than the gentle descent she had anticipated. It was an utterly defeated Icarus who set off up the first hairpin bend and it took very little persuasion from W – an unlikely source of reason – for her to turn around.

'You'll never make it at this pace and above the first village there is nowhere to stay.'

The alternative route took them due south towards the town of Guillestre, which was in fact only thirty kilometres from Briançon via the direct valley route, and three hundred and fifty metres lower. Meanwhile the road from *there* into Italy crossed a further *two* Alpine passes, albeit lower than the Col d'Agnel. The logistics made Icarus's head spin. The landscape was spectacular – the road weaved a cantilevered route between limestone cliffs and the rapids of the river – but Icarus was in no mood for admiring scenery.

'Never mind *rewriting* my story,' she cried. 'My story's just gone and broken, W. Bang, out like a candle at altitude. I've nothing left to give, *nothing.*' If the last three days in the Alps had been a test of her survival skills, the chance to prove herself, then she had just failed spectacularly. Icarus could do little about the tears burning her eyes, nor the guttural roar that sprung from her lungs. Only halfway through the Alps, and a broken woman. Day eleven of France – a

day beyond her most pessimistic predictions, and just her and a bloody-minded talking bicycle whom she had allowed to persuade her into some of the most stupid decisions she had taken all trip, if not in her entire, reincarnated lifetime. If there really was anything in the parallels between her story and climate change then the human race was for it...she reached into her back pocket and threw a good handful of hourglass sand into the verge just for the hell of it.

It was already 5pm when they reached Guillestre. Setting off up the first of the two cols between there and Italy – the Col de Vars – was foolish at this time of night, but she knew she'd never find the will to cycle out of the Alps if she didn't try.

'Where do you think you're going, and at this hour?' called out a stringily muscled gnome who was descending from the col on a recumbent bicycle as they climbed the first bend.

Meanwhile the young woman in the first small village said that she had lived in this valley her whole life, and never *seen* a campsite. 'But that doesn't mean there *isn't* one. You know how it is.'

So far Icarus had avoided camping rough for fear of marauding Ford Cortinas. There couldn't have been a safer place than here in which to *try* it though, Icarus thought, hopping off W to explore – there was little traffic, and the valley was sparsely populated. However some lovers had already commandeered the first spot Icarus investigated, while the highest village in the valley – the boarded up ski resort of Les Claux – was built of so much concrete that they'd have never banged their tent pegs in. Up and up and up Icarus and W climbed. In fact Icarus had been so busy worrying that she had almost cycled to the top of the Col de Vars without noticing her exhausted legs. By the time she took stock they had already spun back uphill to almost two thousand metres where a small lake

nestled into the valley just beneath the col. It was as idyllic a spot for camping as they were likely to find, Icarus was just supposing when W exclaimed, 'or how about there?'

Icarus couldn't believe it. REFUGE DE NAPOLÉON read the large red lettering on the front of a substantial chalet edifice on the far side of the lake. It was one of six Napoleon had built to thank locals for their assistance on his escape from Elba with the purpose of rescuing lost and weary mountain travellers caught out by night.

Napoléon himself was manning reception. 'I've heard about you,' he muttered through a trim moustache. 'You're leading the climate change revolution, aren't you?'

Icarus adopted the comradely stance of her revolutionary bicycle as best she could. 'Yes, yes, I think am,' she said as Napoleon led W into a big dry shed and Icarus up to an empty dorm.

'I will send someone to make the bed,' Napoleon said, closing the door gently behind him, having just charged half the going rate.

Next morning, Icarus lay for a good half hour in the early morning light feeling mainly humbled. A spider roamed the corner of the room, enjoying the dusty peace of a cross-country skiing resort in summer. Icarus realised she had underestimated the mountains – *badly* – and if *mountains* required this much humility, then how much was required by climate change?

At breakfast Napoléon bowed his head towards Icarus with a supercilious politeness. 'Pain, café?'

'Pain café,' Icarus agreed. *Sixty battles fought, six million Europeans dead, nothing learnt which he did not know at the beginning and an afterlife of penance?* she thought, reading the contours of Napoléon's thoughts on his untroubled forehead, before turning to look at the view outside. Penance? What penance?

Having collected W it only took ten minutes to reach the Col de Vars where Icarus leant up against the summit cross. 'I promise never to underestimate the mountains, or the earth, again,' she said quietly, with a piety she had not exhibited in twenty centuries, before removing her weather glass from her bags for a final French reading. 'You know W - it was right yesterday. It might not have predicted the *weather* correctly but it did predict the disastrous nature of our metaphoric fate. I really think it's trying to say something to us. But I just can't work out *what...*'

Icarus ignored W's matter-of-fact snort and stared intently into the water as it bubbled up the spout – *storm* – then fell – *calm* – before settling to an equilibrium in the main body of the glass. Over the course of France Icarus had come to dismiss the weather glass's powers. But as they neared the border into Italy and she remained no closer to having built a stronger case for her conclusions about climate change...might the device come to her rescue after all? 'What really are your powers? What do you want from me?' she asked the glass. Silence. It just spun circles in the sun, twirling a blue ray of reflected light upon the surrounding world.

'Come on. It's just faulty – magnetic variation or something. You won't make that fact any less real by *talking* to it.'

Icarus had just been emptying it as W proposed when she stopped. 'But hey, W, wait a minute, I've had an idea.' She ignored the face W pulled at *that* thought, while holding the weather glass out at arm's length. First she focussed its ray of light upon the cross at the head of the col, and the cross began to pray for climate change. Then she shone it on W, who sparkled like a scientific discovery, while the spokes of his wheels spun around the French love of bicycles, as if this were simply the only way to go from here:

'You've got to look at this!' Icarus exclaimed.

W proved unwilling, but when he did he drew his tyre pressure in sharply. 'Wow. It's like viewing the world from the perspective of the sky.'

Icarus removed her single novel from her bag and held it before her. *Through the Looking Glass. Through the Weather Glass.* Had she been so busy staring at the reflection in the glass that she had failed

to read its invitation *through* – into the world climate changing world beyond? She'd been so busy looking *at* their reflection in the weather that she'd failed to take the leap of imagination to journey *into* it – to *participate* in it the way that she'd long proposed! No, there would be no need for legislation if she were right about this. No need for prayer or nomadic missions. If you experienced the world from the perspective of the sky then humility and respect might simply flow from there. And this her own chance to embark upon an adventure to equal only Alice's? Things had just started getting betterer and betterer.

> biogas biomass bottled gas cabin class channel bass cocktail glass come to pass demitasse dressing glass fiberglass forward pass gallowglass gravitas hallowmas hippocras isinglass laughing gas lemongrass looking glass loveland pass lower class master class middle class montparnasse opera glass outlet pass overclass overpass plexiglas rogers pass ruby glass safety glass sassafras second class shovel pass solar mass solemn mass superclass tourist class underclass underpass upper class votive mass water glass weather glass working class yes weather glass at last at last

This area of France marked the border between the High Alps and the lower Provençal mountains. Grassy hillsides grew to over two thousand metres before giving way to scree and the distinctive horizontal bands of flysch that spiralled towards the snow-free summits. But Icarus's hopes that they might retain some altitude between the Col de Vars and the Col de Larche were soon dashed. The road swept down wide S-shaped curves, past the small village of Saint-Pierre-sur-Ubaye, before following the river downstream

into an open-sided tunnel which shot the frames of Icarus's climate rite of passage.

'So, the weather glass is telling us to *fly* into climate change, through the surface of its lens?' W asked, opportunistically, causing Icarus to chortle.

But maybe he was right. Her ideas, and imagination, really did need to take flight, and wasn't this a different kind of flight than *anything* she had imagined or realised before?

'We could be the letter X you laid upon my wheels in Amboise. Remember? The place where my scientific genius and your imagination meet – mid-air!'

Icarus drew the mountain air deep into her lungs. Right enough, cycling through this world hadn't got her any place fast. Ready? All of a sudden Icarus was as ready as she had ever been, for anything. For once there was none of the pounding heart-rate that usually accompanied her temptation into flight. She felt calmer than ever. This was a chance to change the nature of her own story more thoroughly than she had ever conceived possible, and you never knew, perhaps she really could take the fate of humanity with her. Surely Zeus and Daedalus – Apollo even – couldn't help but be impressed with this.

Over the years the Col de Larche area had been a popular place for making battle. The area had changed hands between France, Italy and the Savoy seventeen times between the seventh and seventeenth centuries and ruined fortifications dotted the surrounding hilltops from the time of the Second World War. Today the pass itself had just been re-opened by a sixteenth century French army attempting to outflank the Swiss who were busy guarding the northerly Col de

Montgenèvre, W informed Icarus as they steadily traced their trail up the mountain, not stopping until the first village bakery.

'Buon jour,' said the curly haired baker in the strongest hybrid Italian-French accent, dusting the flour from his apron. 'Ah, you are a cyclist. You will want apple pie!'

'Why, thank you. But I was hoping for biscuit,' Icarus replied.

'But this the best apple pie in the Alps! This apple pie make you cycle miles and miles. I a cyclist. I always eat apple pie! Army eat apple pie. I eat apple pie. You eat apple pie.'

Icarus really wasn't in the mood for grammatically declining all possibilities of apple pie eating and in the absence of any biscuits on offer – even apple-flavoured ones – she pointed at a pastry.

'So where you cycle today? Italy? I from Italy. But I sell more apple pie in France.'

Outside again, Icarus watched a rearguard French army division of car tyre and plant pot men march upon the col as she ate her apple-flavoured custard pastry. The day had suddenly acquired a magical aura, so when Icarus held her weather glass up to the army she was unsurprised that the device turned every single soldier into a messenger for climate change, marching the weather towards the col in all manner of curious attitudes: coming very slowly, skipping up and down and wriggling like an eel, or with their hands spread out on either side like fans. As Icarus knew only too well, the right way to begin with the messengers would have been to say, 'how d'you do?' But she felt they'd already got beyond that, somehow.

The Larche valley was mainly wooded, with narrow ridges and pleated rockfaces climbing to the surrounding peaks, but the gradients were relaxed, and Icarus and W made fast progress.

'Only two more bends to go,' W said, on this occasion causing Icarus not to accelerate but instead to draw to a stop and lay W down upon the verge where she removed both the weather glass and *Through the Looking Glass* from her bags.

'Will you let me read you a story, W?' she asked.

W looked uncertain but Icarus continued heedlessly. First she refilled the weather glass before directing its blue ray of light upon the words of the Lewis Carroll story that she knew so well:

> *Oh, W, how nice it would be if we could only get through into Weather-glass world! I'm sure it's got, oh! such beautiful things in it! Let's pretend there's a way of getting through into it, somehow W. Let's pretend the glass has got all soft like gauze, so that we can get through. Why, it's turning into a soft mist now, I declare! It'll be easy enough to get through…*

When Icarus had finished W drew his breath between his spokes. 'But if the looking glass caused everything to work backwards, then how will climate change alter weather glass world?'

'Exactly, W, exactly! I guess this is what we are about to find out.'

'Well I'd guess it's pretty complex…'

'And big too.'

'In time and scale.'

'Wicked?'

W groaned. 'Oh, ok, I suppose so.'

'This will be interesting.'

W shuffled his tyres before his face fell into a frown. 'I never thought I'd find myself saying this, Icarus. You were right, you *are* an evolutionary aberration – but one verging on genius!'

Icarus blushed with pleasure. 'Oh, W, I wouldn't go that far. But it's not going to be easy, you know. I've a feeling we're going to need a sense of humour in there. Ready to hitch your scientific knowledge to the quest?'

'You bet!'

The col itself was just a vast, scrappy car-park, with a boarded-up refuge to French-Italian peace. Icarus and W were posing for a photo before the sign marked Italia when a voice behind them called out,

'You get everywhere you do!' It was only the most famous Italian cyclist of all time, Fausto Coppi, who had wandered uphill from Italy to say hello. 'I saw you yesterday on the Col de l'Izoard, smiling so much you'd have thought you'd crossed the Alps already. So I hear from the bicycles that today you finally take flight?'

Icarus looked at W, who had already shrunk into his frame.

'Well I have one piece of advice for you, young Icarus,' Coppi said, before he started shouting, 'RIDE YOUR BIKE RIDE YOUR BIKE RIDE YOUR BIKE!' The order began slowly and quietly, but every time Coppi repeated his dictat he spoke faster and louder and higher until Icarus had no choice but to head towards the other side of the col for a run-up before her eardrums burst.

'I suggest you close your eyes, W,' Icarus shouted above the din as she once more removed the weather glass from her panniers, slowly refilled the vial with the blue water, and focussed the blue ray of light first on her, then on W, then on *Through the Looking Glass*, before putting the book away and turning it upon the climate itself. The first few turns of the pedals were wobbly as she balanced one-handed. Yet they had soon gained sufficient momentum that she could steady herself on W, steady her eyes on the weather glass, and focus on the world beyond as she propelled her imagination towards the horizon of Italy.

Icarus could never quite make it out afterwards, how it was that they began. All she remembered was: they were cycling hand in hand and W went so fast that it was all she could do to keep up with

him, and still W kept crying 'Faster!' Icarus felt she could *go* no faster, though she had no breath left to say. The most curious part of the thing was, that the mountains and the lake never changed their places at all, however fast they went.

ride your bike!
humble stories
imagining playful
presents making do
as if performing
the imaginative real
of the pragmatic present
tense. We opened to experiment of change
what if the moving forwards betters
the sense of humour found in
our confronting death?
the compassion of
flexibility as a form
of easing into open chaos

and so plurally full
of doing becoming
ways of knowing
or accepting
our endurance
of ongoing change
improvising into

Part 4: The Flight

one thing was unequivocal

 flying my imagination into
a warming climate was nothing like
having my face washed by an old cat

 as is now observationally evident
language could have had no hand in the mischief

 it was the weather's fault entirely

we swept downhill
 taking the history of flight by its ear
 dragging the average decline
 in snowcover across europe
like a verge-side weed

the sun was stronger than the valley
which lay quite still

no doubt thinking
that the melting
of the snow was for its good

and while the clouds had been up
in the sky talking to themselves
the mountains had been having
a grand game of contours with the turbulence
of the roads

rolling them up and down until
they all came undone in knots and tangles
running after their own tails

the sky surface of italy was rutted
the first small settlement of
argentera had gone without dinner

did the palliative snow once love this valley
and the population decline of a single woman
bent double as the wind?

so many questions for the well-kempt
belltowers peeling the long term trends of

la stura di demonte
l'enciastraia
monte oserot

i took several further hairpins
of the sky at speed
gathering momentum
as the temperature increased

and what do i have to say for myself?

The globe is widespread and real.
My first fault is greater at northern altitudes.
My pretend identity warmed faster than oceans.

i won't make any more excuses
 three faults of literary warming
 and until the wind changes
i've not been punished for any of them

🜔

it did not take me long to learn
that italy was long as making haste
and rising water

 it was one of those afternoons when
very pretty coffee filled my head with thoughts
of cornmeal biscuits the colour of the sun

 the baker smiled
 he had never seen anybody look stupider

 perhaps my optimism became me:

 do you know what tomorrow is?

 through the climate there is little
geographical balance in the literature
and a bigger scale

 if i couldn't see this thing called
climate change

 then how could i hold it up
to the weather glass and measure it?

the quest had barely yet begun
and the future was already getting to me

 where did all these people
come from and how to answer everything they ask?

 the man's questions displayed some sense
but the effects of temperature

 parli italiano? parlez français?
 but you do not speak them well

 the climate does not like being
 criticised much beyond the scientific consensus
 of two degrees
 and nor do i

 when we speak we all begin
 together
 (it was more dangerous to hold
 my heat-resistant tongue)

that morning i wore the surface
spray up close as a tide

if flying is a bit like falling water
then mortality is global averaged rain

to go anywhere is to be coming
just like a sonnet or a knot

floating through the circulation
in the most natural of ways

buongiorno cried some seagulls
as they took the plain uphill

buonasera i replied *you'll be gone for hours
and already running late*

was i travelling through the
wrong clouds of the wrong
house of the more wrong sky?

most roads come undone if you travel far enough
precipitation tumbles downhill mainly

🔻

in the end the fresh air made the sunshine

i said *let's pretend the mountains
are our heavens and us the shepherds
you can be just one and i'll be all the rest*

i could not travel any faster than
the temperature for everything moved with me

the bottom row of tunnels ate the train

while the road skimmed through the air on ninety
foot stiletto heels

everything was as it never was
 generally getting somewhere else
and all the running you can do to keep imagination
in its place

two farmers banged their fists upon a table
when i sketched my homing pidgin route
 upon the hills

i've known hills compared with
which you'd call those hills a valley!

understanding is alternative to pleasantry
 if landscapes lack in beer and laughter
then the only answer is to run

the winner of the mountains was the glossy
mirrored surface of the sea

(i thought
sunbathing is ridiculous in whatever language
one considers it)

i turned my focus to reflection
 our emissions never ceased
 from rising
and no way of guessing

(everything was about to get a
little hotter)

to sleep will cost a thousand pounds
a minute

take a labyrinth of feral creatures
trapped between a

railway
road
and sea

i stood
silent

for some time

such atmospheric concentration
i had never thought possible
and no big stick to brush it all away

people filled the world
there wasn't even room for one

it was so dusty and so hot
i thought
i'll go the other way

contempt resents a solitary traveller
their displaced air

i wore a front of all the silent eyes
that accused me from the dark

what was i supposed to have done?

to feel alone is to be alone

perhaps i had begun all wrong
i should have bought excuses
from the past one thousand years

the sunset sank into the polluted
absence of the near horizon

(self-pity is no comfort to a greenhouse
century – history will barely glance at *you*
and that's some comfort)

there was no use in speaking
it was best if i said nothing at all

i had read about the winding incoherence
that is genoa

figure spm.4 as the nearest thing to hand

the entangled symbolism melted
as i touched it

sifting worries through the traffic
wearing out my exhaustion
like a bloodsucking gnat

the sleazy port was nervous
of not being liked or being restricted to the brain
compartment where people talk

the street of seedy one-star hotels was lost
and crawling at my feet for bread and butter

to ignore climate change
is to simulate carelessly

what does an idealist live on?
sap and sawdust
go on with the list

the piers had sawed their share of water
from shipbuilding and steelworks and revolutions
of greenhouse gases cut to the size of world war two

the sopraelevata motorway included
deforestation and supposing the fake pirate ship
couldn't find the sea?

then it would die of course

a driver who'd been trailing me
wound down his window
to let me see the lowered hand
of hubris that kept causing
the melancholy increase

undoubtedly there was more
to him than the anatomy of what i did not choose
to see

the wood had melted with the risk
of heatwaves and nothing but the traffic lights to go

so the weather glass was just a pair of edging
scissors and the earth our vast collage?

 then i was glad i didn't lose
 the riviera del levante

 any other coast
 would almost certainly have been far uglier

 rocky scrubby mountains rose steeply
from the turquoise sea
 just like the adverts

 but let's pretend we lost the rich!

it's a comfort to be scenic
if you can remember just in time

 i have discovered my naivety
 now who am i?

the time was easier to answer
 i doubled it up and then i stopped it short

 i will never forget my photo
 of camogli's church the fort
 the pastel villas and the sea

 what's your definition of a pirate?
 are mermaids made of tortoise shell?
 is salt still little and rough?

liguria had been a popular place for thoughts
but they hadn't been made for looking at
for nothing

 the weather glass had just been cutting
 cutting
 cutting

and my wings were already bleeding
at the quick

the sky had been bunched up beyond
rapallo and the bay of silence wouldn't speak

 the long slow climb to the pass
was in no way tired despite itself

 lactic mitigation is a sustainable form
of poetry
 if it's good enough for the view!

 forza! dove stai andando?
 would you tell me which road leads
to the distant wood of sleep?

 i dreamt a fruit terrace larger than a hand
to each never a word said perfect seclusion fully clothed

 heavy limbs through doubt
when my head closed the mountain darkness
with such solitude so thick and fast

 before morning walked on absence low as forgotten
 small scale scenarios / the time has come

to talk of many things like sky and trees and mist

it was so kind
of quite so many bicycles
to come and fly with me that sunday morning
in every multi-coloured shape and size

ciao!

mid-way between
hello and goodbye

the bars at the right of the figure
indicate best the little story

still
my classical past
remained an observational constraint
voyaging towards a very modern end

la spezia curved towards the bay of poets
like a mechanical umbrella

a radiative forcing to an identikit of paradise

if the ascent of selfishness springs
from wonder choking with passion

then the romance of not being lost lays its hand
on your arm and offers you a soothing castle?

come along now!

you won't make yourself a bit more real
by crying over modernity

sea level rise
is a species of futurism
compressing space and time
into a tall red temperature

but there won't be a fountain left
standing before i buy some water from
the shop with the self-satisfied smile

if nothing is coming then you must return
immediately with your hands filled up with things

elsewhere is always on the shelf above
the one you're looking at

(michelangelo's adam is an obscene version
of what's to be expected)

i'd already come to think of the sky
as a kind of miracle

the uppermost limit

of our architecture
 the pinnacle of rise
 everything was crooked
 but we did as best we could

 3.9 degrees of change suspended us
to the beginning of the line

 so the leaning tower of pisa
 had not blown away

 may i put your tourists a bit more straight for you?
which miracle would you choose?

 Greenland should have a lady's maid.
 I'd like to get beyond the inevitability of pleasure.
 Antarctic ice flow is hired at the rate of very good jam.

the effect of living simultaneously makes one
a little giddy at first bearing in mind the hundred year
linear trajectory of talking demurely

 what kinds of things do i remember best?
 things that happened and some aspects of extremes

so if the law of sheep is the ultimate restraint
holding humankind in place on earth

 then no matter how i rubbed my eyes
i could make no more of gravity than the sky's the limit

 galileo dropped two pigeons:
 neither pigeon died

 there is something very queer about laughing
during climate change

 the joke gets stuck in it
 and won't come out no matter how you try

 ◈

but where is tuscany?
 en route i said
 wishing i could manage to be glad

 what if it were overrun
 by tourists like a storm?

 yet tuscany took the measure of my eyes
 scale and timing captured
 in a sudden transport of delight

 the rolling hills were barely capable
of so little as gliding on

light chiselled into ridges
 some feudal villages projected over hilltops

 i had never
 quite believed
 in this much beauty

all at once

 but i'll never forget the shrieking battery
of chickens and the sudden smell of terror that hung
above the terracotta ribbon of the winding tuscan road

i said
i did not put them there and i cannot take them away

 i had come this far
 and it was this early
 and if i thought about the world enough i might not cry

 ♠

so what mattered if san gimignano gained
its beauty at the moment that it changed its mind?

 the most scenic temperature of a jagged
silhouetted skyline is not hurt so carry on cutting
 now what do you want to buy?

 queuing is a means of saving money
 scarcity – a museum of the impact
of the local population's average height

 but where is george?
 has anybody seen george?

george was everywhere
 his calf-length confidence pulled up
to the bottom of his chino shorts

 getting larger and larger
 and more and more human
 according to the best estimate
 of the likely ranges of

it surely can't be anybody else

the overall ethos of my journey is populated
with something not at all like conversation

 i enjoyed san gimignano and its crooked hands
 curative powers are so much
 prettier than many people

the more you walk towards renaissance arches
the farther that the guidebook view recedes

it's my turn to choose a subject
so here's a question for you

 how does a bird regain its balance
 when it takes a corner fast
 and loses grip upon the air?
 wrong! if i'd meant that i'd have said it

 i fell as far as i beg your pardon
but twice as quick

at least you're here to sand the edges
from my dented pride

if only i knew which was neck
and which was waist
have you noticed anything unusual?

(if nature had two eyes
and a nose in the middle
and a mouth right under
that would be some help
but it wouldn't *look* so nice)

the impacts of a subject will be realised if you cross
your knees and clasp your hands around them

the uncomfortable stories of our age can't help
but growing older

there was no ideal way to navigate
siena's labyrinthine red-brick streets
and nothing could steal the bareback horse race
from the scalloped square

but where certainty is conservative
then capitalism will try and price
the warming air

to stabilise the atmosphere is to pay it extra
the question is, which gas is to be master?

the question's whether gases can ever mean
such different things

the duomo's penitential labyrinth

is a polychromic adaptive capacity

to escape is to go round and round
and to smile is to find holes in things

(god i wasn't sure about
perhaps it's short for home
meaning we'd lost our way you know)

who's been repeating all this hard stuff to you?

I read about the sun in a book.
The air is a knock-down argument.
I can even draw you storms that look like statues.

i never wished to conclude my flight
through tuscany

le crete senesi was a poor bleak field
of hills once under water

such sub-optimal delight yet cultivated
with a sharper eye than most

utopias come in twos and threes
umbria is calling me and i must go

but thank you for this environment
of pen and ink and calcium carbonate
re-imposing itself

the tuscan hills are naked
insensible to having been put out
the minimalist interjections of a temper

in retrospect
i've often wondered
if we meant to set the sky on fire

 the lago trasimeno sun became
 more extraordinary with every moment
 even the endorheic lake felt faint

 see a young boy
 mirroring
 a heron fishing?

the kindly man who spoke to me
had a white beard
and a fat belly
but no horn to distinguish him from a unicorn

 are you not lonely?

 i looked around and nodded

 only when i'm not alone

 a day to come and another one to go

 the heron and the boy continued fishing
 the greenhouse gases turned my gaze to stone

 the orange black and purple of the sunset
 were getting on together like a house on fire

 when i deposited the day into the lake
 i was very much surprised it took it
 quite so quietly

 now you understand the way things
 happen here why don't you scream?

 i held my hands to my ears before
 the increase had already been and gone

 what would be the use of having it all over?

 ♦

 i'd come to think the bicycle
 a work of evolutionary genius

 the only problems with denaturing
 were the wheels
 the head was high enough already

 invention has a taste
 of morning cappuccino and chocolate cake
 the great art is to keep your balance

 (if cappuccinos were created
 for our own amusement then
 i really ought to listen to them)

 if you want to get to somewhere else
 then you must eat more cake and

double up on coffee

 i sat down on the saddle and said thank you
 rather sadly

there had already been so many views
and my eyes kept getting loaded

 umbria was a landscape without corners

 wooded hillsides
 angled ridges
 hilltop villages

 carving out our share of climate
 as a means of lifting off the surface of
 the earth

 just look at all those medieval
 houses
 falling over

 but there cannot be a use for
 waterfalls whose water's fallen out

 if you believe in landscapes they'll believe in you
 is this not a bargain?

no! cried a woman
 stop! exclaimed a man

 rushing over before i took
 the highway to the sun

 roads join on

as large as life and twice as natural

they won the conversation easily

 i couldn't get a word in
 to avoid the quarrel going on

so i flew above the world
from the perspective of the trees

 DUX read the plantation
 on mount janus
 looking that way this way that

 if diversity is to be your light
 then realign it, come!

 i was just coming to that
 now follow me

 if democracy is very long
 then liberty is tired

poetry is beautiful in theory
(in practice it is fallacy)

glacier run-off trickled from
the slopes of twenty million
years of mountain

i was more frightened for my own
anxiety than for the mountains

the future faces forwards to the light
the past quite dazzled me with shadows

the abruzzan mountains listened in a half-dream
to the melancholy music but the tune was not
its own invention

not a single species
not a single Mussolini

not a single chamois mattered
in the slightest

and while i'm on the theme of death
the toll of l'aquila was distributed
unevenly

the bleak mall didn't care one
bit for the homeless man who barely dared
to beg and the eagles had deserted us

life goes on from day to day with
suspicious regard

what d'you think you're doing here?

(getting a little fatter)

an earthquake's
no design of governance
to keep the world from rust

 even high adaptive worlds
are vulnerable

 a natural disaster
 is both everything and nothing
 about the shimmering prosecco bar
 that's thriving in the broken square

 the soldiers turned their guns towards
 me and instructed me to leave

 pride has been known to refuse assistance
but if everyone obeyed that rule

 thank you for coming all this way
 you have not cried as much as i expected

i'd never seen shame manifest itself
with such a frown

 🔥

that night there was no place to stay
where i was no guest

 italy is a difficult temper mitigated
only by a little kindness

 it means so well
 but has been known to say
 such foolish things

but not even the price of carbon
could account for this man's loss in temper

why pursue an argument
when you are found fault with all the time?

where have you come from?
that's impossible!

where are you going?
wrong!

what on earth are you doing out here alone?

his questions cut as deep into
my confidence as the fast-approaching night

there were many enemies after me no doubt
the world is full of them
no use trying to help me

if i'm not fully woman
and not fully servant
then wherever the moment took me
and as fast as possible?

courage is a constraint
as much as an opportunity

i thought

i came to punish the fish but i can barely even
remember my own name

always getting closer to the end
that was no end and cutting cutting
 my sweat had begun to cut into my skin

 a deciduous gorge of transport
curved around the foothills to the sea

 if the micro wind turbines had spoken
what might they have said?

 building codes / certification
 / are you deaf?

 the stop signs had been eaten
by fossil fuels and snails

 a young boy straddled his mother's moped
with an upraised finger and a sneer

 but it isn't etiquette to mitigate anyone
 you've not been introduced to yet

 the air cut up the space
beneath the motorway with a blade of warm sea wind

i refused an introduction to the adriatic
or i'd never get the chance to swim

 i ran into the water without looking
 blending into the surface of a net

the youthful lifeguard didn't pause from staring –
 but then sex fits nicely on a gutting table

 where did you say you'd come from
 and carrying all that muscle?

 i tried to submit to mitigation
 with good grace but it did *push* so

 it surely isn't possible that womankind
 has come that far!

 every poem is a variation
on the exploited shortages of fish in some way
 you cannot disagree with that

further down the coast some stilted fishing
platforms – trabocco – hemmed the adriatic sea

 flotsam and jetsam
 acquiring the shape
 of prawns
 sitting up a bit more stiffly

 and curtseying while thinking

(it saves time remember)

cars sold vulnerabilities from open boots

honesty won't be long
 you can make believe another fifteen hundred years

what's the matter with the future?

 it had once again been flooding pakistan

 one good pull and the environment
comes crashing down together in a heap of lies

in the dawn ferment
everything including the sea was turned
 the other way

 waves smashed against the sky like winter
 there was evidence of the increasing
vulnerability of minority groups like the verge bamboo

it took the wind to upturn everything i knew
balance was no longer even true
of the ballast of books

we were flying hand in hand
and the wind was going so fast

i could not travel any faster
though i did not have the breath to say

certainly fast progress is a loss of better
understanding than the one i leave
behind

change runs so fast you'll as likely
catch a virus or a temperature

all destinations are too near or far
or too off-route or too against the wind
and the italian cyclists were simply far too patronising

if they ask me if i liked
my stay i will say i liked it well enough

only it was so windy
and so hot
and the white horses
and white elephants did tease so

i elevated both my wings and curtseyed coughed
then sat upon the tails of arrogance and pride
until both turned to water

but you will never overcome
the beauty of change
 let us not pretend it ever
 might be otherwise

the puglian sky was bigger
than my imagination
and decorated with cotton wool puffs made of paper

 the gargano peninsula grew mountains
 the polytunnels were spreading
and the wind turbines continued making wind

 the marginal smallholdings had lost ground
and the esso garage was like an advert pulled into
the far horizon

 the 1950s bar was located in an unshaded area
of the graph where the end of nowhere is a baseline
scenario characterised by a chained-up dog

 it had big eyes but it did
 not seem a bit frightened

 i identified three reasons for concern:

 my exhaustion had crept up on me with
 a sweet voice /
 the dog was eating metal /
 i wish i knew nothing just now

 the more precise identification
of the circumstances that make things vulnerable

 the tavoliere landscape had already opened
up around me and was running out of water

a patchwork quilt of goats and mozzarella buffalo
and stubbled wheat and putrefacting fruit

 i had run against the world before i could begin
to stop myself

we paused
we breathed

we took in a load of oxygen
and inhaled it from a site located near the adriatic sea

giuseppe wasn't sure about the internet
though he did know of a bar

 the bar-dog raised one eye and said

 life would have been far preferable
 without the music from the fruit machine
 but you must sit in both if you buy two

he pointed at the empty chairs around

the out-of-season bar

 to search for the internet
is to underestimate the clouds' capacity for useless
information / gossip / facts:

the messenger's in prison being punished and
the trial of warming will begin next wednesday
and the crime comes last of all!

 the hangover from summer is crooked
and all over pins
 may i put your decade a little straighter for you?

 what was most provoking was the wifi
equilibrium travelling up and out the ceiling

 ♠

the wind kept sweeping us due south
 everything became a target
from the moment i approached

 swathes of undrained swamp
 orthogonal embankments
 channelled basins

 six million tons of salt
is harvested per year
but where are all the birds?

 the sky was spacious
 i failed to see flamingos
 even though i really tried

 the smallholdings had received
a delivery of tubing (there is something

very odd about potatoes)

these didn't sound like thoughts that needed
any answer so i pulled away said nothing

even real salt only lasts a very little while
and these being dreamsalts melted quickly
just like snow

♦

so the macro-economic costs of adaptation
rise with the stringency of facing
backwards forwards simultaneously?

(i'd rather see that done on paper)

the SUN FUN MALIBU beach park
looked a little queer whichever way i held it up
but trani had been done alright

the cobbled jewish quarter led
towards the medieval port where some old men
sat outside a café playing cards

(culture is catastrophic to outsiders
but what does impenetrability mean?)

the local boys had the eyes of gangsters
blocking up the wrong gate out of town

beyond bari lay a semi-rural idyll
formed of olive trees and peach and almond groves

i found the local prostitutes – sitting reading

where do you want to be

and can i really help you?

it is very likely
that the hand crooked in her waist
was for the bandersnatch

 hot days and nights and passing cars
 you don't spell prostitute with a double o

 i made a memorandum
 of her directions
 to the motorway

 smiled (no longer feeling lost)
 and headed elsewhere

sleep won't fall into your hands
 you must get it for yourself

the world is very long and dark towards the end
and the sky receded the closer that i came

hope is a memory that works both ways

self-belief remembers things
before they happen and it's a sorry
melancholia that operates backwards

(i'm becoming harsh on us but perhaps that's
part of it)

♦

trulli are the shape of ancient breasts (for living in)
some are whitewashed some not but all of them
were built from limestone and wax

to wander is a loss of tourists
to be practical is a severe tone
to be playful is to loll about town like that

i stood before an arched doorway marked
ICARUS in the red and yellow colours of the sun

to answer the door?
what's it been asking of?

advances show that discernible human
influences extend beyond average temperature
since conquered by any empire worth their salt

The Ostrogoths know very well that they're not real.
The Byzantine empire contributed to the sea.
The Saracens began to cry.
The Bourbons seemed so ridiculous.
I hope you don't suppose those real biscuits?

monocrop plantations lined the verge-side
all the way into brindisi

salentese ncuria is resistance to new ideas
 caught up in the slatted netting curtains

please tell me your name and your business
 my name is icarus but whatever does it mean?

can you take flight
from a state
of already having long since
taken flight?

 was everything about to cut yet hotter?

 the embarkation zone looked sulky
 the scenarios report accelerated
up the ferry planks onboard

 where do you want me?
 oh anywhere i really do not care

a bit experimental one man said
 too mainstream said another

adjusting the angle of his hands upon
his jutting hips

 an experiment in a fossil fuel free for all
 watch the aeroplanes take off into the sunset

 there was something
 not quite right

 if temperatures are relative to burning wings
 then what do you have to say about grace?

take care of yourself the circulation said
 something's about to happen

 and then all sorts of things
began to happen in a moment

 🔥

an unknown language raised the atmosphere
above the table

 WHERE ARE YOU FROM?
 and WHAT'S YOUR NAME?

 the bulgarian man's questions grew up to the ceiling
and the group's hilarity fitted wings

 my name was the cause of all the mischief:

 my name is icarus i replied
 increasing the fraction of emissions
 with a smile

 your name is what?
 my name is lucy i replied

it was hard to keep my place while pushed so
and their laughter might have squeezed me flat

 here i am i thought
 propping myself upon one elbow
 with not a moment to be gained

 tears are a salty acid
 pulling at your emotions with both eyes

a man looked through my bags as if my gender
were an analytic pattern of the trends of change

 i shook my wings back and forwards
 with all my remaining might

 my identity made no resistance
 the colours of the sun grew
 smaller and the heat grew green and black

 the poleward shifts of the weather glass
become an icarian dream
 likely decreases / over / past / beyond

 a keeping up of conversation
 a geographical pattern of surface
warming breaking up the map

 it is more than likely that
 the sky had turned away its head at the point of impact

Part 5: The Fallen

Where Icarus fell, the Ionian sky was blue and flawless. It was still early, not yet seven in the morning, but the sun was already bright. The world moved around Icarus but she sat still, where the weather glass had ejected her on the concrete steps of Igoumenitsa's ferry terminal, like a forgotten heroine of a silent film. If Icarus's initial landing and re-embodiment in Salford had been gradual, nothing had eased the brutality of this fall. Icarus felt as if she had been spat from a combine harvester. It was like she'd been tumbled through cumulus, or seaweed, or bushwhacked through the mesh of the world's accumulated weather. How had Alice been so calm, so nonchalant, upon returning through the looking glass, as if nothing much had happened, and life could carry on like nothing much had changed?

But her journey through Italy in weather glass world had been no dream to be shaken out of; it had *really* been for real. Extraordinarily so! Didn't she have the photographic evidence? Icarus pulled her

hands through her curly blonde bird's nest of hair and looked herself over. She was as deeply tanned and lithe as a castaway and her clothes were well-worn, in places torn. But it wasn't only Icarus's clothes that were torn. Icarus sliced her hand through the clear morning air as if cutting her emotional aura with a knife, creating a carbon cut-out of the woman she had once been.

'You ok, Icarus?' Wings asked.

Icarus half-smiled, noticing her bicycle companion for the first time since landing. He looked almost as rough as her. His frame was dusty, scratched and even dented in a couple of places. But in contrast, the curves of his cables and his handlebars smiled as broadly and as smugly as ever, as if to say, *why that was some adventure, wasn't it?* Icarus sighed. She was still Icarus, and alive with it, but she remained to be convinced she was ok. 'You know how I was meant to be finding a solution to climate change?'

W nodded.

'Well, far from it, I feel like I've become *dependent* on it. As if there is nothing really of me on this quest *but* my quest; as if climate change is in some strange way residing inside me, or speaking and acting itself out through me. It's scary, W, it's freaking me out!'

But if Icarus had been hoping for some reassurance then she was looking the wrong way. For W just smiled even more broadly and embarked upon a lengthy explanation that helped not one jot. 'Well now Icarus. For a change, your instincts are not far wrong. As quantum physicists might say, we are a part of that climate change that we seek to understand. Some theorists would even go so far as to agree that yes, your identity on this quest is co-constituted with the material fact of a changing climate. And that the meaning of climate change is dependent upon this process of negotiation. You see, weather glass world was a knockdown argument against dualistic thinking. As it demonstrated, far from the world being composed of discrete entities, all that exists is a mesh of relationships

from which we differentially emerge. Do you see where I am going with this?'

'Oh,' Icarus replied, scratching her head at what – if she was not mistaken – appeared to be really rather a *different* approach to climate change than W had professed so far. Did the mesh not sound rather similar to the entangled scribble she had drawn back in Normandy, which W had been so angry about? Next thing W would likely be proclaiming that the mesh couldn't be solved and everything...but any such way, Icarus was loath to get involved in any kind of discussion involving quantum physics before her first coffee of the morning. 'Do you know why they're so fond of the weather around here?' she asked instead, looking around and trying to lighten the conversation.

'Probably because it's nearly always sunny,' W replied.

whether
weather the whether
weather

For the next ten minutes Icarus sat vacantly watching a lorry from the Hellenic Environment Centre refuel the ferry.

'Can we go yet?' W eventually asked. 'It's already four weeks since our quest began. Two-hundred-and-twenty bicycle years and almost two-million human years since time began, but closer to being out of time entirely, and passing.'

Icarus gave W's handlebars a gentle squeeze and smiled an upside-down smile. 'Far from it, W, I fear we haven't yet begun.'

Nonetheless, she gathered her limbs together:

your foot bone connected to your whistle bone,
your whistle bone connected to your climate bone,
your climate bone connected to your bicycle bone,
your bicycle bone connected to your hip bone...

At least she was still a woman; to have further complicated her hybrid identity would have confused everything right then. In fact, despite everything, Icarus felt more at one in her hybrid female body than she had all trip. Previous to voyaging through the weather glass it had been as if she – Icarus – had been somehow inhabiting or visiting upon Lucy's form on earth, attaching her myth and personality to someone else's life. But now, in contrast, Icarus would have struggled to separate out her apparent alter ego from herself.

'Eh Lucy?' she asked – a question met with the requisite silence, them being as one now and all.

Icarus levered W off the concourse and pushed him into the terminal. In weather glass world, time had been both flexible and circumstantial, far removed from modernity's linearity. And according to her reading of the weather glass clock there was always time for a morning cappuccino and a biscuit.

Inside, Icarus settled into a plastic chair, blew upon her coffee, and wrapped a jersey around her shoulders to guard against the over-

enthusiastic air-conditioning. It was hard to believe in weather glass world in retrospect. The flight had been pure adrenaline, the experience of her life, a cultural and aesthetic spectacle. There had been nothing quite like the cyclists taking over the Sunday morning skies. There had been nothing better than allowing the weather to sweep her south along the Aegean coast, at the speed of the gale. There had been an abundance of coffee and cake, and she'd believed in the unicorn and he'd believed in her, and that had been a bargain. She'd believed in climate change and it had believed in her, and that had made all the difference. If Icarus had chosen a landscape it might have been like Tuscany, marked out with the cuts and angles where humanity had inscribed meaning from it –

– a shifting microcosm of the repatterning of the world. And her, an active participant, renegotiating the boundaries of climate change as she went. Yes, Icarus had rewritten, and was still rewriting her fate, no matter whether it was the version Zeus desired. She had learnt that there was no fixed identity called Icarus nor a stable fate, just a story and her memories, there for the rearranging. And Zeus could

frankly sod his disapproval of who she had become. For who else could she possibly be? What was she trying to prove? She was never going to have been an Anglo Saxon messenger for his whims.

If only the whole experience had been less *personal*!

If only the world had applied the weather glass more open-endedly!

If only the rest of humankind had travelled through the weather glass with her, rather than objectifying her from beyond. At what price the weather glass traveller in a world that otherwise remained unchanged?

Icarus felt not only cut-out, but cut-up, where the world's hubris and ends-oriented ambitions and machismo and capitalist greed and fear of apocalypse had self-harmed upon her. Above all, what Icarus couldn't forgive about weather glass world was the behaviour of its men: exposing themselves at traffic lights, stalking her, shouting at her for cycling through their country alone, refusing to believe the nature of her quest, interrogating her gender. On the ferry a neighbour had reassured her 'it was ok,' the men had 'meant no harm.' Pray tell her which part of *that* interrogation had been ok? Checking to see if her identity was written on her underwear? And to top it all off, if she *was* the person who emerged from her relationships as W suggested – as part of the mesh of inter-relationships comprising the world rather than a pre-existent Icarus – then this harassment had *become* her.

'So are we travelling back through the weather glass to Athens?' W interrupted.

Icarus shook her head. 'I'm too tired. I think I need to find out a bit more about the person who has exited the weather glass before I jump straight back in again.' Nonetheless she filled it and watched the water settle low in the spout. Fair weather. The most superficial reading of all – which she'd take all the way to Athens if possible.

207

i awake between the universe
i come alive

come and meet my invitation
to become!

practising a dance-like form
of *opening* of my body as if my mind
depends on it

to flourish is a mutual riff on time
the future folding in upon the past
becomes the present

now

where the objectivity of
emergence
is a form of change

a bringing forth the
halfway
of the music

to be alive
is a possibility of ethics

another cut
another time

and this makes all the differential difference

It was eight o'clock when they set off, seven o'clock Italian time, and
the coastline already mountainous. Icarus struggled up the first
headland, but the view from the top took her breath away. Helios's
morning rays had carved grooves in the landscape north towards
Albania, while boats scuttled back and forth between the mainland,

Corfu's breasts, and beyond. And despite everything that had happened lately, when Icarus rolled W world-wearily off the headland's lip there was no denying the feeling of warm wind in her hair, nor the poise of the heron standing knee deep in water, nor the taste of salty blue sky on her lips. Suddenly the world felt full of possibility, creativity, change. Icarus was so tired it was almost as if she was hallucinating, floating.

Today's cycle took them through the Epirus region of Greece, one of the country's poorest areas: home to partisan rebels during the German occupation and ostracised by the Greek government ever since for their communist sympathies. 'Revolutionaries. Your kind of people, W,' Icarus said, winking. These days Epirus was an easygoing revolutionary backwater, however, given over to low key tourism. Icarus already felt less hassled. The lad unloading nectarines into a village shop moved W gently from his way, and the Greek man with the handlebar moustache happily directed Icarus towards the 'difficult way' along the coast road, if that was how her stupidity chose to go. Icarus barely made it ten metres up the track before W's wheels sank into the sand, and she returned to the main road, the 'easy way':

 continuing is slipperiest
 content sidling east

 thirty years of non-existent past
 flying past the window just like history

 the weather was prone to change

 coldness
 celsius

 or walking upon the unforgiving
 surface of the clouds

the ceilometer proved insensitive to our failures
in our repeated quest for sustained fleeing /
otherwise known as flight

 Through a combination
of the laidback
atmosphere and her
sleep deprivation, by
mid-morning, Icarus
was already dreaming
of stopping off early
and spending the day
sleeping beneath a
parasol on one of the
many small sandy coves they cycled by. But even though they had
made up time through the weather glass there was still a long way to
go, and as W was soon to realise, Icarus's route choice had just made
it even further.

'But do we really have time to go that way round?'

Icarus shrugged. Time for what? According to who? The island-
hopping route through Lefkada, Kefalonia and the Peloponnese
looked like fun! True, it was certainly *further*. But she was far more
likely to survive it than the infamously treacherous mountain road
or the dirt track alternative through snake and bear-infested
backcountry. And the main road south of the mountains not only
looked dull as a foggy morning but accommodation was scarce.

The same could certainly not have been said about Parga, the next
town south in the direction of Lefkada. Everyone had once had a
hold on it: the Venetians, Napoleon, the Russians, the Brits, who had
sold the town to the barbaric rule of Ali Pasha in the early nineteenth
century in exchange for a handful of peanuts. But most recently
Parga had been ruled by tourism, and signs for rooms to rent –

DOMATIA – were everywhere; who could have blamed the hotel touts for interpreting Icarus's horizontal lunchbreak on a bus stop bench as an advanced stage of fatigue? It was an attractive, small resort with red-tiled villas gathered around a turquoise cove and a small, commercially operative fishing harbour. Icarus certainly didn't have the carbon credit necessary for a hotel room, but the campsite would have been impossible to resist if it hadn't been for its stubborn manageress. 'You can camp there!' her arthritic fingers insisted, pointing to a sun-pounded space between a coachload of boisterous German teenagers and the stinking toilet block.

✦

In the circumstances of instead continuing, Icarus could have done without the mountainous headlands and the glaring sunshine that extended south. Up a one hundred metre headland, down. Up a two hundred metre headland, down. Icarus would happily have seen the Greek coastline ironed flat. But it took some time before that wish was realised. It was a good couple of hours and several bodyweights of water later when the road finally descended into the Plain of Fanari, home to Acheron, the temple of necromancy, where Odysseus had conjured Tiresias to guide him safely home.

'I thought you were frightened of the underworld!' W exclaimed, as Icarus swerved off course in that direction. 'It will be full of bats and murderers! And who do you wish to talk to anyway – isn't the point that most of your friends on Planet Zeus are immortal?'

'But did I never tell you about my Mum?' Icarus replied, pulling up a short distance away, leaning W on his left-hand pannier and turning towards the temple. 'I've been thinking – you know – perhaps I could just say a quick hello, after all this time. If everything's gone as badly wrong as I fear with Zeus and Daedalus, then she's the only person I have left.'

W turned sharply away as if he had just been mortally slighted. 'Well then, you had best go.'

As Icarus approached she reflected for the ten millionth and one time on the cruelty of the social norms that had denied Naucrate, prostitute and drug addict, continued access to her only son. Was it surprising that she had overdosed in reply? Icarus could still picture her mother clearly on the day Zeus had had her escorted from the premises – the hauntingly gaunt beauty of her profile against the sun, several wisps of hair escaping their pins, and her linen pelops gathered around her bony chest. And Daedalus? Standing by in the shadows, powerless, or too spineless to resist the orders of his employer and artistic patron.

Icarus inhaled to the bottom of her lungs, pushed back the ivy and heaved open the heavy wooden door to the labyrinth of tunnels, trailing salt behind her as she went. 'I won't need your hallucinatory lupin seeds,' she told the headless priest guarding the antechamber. 'Hades,' she cried, 'it's Icarus!' And whether or not Hades heard, the door swung open. It was so dark inside that she couldn't even make out the flapping of bats' wings. She sat cross-legged on the flagstones and addressed the void. 'Mum? It's me, Icarus. I've come to say hello.' The chamber echoed for some time with only the sound of Icarus's breathing, but also, finally, if she wasn't mistaken, the gentle lilting tones of the mother she had barely known.

'I hear you my dear Icarus. So you have come to say hello. Now, come into the light, where I can see you a little better.' A bulb of glow worms obligingly shone a spotlight in the middle of the room. 'Your father's eyes,' Naucrate began. 'But you have my figure, undoubtedly....'

Icarus waited for Naucrate to pass further comment, but her mother had more urgent, pressing things to say. 'I have been given little time, but I have three messages for you. First, be on your way, and don't let your doubts defy you. Deliver your ideas to Athens just

as the great bustard proposed. But secondly, beware. Yours is not the usual nor the easy path; there will be those who will resist you – betray you – on your way. And finally, Icarus, remember. You are not alone. You've had your troubles, but your father is a good man. Seek him out and he will be there for you at your time of need.' As Naucrate had been speaking her voice had become ever fainter as if she were literally fading away. 'Thank you for visiting, Icarus. Death gets rather lonely without the occasional visitor, you know. I'm proud of you...'

When Naucrate's voice had completely faded into the silence of the dark, Icarus sat still in the resultant emptiness, for fear of jolting several centuries' worth of tears from her eyes and flooding the Greek underworld. Was her Mum right that it was time to mend her relationship with her Dad? Would he be there for Icarus after all? If Icarus really was made by her relationships then perhaps it was time she mended the most fundamental of all – and soon? For climate change wasn't about future generations like everyone said. It was about the immediate present – now.

The peninsula south to Preveza was flat and fast-going. Icarus and W had already long since committed themselves to their island-hopping route when a large sign announced that the bridge across the estuary ahead was in fact a tunnel – and banned to bicycles.

'What now?'

'We stay here I guess,' Icarus replied, following some small handwritten signs towards a local campsite. 'And worry about *that* tomorrow.'

If only they could have persuaded the campsite manager of this plan. 'We're closed,' he gestured through the reception glass, before returning to his telephone conversation.

'So, we'll wait right here until he re-opens,' Icarus informed W, adopting the stubborn pose of someone prepared to wait until next season, if necessary.

In fact, notwithstanding the manager's preference for speaking to his friends to work, it turned out that the site wasn't *really* closed. Five minutes, ten minutes, fifteen. The man's guilt finally got the better of him; he ended his call and opened the hatch. 'You are only staying for one night? Then of course we are open!'

'You'd have thought businesses would want our custom considering the economic crisis,' W objected as Icarus pitched her tent. Over the last couple of weeks the impending financial collapse of the whole of Europe, and not least Greece, had competed with the upcoming conference for headlines. Already protests had begun in Athens against the proposed austerity measures. *Austerity*, Icarus thought. Let the world economies collapse as far as she was concerned – if only there was some way of preventing the suffering that would presumably accompany such dramatic change...But that was about as far as her weary critique of capitalism got that night. She cooked quickly, and was already unzipping the tent for an early night when W caught her sleeve.

'Icarus, remember what you said about being good at bedtime stories. Well, I must say it was rather spooky in the bowels of the Ionian Sky, and I just wondered...'

'Of course. I can always tell a story W. But which story do you want to hear?'

W barely hesitated. 'Do you have one called Icarus Through the Weather Glass? Because I'd like to hear that one most of all.'

Icarus smoothed down the sheen of W's black paint before settling into a storytelling pose. No, she didn't have such a story, but she could always invent one, she supposed:

Once upon a time of Icarus
but there was no time

Once upon another time of Icarus

*

We took the weather of the sky and
laid it on the colour of our eyes

a young man flew a woman
to the sun

a father lost his warnings
to the angle of the sea

Icarus waited by the water's edge alone

Come Icarus, we said to him, but
it was another Icarus who came

Others might have commented upon
the fullness of the emptiness where
a certain pride had been

you could see it in the altered tone
of the weather of his eyes
so full
so full as a blue blue moon

*

Pronunciation: /'hju:brɪs/
Etymology: < Greek ὕβρις

Presumption, orig. towards the gods; pride, excessive self-
confidence

You said, 'what have you done with my story?'

I had never thought it belonged to you in the first place.

*

Our flight path had become a shifting
wave moving in and out of time like
the fluid progression of the weather

How do you want to be yourself?

There was no beginning beyond
appearances and no apparent end

Our wings were but the tattered
weather of a well-known story

Beginning over again, and elsewhere

When Icarus's alarm rang the following morning, two things were uppermost on her mind: (1) the matter of the tunnel remained unresolved, and (2) if she were as implicated in remaking the meaning of climate change as she feared, then she had better start behaving better. 'What a nice day for being good!' she exclaimed, poking her head from the tent, and pointing at the sunshine.

W grunted. 'I think you are over-simplifying, Icarus. But we will see.' And so they did.

'Are you going to the tunnel?' Icarus asked, hoping to hitch a lift from a Greek man and his son who were brewing some coffee from the tail-gate of their van.

'We're going to Igoumenitsa. Why don't you cycle?'

'Excuse me please?' she asked a German family with a large, luxury motorhome.

'What, take you and that, in this? No, I am afraid we have no room at all,' the mother replied, casting a disapproving eye over Icarus and her ramshackle bike.

Icarus felt too shy to interrupt the early morning romancing of a young Greek couple, who would have been most likely of all to take an hour out of their morning to drive Icarus and W to the other side. If only they had stopped kissing. 'Shall we just cycle to the tunnel and see?'

The revolving electronic noticeboard above the tunnel could not have been less ambiguous: NO BICYCLES, in both Greek and English, in bright red flashing print. Icarus pointed towards the rabbit-hole entrance. 'But there's no-one around. What have we got to lose? And more importantly, think what we have to gain?'

'I thought you didn't like tunnels! What happened to today being an experiment in good behaviour?'

Icarus already wished she'd never shared that. 'But I managed the temple yesterday didn't I? And who's to say this is being bad? Stupid rules are there to be twisted! Why obey the law when we could improve it?'

The sudden appearance of Antony and Cleopatra sealed it. 'Do it,' Cleopatra said. 'You'll regret it if you don't.'

'Go,' said the ethereal voice of Antony. 'Don't let the Gulf trap you from your dreams the way that it defeated us. Have courage in your cause. Make haste.' It was on this stretch of water during the Battle of Actium that Cleopatra's fleet had fled from the siege of Octavian, and Antony had abandoned his troops to follow her – a decision to flee that had caused them both the guilt leading to their ruination.

The tunnel turned out to be the broadest, best surfaced and lit they had yet cycled, with barely any traffic. 'How about this?' Icarus cried, accelerating into the tunnel's dip. W gave a thumbs up with his bar-ends but their elation was soon cut short. A vehicle had just

braked behind them, and the sky of the tunnel had begun flashing orange. 'Oh, oh.'

'They must have seen us on CCTV.'

Over Icarus's shoulder a pick-up truck had mounted the pavement to escort them to the exit, where a far worse fate apparently awaited than being buffeted by passing trucks. The last few hundred metres played out in slow-mo. The circle of light beckoned them onwards, up a steady incline and back into the sunshine where the tunnel ogre drew his pick-up truck alongside and rolled down his window.

His face was deeply stubbled, and he was wearing dark shades and an officious tunnel authorities cap. 'IHUVF:K?JB :WTUIOG:WTJ ?TJ,' he shouted. Or else that was what Icarus heard. 'K glajdbyoauiegtylJM dh/adnh.' His stubbled chin trembled frumiously as he first pointed to W, then at the tunnel, then at Icarus, before spreading his palms wide.

'I'm really sorry,' Icarus replied in English.

'BVADUOGrh abjW;QIYBQ;RLHGnvxh?!'

'Yes, I agree, it was wrong of me.' Icarus handed over the British passport she had forged from Lucy's original, but the man just flicked through it, unable to read a word. At least the Mappa Mundi was partially written in Greek script. Icarus pointed to Lefkada, pointed to W, sketched the alternative route north and then around the Gulf and spread her palms wide. The detour would have added at least an extra two days.

Suddenly it was as if a stopper had been released from the sky, achieving an instantaneous drop in air pressure. The ogre removed his shades and smiled from ear to ear. 'You are going to Lefkada? I'm from Lefkada,' he indicated, beating his chest. He handed Icarus back her passport before waving them around the back of the nonplussed women at the toll booths. 'Go!'

During Byron's travels he had done much to publicise the plight of the Epirus people in their resistance against Ali Pasha, before moving on to train Greek troops for the War of Independence in Missolonghi, where he died of malaria. But not before having the foresight to post some graffiti on a signpost along Icarus and W's way:

here we sit in this realm of mud & discord called climate change

The next village of Agios Nikolaos itself looked like it had been washed up on the shore as mud and discord, flotsam and jetsam: rusted cars and tractors were scattered here, fishing cages there. Chickens and entire prefabricated houses had been deposited where the sea had left them during the latest storm, while out in the early morning channel two fishermen harvested fishing net from the sea. It was a peaceful, unintended scene – until W suddenly let fly.

'Tell me. What does breaking the law have to do with everything you've come to think? I thought you'd settled on some principles, all the way back in the Loire. At least that. But what was respectful, humble, responsible about what you just did?'

Icarus sat down on a fishing pot, as if she had also been washed ashore, and wound a thread of blue rope between her fingers. 'I didn't say I'd be good the way the world wants me to be,' she said tentatively, as if testing that response's validity on the air. 'You see, when I use a word like good, it means what I mean it to mean – no more, no less!' she joked. But *that* joke was met with an aluminium silence. 'Oh, I'm sorry I upset you, W. And I do take responsibility for what I just did. But it's not easy accepting the ways of the world; not when it's cut upon you this much. And nothing will ever change if I just let the world dictate the way that things will be.'

'You could at least *pick* your fights. Don't you *want* to get to Athens? You just risked my only chance to make something of my life – to share my discoveries with those who matter. Nobody's going to listen to me from a prison cell, are they, let alone Zeus?'

Icarus raised her eyebrows. 'Of course I want to get there! But I never said I was an angel. I'm not even semi-mortal any longer, and certainly no God…W…W…what did you just say, W?'

But instead of answering, W had begun whistling, in a none-too-subtle parody of Icarus herself:

> to the weather glass world it was icarus who said
> i've a bicycle in hand
> i've the sun on my head
>
> let the weather glass creatures wherever they be
> come talk with the climate the greek gods and me
>
> so fill up your stomachs with coffee and cake
> and sprinkle the landscape with mountains and lakes

 set smiles in the ocean
 subject hubris to tax
 and do all that you can not to melt just like wax

 o weather glass creatures
 quoth icarus draw near

 'tis an honour to see you
 a favour to hear

 'tis a privilege high to have dinner and tea
 along with the beasts of the land and the sea

 then fill up the weather glasses quick as you can
 and sprinkle the table with gluttony and spam

 place smiles up in heaven and drown pride
 in the sea

 and welcome good lucifer unto us, you and me

W's tune had gradually built in a crescendo which climaxed upon its
final words, causing Icarus to bend double, as if she had been
punched in the stomach 'No! *No!* I won't accept that!' Icarus grasped
her head between her hands as if what W had just implied
threatened to blow its sides off. *Lucifer*, the angel whom God had
cast from heaven for wanting to become a God? Was this what Zeus
had been suggesting all along by ordering Apollo to push Icarus off
the edge of Planet Zeus? Was the alter ego of Lucy just an ironic foil?
Just when Icarus felt as though she had become one with Lucy, was
Zeus now proposing the introduction of a rather different kind of
alter ego, in the form of his favourite, most beautiful fallen angel?
Were Icarus's conclusions about climate change simply meeting
Zeus's Satanic expectations of her? Had Icarus been sent on a quest
to negotiate the world's descent into an apocalyptic hell on earth?

'Oh, don't be such a drama queen, Icarus,' W exclaimed. 'It was just a play on words to try and encourage you to behave a little better. Don't go all crazy on me!'

But once Icarus had started down this particular path there was no stopping her. 'Is this right, Lucy?' she asked herself, as if it might still be possible separate her alter ego from the person Icarus had become. But then again, Lucy was no Lucifer either. For the first time, Icarus realised how much she had come to understand her apparent alter ego – could feel her instincts deep down in her gut as strongly as if they were her very own.

Lucy the cynical environmental campaigner? Not at all. All Lucy had wanted was permission to continue, with thoughts about which she'd felt guilty, ashamed. Lucy *needed* Icarus to help her on her way. And no wonder if her own experience of weather glass world and the politics of climate change had been comparable. Wouldn't anyone have put up a protective barrier of apparently not caring? Icarus kicked the dirt and swore. Why did everything have to be so blooming difficult all the time? Why couldn't Zeus allow her a summer holiday for once rather than these endless quests to the end of the earth?

'Tell you what. Why don't we use Lefkada as a test of your capacity for good behaviour?' W proposed. 'To prove Zeus wrong?'

Icarus nodded half-heartedly, looked W only very briefly in the headset and then onwards towards the causeway to the island of Lefkada. And so her story was obliged to continue to continue?

In order to catch the ferry to Kefalonia, Icarus and W had to cross the island causeway and then cycle the length of Lefkada – a relaxed kind of an island where, as chance would have it, Icarus felt more on

holiday than she had yet. It did prove much easier to *almost* behave yourself when people were *nice* all the time, Icarus came to realise.

Earthquakes had spared Lefkada town extensive tourist development; these days it was mainly given over to the needs of sailors and pirates. When Icarus climbed down into the dark bowels of a chandlery in search of a climate jolly roger with which to tease W, she couldn't immediately locate the voice that addressed her, but gradually her eyes adjusted. Shackles the size of chimneys hung from the roof, there was a roll of Kevlar long enough to stretch back to Salford, and a dusty prosthetic leg leant against a tub of grease. But finally she located the old cobwebbed pirate sitting in a rocking chair, who gestured to Icarus to sit. Icarus sat down on an upside down, rusty paint pot and shared occasional smiles with him, and the pirate appeared perfectly content to enjoy ten minutes of a woman's silence. Icarus dug deep in her memory for some residue of her Greek mother tongue. But the best she could come up with were the first two phrases in a Greek guidebook she had flicked through in a tourist shop five minutes ago – 'help' and 'I'm wounded' – neither of which felt appropriate. In the end the pirate refused any money for the flag, but he did accept the remainder of Icarus's hourglass sand, which he threw over his right shoulder into the void.

Outside again Icarus sought out an open-air café on the quayside to stock up on sugar and caffeine before they tackled the reputedly wild interior and west coast of the island. She took a pencil from her panniers and scribbled a short poem on a napkin before ordering:

> The answer to the question of climate change
> was yes – but you preferred cake.
> On some level cake was always the answer.

'What do you think, W?'

W's silence suggested he thought lots of things but not much about this.

'A pint of iced coffee made with condensed milk and an extra-large pain au chocolat,' Icarus ordered from a yawning waitress. 'And the same for him.'

⚜

In the interior of Lefkada, everything was small-scale: the single tiny tractor, miniature boxed houses, patches of smallholdings, and the characteristic white stone walls which goats were using for high jump practice. It was tatty kind of a landscape right enough but nowhere near as wild as she had anticipated – until suddenly, the island fell away below them to the west coast. W drew his breath in sharply and dug his tyres firmly into the loose pebbles as they followed the road which skirted along a terrace, high above the cliffs, allowing only occasional glimpses of the startling white coves below. Exanthia village was stacked precariously on top of itself like a big game of jenga. If you'd taken a single building out, the entire village would have tumbled down the hillside into the sea. Kalimitsi village had already fallen most of the way – far below them on the coast – and an old graffitied campervan had been deposited by the roadside ready for anyone to push.

In addition to their rugged appearance, the villages were sleepy kinds of places, where even the clocks ran slow. A one-eyed bandit of a mongrel lolloped along the middle of Exanthia's main road as if he were stoned, service in a local shop was so slow as to be non-existent, while the aged olive tree of a woman in the taverna had been slow-cooking an indeterminate meat stew for approximately two centuries. The lethargy caused by the prevalent atmosphere, the sunshine and Icarus's hunger combined to cause her legs to slow to a

comfortable whir which in the end was destined, sometime, to deliver them a further ten miles or so to their destination of Vassiliki.

Their plan was to catch a ferry from Vassiliki to Fiskardo on Kefalonia, then cycle to a campsite two hours further south. But this was taking no account of ferry times, fish restaurants, and the lazy charms of Vassiliki itself. The only things of speed around town were the windsurfers and catamarans, which whipped around the bay taking advantage of the famous afternoon wind known locally as Eric. Back on land, equally sunbleached individuals as Icarus sauntered around on equally battered bikes, while at the far end of the village some street vendors were selling home-made jewellery and restaurant waiters competed good-humouredly over the prize of a cyclist's appetite.

'I feel for the first time in weeks that we fit in!' Icarus exclaimed.

'Me too! But come *on*. Look, the ferry is already here.'

Icarus and W scattered chairs and tables in all directions as they defied the slow-mo atmosphere in a frantic rush to the pier where…

'What, that?' Icarus pointed at the blue lettering 'EXPRESS' adorning the hull of a ferry boat which had spent more time rusting than sailing as of late. The times of the actual ferries were printed on the wooden ticket office. 'We've already missed the morning and the lunchtime ones,' Icarus said, 'and we'll never make it to the campsite before dark if we leave at 6pm!' She smiled more broadly than she had since landing from the weather glass – a smile which led them back to a café, then the Vassiliki campsite, a bar, and later dinner.

'See, I was perfectly well-behaved today, wasn't I?' Icarus asked as she picked fish bones from her teeth before bed.

'Not too bad, I suppose,' W replied. 'But not every experiment can be a 100% success first time around. Because I'd love to hear how you think we will make the conference if we continue at this rate.'

As Icarus curled up in her sleeping bag later that night she mulled over the approaching destination – conclusion – to their quest. Far

from arriving *on time*, rather it didn't feel like this quest *could* ever end, the way it kept reinventing itself and taking her elsewhere. And it seemed more important than anything to remain open to these possibilities, improvising as she went. *Yes*, she promised the sky, she would take responsibility for the way in which she became entangled with the world. But she'd undoubtedly make all manner of mistakes along the way and that was ok too.

So far Icarus and W had experienced a wide range of weathers, including rain, but not as heavy as it was falling the following morning – the kind of wet rain which soaks you just looking at it. Indeed, a downpour of stray cats and dogs had been falling on the tent all night and it didn't look like this was going to change anytime soon. 'It would be sunny yesterday, and sunny tomorrow, but never sunny today?' Icarus proposed.

W's brassneck response caused Icarus to snort her nose off with disbelief. 'But of course, there's no solving the weather.' W wiped the rain from his frame. 'Because what would we solve it to?'

Icarus had let W's apparent change in the philosophical direction of his science go – only a few days back in Igoumenitsa – in the

interests of avoiding a conversation involving quantum physics. But this was the most spectacular scientific volte face she had ever heard of!

'You see, there's no such thing as balance or harmony,' W continued. 'Chaos more accurately represents the climate's state of change.'

'But, W, isn't that what I've been saying all along?'

'Far from it, Icarus. Previously you had undefended theses which I put to the weather glass test. The challenge is now viewing technology in this light, cognisant of its complex inter-relational properties. And is a bicycle revolution not precisely the light carbon-bike-tread technology with which we might proceed?'

Icarus blinked. He was good; there was no denying he was really good. There wasn't even a flicker of guilt in W's headset to betray the way he had just twisted an unprecedented U-turn to his own technological agenda – then assumed the discovery as his own! 'So remind me, what exactly was it that we fell out so badly about in Normandy when *I* said the climate couldn't be solved? Why were you so furious and disagreeable about the idea of my climate scribble?'

W just shrugged, encouraging Icarus to continue, in a stronger, more confident voice than she had found all quest – as if through a process of osmosis the combined Lucy-Icarus persona had acquired the strength of numbers.

'You know, I've been thinking about your idea of climate revolutions W.'

W looked up, momentarily.

'And you're right. There has never been an issue which has demanded such a complete revolution in our thinking – in our understanding of the meaning of human life on earth, and our technological approach. Tell me – how do you extract technology from the assumption that climate change is something needing

stabilised? Perhaps, W, we actually need more climate change not less of it, where the climate is seen as the prevailing tenor of thought! What do you think of that?'

W snorted. 'To be perfectly frank, Icarus, I'd prefer *not* to think than to think that way at all.'

♠

Having finally struck camp and made their way through a soggy Vassiliki, the Captain Aristides ferry turned out to be a basic creature, if not quite as basic as the EXPRESS boat they left rusting its old age into the harbour. Icarus wrapped up, leaving the boat's musty cabin to brave the deck. When they had set out W had worried that travelling by boat was cheating. But what was she meant to have done – swum the English Channel, or arrived late by cycling around the Balkans? And once *one* section of the journey had been done by boat, then why not tag on a few others for good luck? Indeed, was impurity not what this quest had come to be about: breaking down boundaries, inhabiting the in-between spaces?

Icarus looked up as the ferry passed Cape Lefkada, where Sappho had reputedly thrown herself off the cliffs for her unrequited love of Phaon, the ferryman. Yet such heterosexual dalliances and her suicide had clearly only been temporary affairs. For there she was, silhouetted on the tip of the peninsula, waving to Phaon's brotherly toot of the horn, and crying: 'to Icarus – the eleventh muse of climate change poetry!' Icarus retreated into her collar for fear of being identified. But then why *would* the other passengers ever guess? Icarus looked up and down the trim athleticism of her curves. Vassiliki had treated her well. She hadn't once been mistaken for a boy but neither had she been made to feel an inferior woman. She just was. No wonder Sappho liked to hang out hereabouts – Icarus

could easily have upped and left her quest right there and been done with it:

> so i accepted the sunshine you extended
> from your palm
>
> a single bite and suddenly
> it was as if no-one knew me from adam

Upon arriving in Kefalonia, their main challenge that day was beating the weather along its eighty kilometre length to catch the last ferry to the Peloponnese within the space of four hours. The temperature in the pretty arrival port of Fiskardo was far from the usual 28.5 degree September average and Icarus manoeuvred herself into pole position to disembark and get moving before the wet chill could inhabit her bones.

'Have you finally found some urgency, just when you gave your last bit of hourglass sand away?' W asked.

Icarus smiled and began whistling. Urgency was having something that you wanted, needed to say, that didn't make your toes curl in the whistling of it.

As the road climbed the rain became ever heavier, and soon the mist enveloped everything. Some local workmen had already gathered beneath the canopy of a tavern as if the rain was as good an excuse as any for a holiday. But towards the west coast the stream of ferry traffic began to dwindle, and soon Icarus and W were alone: them, the rain, and a landscape which was about to fall off the edges of the earth. To their right, cliffs dropped a thousand feet through the gloom to the sea, while above them the unstable hillside had begun to deposit mud and rocks onto the road. In places the road itself had already fallen away.

'Thank Zeus we didn't try this last night,' Icarus said, blinking back her sense of foreboding. Right then Kefalonia could have just taken her, and who would have known? Earthquake, landslip, gust of wind…yet on this occasion it wasn't the cliffs that Icarus fell from.

'Take it easy,' W cried above the whooshing water – from above, below, within – as the road began to sweep up and then steadily down towards the eastern coast and the rain became heavy as a waterfall. 'My brakes are worn down to the gum.'

But it was too late. W's back-end skidded from under Icarus before she could do anything about it as they swept round one especially steep corner, only just regaining balance in time for the next corner where W skidded the other way. BOOM! Icarus entered the village of Agios Effimi on her side.

It did not take long before the postman, who had parked up to outwait the storm, began laughing. 'Ha ha ha.'

'He he he,' giggled W, causing Icarus to blush even deeper.

'Ha ha ha he he he,' cried a man a short distance further on who was digging in the river road for his flip flops.

HA, HE, HA. The raining and the laughter stopped as suddenly as it had begun. Even after she had picked herself up, Icarus looked all crooked and over pins, but no bones were broken to speak of.

'May I put your helmet a bit more straight for you?' W enquired.

ours was an indivisible kind of wetness
mountains drained of sound:
just shadow firs and the thick push of mist

the sky threatened to consume the road
but I delivered my message

come! we've lost the morning
and we're running out of wind!

 the sea was everywhere
 white horses mounting
 the cement like cirrus
 i could feel my eyes –
 i didn't even need to look

Icarus and W saw nothing of Kefalonia's mountains but the glare of Icarus's cyclopic headtorch in the mist, but there was no denying the smells: cypress, eucalyptus, mint, fennel. Icarus floated off her saddle on the pungent waves of the olfactory eden, while W's top tube straightened where it had been slunched. It was so gloomy that cars were driving little faster than Icarus was cycling – up up up as far as the ghostly summit buildings ruined by the 1953 earthquake. It looked kind of cosy inside the bubble of the cars, Icarus couldn't help but think. Although the passengers were missing out terribly on the island's incredible scents, she consoled herself, shivering.

There were few advantages, meanwhile, to ruined brakes, but one of them was that Icarus and W were forced to take the descent at kamikaze speed or else they would never have made the ferry on time. When they reached Poros the boat was already boarding and the ticket office in no rush. Once Icarus had finally secured a ticket she made a mad dash, pushing W onto the ramp just as it began to rise – shunting bicycle and human passenger ungracefully onboard.

No existing words could have described how Icarus felt as she climbed towards the passenger deck. *Kefaloniaed.* A visceral weather experience involving all sensual dimensions; feeling simultaneously ruined and victorious, exhausted and alive, and very very wet. So this was what the climate was making of her, Icarus thought: a drowned and exhausted rat? Unhelpful as such thoughts might have been, Icarus began dreaming of a hot shower and an afternoon snooze to help prepare her for the last hour's cycling on the far side.

But she certainly wasn't *expecting* what she discovered in the ladies toilets.

No! Icarus blinked and looked again. Yes! The facilities she had just discovered undoubtedly weren't intended for short crossings, but try and stop her now. Hot, strong, heavy. Hot! When Icarus re-emerged from the shower her skin was wrinkled, and when she levered herself onto a reclining seat in warm dry clothes she fell to sleep immediately – the deep, undisturbed repose of one whose recent experiential climatic averages has just been overwhelmed.

♦

The Peloponnese had grown into a peninsula – almost an island – from the leaf of Tweedledum and Tweedledee's mulberry bush. Or so Icarus tried to persuade W. But Kyllini port was far from anybody's romantic imaginings. Its scrappy beach had been abandoned in the bad weather to dog walkers, while the arcades were doing a slow, noisy trade; teenagers were hanging out beneath bus stops eating souvlaki and fries while the air smelt of stale grease. But this was a far more pleasant smell Icarus and W soon agreed than the stench of the live chicken lorry they trailed due south. The lorry was going just fast enough that they couldn't overtake it, but stopped often enough for the driver to jump out, snap a chicken's neck and present it to a happy customer that they kept on catching up. Both cyclist and bike were delighted when a series of local villages gave way to a stream of self-reliant roadside smallholdings with no use for broken chickens bathed in their own shit.

When they finally arrived at their destination for the night, Camping Palouki's owner was sitting on a stool resting his overworked stomach on his knees. 'So where have you come from today?' The man shook his head slowly at Icarus's response and

chewed his moustache. 'You will have had plenty of weather. We could see it sitting on the island. It's been sunny here all day.'

The site was set just back from a white sandy beach, with a palm-fringed bar-restaurant serving up a range of local delicacies listed on a blackboard. 'Souvlaki, feta and arrogant fish.'

Easing limbs and languages
around the curve of borders

 shifting paper:
 printed possibilities

 i will have a serving of souvlaki
 and some arrogant fish

how much it sets you back
 towards

a spine, a line.
 Absorbent money.

Over the course of the long distances of Italy, the pain behind Icarus's knee had miraculously eased – as if it had learnt it wasn't going to win the battle of wills. W's ailments had proven more stubborn, and if a sunny beach and the chance to recuperate before tackling the Peloponnese weren't good enough reasons for a day off, then giving W some long overdue attention certainly was. 'Fancy a tune-up?' she asked after breakfast the following day.

'From you?'

'I know, it's not ideal. But I've got to do something about those brakes.'

W's look of horror had little even approaching 'the ideal' about it. But he knew even better than Icarus quite how urgently some work was needed. 'Better two thousand miles late than never.'

In reality there was little Icarus could do with a small multi-tool and her mechanical dyslexia. The brakes were worn down past the rubber and she had no spare parts, while the front gear cable was snapped to a stub around the mechanism, making adjustment impossible. Meanwhile, to the best of Icarus's knowledge the clunking of the bottom bracket was frankly irreparable. 'Well that's tidy enough,' Icarus said after a couple of hours, which had mainly comprised her standing with her hands on her hips or scratching her head. At least he looked clean-*ish* and had a new coat of oil. 'Beach time. You coming?'

W stuck out his brake blocks and shook his handlebars. 'Sand gets on my chain and into my sprockets.'

It was Saturday afternoon and the beach was busy: teenagers playing volleyball, children making sandcastles, and all shapes and sizes of adults scattered about the sand. Icarus stripped down to her bikini self-consciously. It was the most she had bared herself all trip, but no-one noticed anything peculiar. In fact, the more Icarus looked around, the more 'normal' her own body appeared. She lay down and pulled pen and paper from her bag.

TRANS – she wrote in big letters. Trans-sexual, trans-gender, trans-climate change, trans-genre. Trans-art, trans-life, trans-performance, trans-her. Trans-fat chance too, presumably, she thought, laughing. Trans-bikini! Part human-part organic, part machine-part nature, part story-part reality, part nothing-part everything, part culture-part chicken or was it really first the egg? Part bicycle certainly, she thought, looking back towards the campsite where W was resting in the shade. If the quest was about breaking down boundaries, she'd take them two by two! After all, what did it matter what body she wore when her mind went on all the same?

When Icarus laid her pen down after an hour of writing, it was to wash an increasingly fluid self in an increasingly fluid sea. Not just climate change not just me. *This* was how far she had travelled from Salford. Not just nowhere not just everywhere. Not just a weather glass. Not just gender, not just genre...'I wrote some poems,' she said to W upon her return, handing them over to him to read.

W blinked his headset bolts. 'But they look unfinished?'

'Always,' Icarus replied.

 craving angles
 we found ourselves within
 a constant lean of curves

 out of site horizons
 if we only walk a little further

 we walked a horse shoe top to bottom
 on its side

 letting luck from left to right
 stabilising openings
 into circles

 tangents
 two degrees

 it was a tale of increments

 the concentration of the parts
 of each notation on the page

 what then?

 the people kept their heads low
 watched the road and kept on walking

The next morning Icarus began the day by admiring the dawn. She was the only person on the beach apart from a middle-aged German woman who had just stripped demurely under cover of a palm umbrella before running naked into the sea. The dawn wasn't as impressive as the sunset, Icarus thought. But then why would it be? If she were following the sun across Europe, then she was currently facing the wrong way.

All things considered, perhaps it was understandable that W might have confused a proposed visit to Olympus later that morning with delusions of Olympianism. 'What d'you reckon?' he asked Icarus, flexing his frame muscles before setting off. 'Reckon we could win the cycle race?'

Icarus grinned and jumped onboard to get going. 'I think you're being a little narcissistic, W.' Pride, hubris, arrogance, narcissism. They got everywhere, from the God of the Gods – Zeus – the King of Hubris himself, right down to the aluminium body parts of a tatty bicycle. Icarus looked to the skies. She still failed to understand why Zeus hadn't yet revisited her to denounce her Lucifer-like ways.

Unless he really was impressed? Such a thought made Icarus start coughing uncontrollably.

W scratched his cables and interrupted her fit. 'Indeed, you may be right for once Icarus. I'm not sure that humility has anything to do with our accepting Phaeton's challenge of a chariot race to the sun.'

'Wait, hang on now. A bicycle race is one thing, but...' Icarus groaned – she had forgotten entirely. Every ancient Greek citizen who visited Olympia was obliged to accept *this* challenge. But really? Up in Planet Zeus, Phaeton was the resident pyromaniac cum professional fire-raiser, hireable by anyone from surrendering Turkish forces to Nazi collaborators, as the nearby town of Pyrgos had twice found out to its detriment. 'I can't believe you still want to fly with me, W, after everything. Don't you want a break?'

'Of course I want to fly again. How else will I ever get my bicycle revolution underway if not leading from the front? You're right, you aren't the ideal pilot, but right now Icarus – you're all I've got.'

6 degrees of separation

Fact
Faction
Fraction
Friction
Fiction
Fict

Modern Olympia turned out to be a small characterless town, lined with shops selling kitsch and restaurants serving TRADITIONAL GREEK CUISINE. Ancient Olympia was located a short distance beyond town – its entrance scattered with wooden ticket sheds.

'But why are we queuing?' W asked. 'Surely there's a back gate for competitors?'

Ahead of Icarus some students were struggling with the jobsworth ticket officer. 'There is no date on this student card,' the grumpy gnome said, dismissing the first young man. 'Iceland isn't in the European Union,' he said, dismissing the second.

'I'd like to claim free entry, on account of being Ancient Greek,' Icarus explained, pointing to the sign indicating free entry for Greek citizens, EU students, and chariot race competitors and handing over her forged passport.

The officious gnome peered over his glasses as if this was *highly* unlikely. 'But this is a British passport, not an Ancient Greek one.'

'Yes, but I forgot to bring my Planet Zeus passport. I didn't know I was coming on this quest, so how could I come prepared? But it's me, Icarus, can't you see?'

'Icarus? You? You're not Greek, and certainly not Icarus. You're a woman. See it says so, on your passport, right here.' The gnome looked Icarus's female form up and down, clearly unimpressed by what he saw, and passed a note to his colleague gnome, who shook his long golden beard and red bobble hat sympathetically.

Icarus swallowed her pride, paid up the six euros entry, and had turned towards the entrance gates before noticing that W had turned white. 'What's up?'

'Do you not realise what just happened?' W stuttered. 'If *he* didn't let you in on account of not being Icarus, what hope do we have of gaining entry to the Pnyx? Just as I feared. We've cycled all this way for nothing.'

Icarus stopped dead, closed her eyes tight, and crumpled her ticket in her fist. This *bloody* quest! Why was she recognised as a woman when it didn't suit her, and mistaken for a boy when it did? She-Icarus, the Satanic mortal off on a two and a half thousand mile cycle to a conference where her views would only be denounced in the unlikely event she was even admitted?

Unsurprisingly Icarus didn't enjoy Olympia much. Far from competing with Phaeton, W had been turned back at the gates leaving Icarus to wander the ruins alone: the Temple of Zeus, a shrine to Pelops, the Temple of Hera, the Gymnasium. Rocks, more rocks. Phaeton was waiting for challengers by the gates of the Olympic stadium, the wings of his chariot fired up and ready to race any foolhardy compatriots to the sun. And Kanellos Kanellopoulos, the Greek Olympian who had cycled his plane from Crete to Santorini in Icarus's name, was there ready to take him on – standing, waiting, bicycle in hand.

'Could you please take our photograph?' a nearby Japanese couple asked Icarus, politely.

By the time Icarus left Olympia, she wasn't feeling well. Her forehead was beaded with cold sweat and her arms were burning with goosebumps. 'Do you think I'm coming down with something?'

W shook his head. 'Have you checked the weather glass? I think it's about to come down on us.'

Icarus looked up. The sky on the horizon had turned the colour of petrol and the clouds were hurtling towards them. 'Good Zeus!' She might have summoned her surrogate father on many occasions this trip, but not like *this!*

'This way!' W cried, pointing towards the road – uphill.

Over Icarus's shoulder the storm clouds raced towards them. They were as likely to catch a bandersnatch as outrace Zeus's furies, Icarus thought, pushing hard on the pedals. 'Please Zeus, please. Can't we just talk rather than engaging in shouting matches? Please don't mow me down now when for the first time in my life I've got something I want to share with the world. I'm so close, *please*, at least for W's sake, if not me.'

Contrariwise, the sky split with lightning, soon followed by deep rumbles of thunder, coming closer, closer. The lactic acid in Icarus's legs screamed STOP! But the storm wasn't for listening. Twenty seconds, ten seconds, five came the thunder. Three, two...

'They say it's advisable to head for shelter at thirty seconds,' W cried.

The only possible shelters were some small spindly trees, which were already bent double in the gusty wind. They entered a village as the first raindrops fell. One second. Icarus sprinted to a shop awning, closed for lunch, as Zeus suddenly unplugged the sky. The rain was so heavy it pounded off the road, while the wind threw the tables and chairs of the café opposite into mid-air. If the café hadn't been open, then it was now, and the weather had arrived to demand a feast. And if Icarus had been in any doubt who was behind the

storm, she was in none at all when a single fork of lightning landed at her feet in a huge letter:

Z

'What does that mean?' W cried above the gale.

Icarus leant against the cold concrete walls, her teeth chattering with fever. Z: Zeus's signal for the end. The letter he reserved for when he was so angry he had nothing left to say. Rewriting her fate? Having something to say? Going seriously off mythological message, to his mind, more like. Icarus turned to face the lightning as Zeus slashed and boomed her sins off the surface of the earth: from carbon dioxide smuggling to breaking the law to – worst of all – disobeying the very parameters of her quest. Coming up with a solution to climate change? She couldn't have come to a conclusion any further from it, Icarus agreed, hunkering down to touch the texture of the burnt letter on her fingertips.

'Don't touch!' Zeus boomed, stinging Icarus's ears as much as the Z singed her fingertips. 'Until I tell you to!'

'Oh, I'm sorry.'

'And don't speak until you're spoken to!'

Icarus pulled a face – she couldn't help herself. God of the Gods or no God of the Gods who was Zeus to dare misquote *Through the Looking Glass's* Red Queen at her. 'But if everybody obeyed that rule.'

'Ridiculous!' Zeus replied. 'So you've given up on climate change? Is that what all this is about?'

'I'm not quite sure I meant…'

'That's what I complain of, Icarus. All the ways you might have meant and never did! As if you had your own system of meaning, all

to yourself. So, if you have come to know quite as much about climate change as you proclaim, here's a riddle for you: take the weather from the climate, what remains?'

Icarus sat back to consider. For a millisecond it was like their surrogate father to son banter had re-surfaced. 'Well the weather wouldn't remain, of course, if you took it, and the climate wouldn't remain and I'm sure *I* shouldn't remain!'

'Then you think *nothing* would remain?'

'I think that's the answer.'

'Wrong as usual. My temper, Icarus, would still remain.' And on that note Zeus struck a final blade of lightning, roared a final boom of thunder, and was gone.

An hour later, when the sky rain out of rain, Icarus pulled W back out into the road. 'I'm scared Icarus,' W said, finally breaking the silence.

'Oh, don't be scared, W.' Strangely, Icarus had never felt calmer. The wind of her enthusiasm had long since been sucked from her, but now so too had the wind of her fears. 'How could things go any more wrong than this?'

If W hadn't already demonstrated his sizeable imagination, then he did now: beatings with olive branches, a lifetime of bicycle factory

hard labour, or even worse, being replaced by a carbon bike and taken to the dump.

Yet stranger still, the more hideous ends that W listed off, the less scared Icarus felt. She jumped off W and held him out before her before wrapping her arms around his gangly frame. 'We will be ok, W, trust me.'

'You mean, even after that, we're continuing? We're still going to Athens? After all?'

Icarus shrugged her shoulders this way and that. 'What choice do we honestly have?'

W smiled an upside-down smile. 'Oh, ok Icarus.'

The road ahead descended into the Erimanthos valley, where the river was so high it threatened to submerge the bridge. But by the time they'd climbed the next ridge the sun was emerging, and a view of the sparkling Ladonas river valley opened up below them.

'This is the environment *I* would imagine if I had the choice,' W said. The vegetation sparkled, the beehives were the colours of rainbows, while swallows prepared to migrate. Smallholdings were weighed down with vegetables, and cypress trees pricked the skyline. An old man walked slowly down the road towards them with no clear purpose in the world, while the mythical river Ladonas weaved its entangled thread of stories, a good quantity of mud and several tree trunks down the valley towards the distant sea.

Icarus nodded. It was among the remoter places in Europe, and none the worse for it. 'The prettiest landscapes are always the furthest away ones after all...'

At the head of the valley the road inevitably began climbing. Icarus wiped her fever from her brow where the weather extremes had upset her thermostatic balance. 4.30pm, and it had already been an eventful enough day to last a month, a year, a quest – and thirty three kilometres still to go. The road followed the river upstream, higher into the rugged mountains, hugging the sides of a gorge,

narrowing to single file or pinned by a platform to the rockface when space ran out, and through villages where time had become an irrelevance. In Stavrodromi, two aged farmers passed by with vacant looking donkeys pulling empty trailers while some men played out a lifetime's game of dominoes on some rickety tables and the old women compared lace patterns and gossiped by their overflowing flower baskets.

'Why is everyone so old?' Icarus asked.

'It's because time's so slow and there is so much weather up here. The people age quicker,' W explained, authoritatively.

<p style="text-align:center">♠</p>

The light had already begun to fade when their destination of Langadia appeared ahead, tumbling down the hillside like ivy. And upon closer inspection, what had at first looked like giant ants crawling up the ivy turned out to be funeral mourners, toiling their way uphill towards the tolling church.

'I can't interrupt their mourning for something as prosaic as directions to the campsite,' Icarus whispered to W, pointing at the campsite symbol on the map, of which there was little evidence on the ground. As it was, the pair of them felt self-conscious enough just cycling slowly past, Icarus glad of her black lycra and W for his black frame. But by the time they had reached the far end of town there had been no further indications of a local campsite. Icarus drew up and pulled her mappa mundi from the bag. 'What now?'

The only obvious option was the next campsite symbol, ten kilometres further on in Karkalou, over the summit of the mountain pass. Icarus and W climbed while the light kept fading in inverse proportion to the gradients and Icarus's anxiety. Even when they began to descend, the next valley felt untouched by tourism, while Icarus had never met a village less likely to be home to a campsite

than Karkalou. It was mainly a road junction, with a roadsign, a boarded-up shop, a petrol pump and several houses.

'We could always camp rough?' Icarus proposed, with a shiver which W's mention of brown bears and wolves didn't ameliorate.

'But do we have anything to eat?'

Icarus nodded, doubtfully. 'We have a square of nougat.'

Within minutes of arriving a small gathering of poverty-stricken locals had gathered to stare.

'Excuse me, do you speak English?' Icarus asked. 'Would you tell me the best way out of these mountains, please? It's getting so dark. I need to find a place to spend the night.'

The small group's expressions were unedited, frank. They shuffled, muttered and shook their heads in an irritated way as if to say, 'how dare you shame us by suggesting that we didn't understand a word that you just said.'

Icarus took a step back, and held her hands out, palms up. 'Camping?'

This word had at least seemed universal the breadth of Europe, but the shuffling on this occasion represented an even more emphatic, 'no'. One of the men even ran his finger across his throat as if to suggest that the campsite owner had been murdered, or the campsite had, or that if she dared to stay there she would be. Icarus laid her head on her hands as if sleeping, hoping they might offer her a bed for the night, but the group waved her onwards.

'Dimitsana,' they said, the name of the next village due south.

Icarus received the news as if a physical blow had been landed on her body. She held her hand out at different angles: flat? Uphill? Downhill? *Slightly downhill of flat.* At least that.

By the time Icarus reached the hilltop town of Dimitsana it was completely dark, and in the absence of a local cash machine, whether they even had enough money to pay for a room was debatable. She jumped off W and pushed him up a narrow cobbled alley, following

a small handwritten signpost for DOMATIA, hoping she would find some cheap as sawdust hovel at the end of the lane. Of course, no. The house was smart and modern and its manageress stylish and chic. Icarus balked at the door, but the woman reassured Icarus that the price would be ok, indicated a place on the patio for W, and led Icarus indoors. When she had gone Icarus flopped her fever onto the double bed. On the back of the bedroom door the usual price list was printed. She let out a small cry. She'd just been charged a quarter of the going rate and even had enough money left to buy dinner.

So this was Arcadia, Icarus thought the following morning, shaking her head clear where her fever had departed and looking over the end of the terrace beyond Dimitsana where Megalopolis's power stations were filling the Loutras valley with cloud. The locals' behaviour in a bar at breakfast time had certainly proven wild – in the most spoilt, unharmonic kind of a way. Icarus hadn't been about to be served a morning coffee if she had waited for eternity.

The bar had been already busy for 8am, but the waitresses were attending admirably to the needs of the Greek orthodox priest, the local builder, King Teuthis and a street-cleaner. Dimitsana had been

a rebel stronghold during the War of Independence, and there was the rebel leader, Kolokotronis, playing dominoes with the supposed village intellectual and the supposed village idiot. But Icarus was being ignored; she had removed herself before the bar's misogyny could become her.

'Et in Arcadia ego,' W said.

'Even in Arcadia, there am I.'

Today they were heading off-route, off-guidebook, and where better to test out off-guidebook ideas about the environment than the original pastoral idyll? All began well. The road ahead followed a high-level terrace to scenic Stemnitsa before bearing west, into the pastured wilderness. Arcadia was already feeling magical, in the most timeless of ways. The grass shone with glitter and the blue sky was smooth as an unbroken china vase. Icarus stopped to photograph some distant sheep dogs that had been left overnight to guard the flock. It was as if someone had lifted a romantic painting and placed it in front of Icarus's camera lens. Except romantic images didn't tend to pixelate when you zoomed in, and neither did romanticised dogs suddenly leave the picture and make for you. Icarus threw her camera back into her bag and began pedalling.

'Oh, oh,' W said, with exaggerated understatement.

Even yesterday when she had fled the storm Icarus hadn't pedalled this hard; still, with every stroke, the barks were getting louder.

'Faster!' W yelled, hopefully.

The anaerobic lactic acid cut through Icarus's quadriceps, while the barking neared. A bend and dip in the road ahead offered their only chance of escape. Hopefully the dogs would lose interest once they were out of sight because there was no chance of outcycling them.

'Anatolian shepherd dogs,' W panted. 'Bred to protect flocks from lions, cheetahs and wolves. Although they're a bit big for that. Kangal dogs perhaps – Kangals can run over thirty miles an hour, you know.'

Icarus was quickly learning. The dogs had already reached the road and were now bounding up it towards her. She could feel their paces in the surface, in the beating of her heart, in the throbbing of the blood behind her eyes. A right arm severed at the shoulder socket. Another dog's jaw clamped around her neck. Icarus dug in for a final sprint: letting her momentum throw them round the bend, and *down*...Icarus didn't dare stop cycling until they were at least a mile away in the shelter of some woods where she bent double over W's handlebars. 'If I have to die, then I'd prefer it didn't happen at the jaws of a rabid dog. Ok?'

If only Arcadia had stopped to listen. They were barely a couple of miles further on when their path was blocked by two huge mastiffs guarding a scrapyard, and currently patrolling the road. Icarus looked at them. The dogs looked at her. 'Quick!' Icarus yelled, hearing a car approach. It was less a case of speed than timing. Icarus swept past the dogs at the precise moment when the Fiat Punto came between them. The dogs launched themselves at the car's body with a horrific gnashing of jaws on crushed metal. By the time the car was past, Icarus and W were already gone from sight.

 i had watched on television
 as the oak trees of arcadia burned

 the deepest shades of sunset
 i had ever seen and the pathos of gesture

 hosepipes
 buckets
 and the sea

 you left us twisting skyline vertebrae of trees
 these spider webs of diamond dew

At the bottom of the hill lay a wooded river valley. The sun cut through the trees. The ground steamed. The spiders' webs sparkled like bejewelled labyrinths and the thistles cast early morning shadows on the earth. Icarus and W held their breath. The hillside above had been devastated by forest fires where the Greek Peludas had come before them, but the atmospheric magic still felt brittle enough to shatter with a footstep out of place.

'How would you like to be just now, W?'

'I think I'd mainly like to be silent Icarus.'

Time remained indistinct, and it was an uncertain five minutes later when a young man appeared out of thin air, with the hindquarters, legs and horns of a goat.

'Hello,' Pan said, resting a hoof in the nook of his waist.

'Are you going to play a tune for us?' Icarus asked, whistling one of her favourite ditties, hoping the man-creature might join in on the pan-pipes strung around his neck.

But Pan just turned up his nose at Icarus's taste in music and began playing some pan-pipe hip-hop instead. Once Pan's tune was finished he held his hat out for contributions. Icarus didn't hesitate to donate her last coffee money, if it meant that she would *never* have to listen to this variant on 'music' *ever again*.

Tripoli was Arcadia's principal town, and not attractive at first sight, nor upon closer inspection. Multi-storey apartment blocks led to a highly congested centre, and the air suspended the type of story molecules most modern towns wished to forget. Greek rebel troops had once massacred twenty thousand Turks before the Turkish forces destroyed the entire Medieval quarter in revenge. But at least modern Tripoli had banks, and a huge Alpha Beta supermarket. Icarus even dared wonder if there might be a bike shop nearby. 'I've

seen more bicycles here in twenty minutes than in the rest of Greece.'
As it turned out Icarus only needed to frogmarch a pale, shaking W
one hundred metres up the next street.

'If we really must,' W stammered.

'Yia, sas,' Icarus said to the woman behind the bike shop till – the
Greek for hello, an apparently uncommon greeting she had seen on
page thirty eight of the Lefkada phrasebook. 'Do you speak English?'

Both the woman and her bicycle mechanic husband admitted to
speaking 'a little English,' which was more than enough for the
mechanic to admonish Icarus. He pointed, tutting, at the brakes.
'There's nothing left of them! How did you ever stop?'

'Well, you see that was the problem. I couldn't.'

While Icarus waited for W to be repaired she browsed the high-
tech bicycle gadgets for sale.

'GPS,' the shop assistant clarified, noticing Icarus's furrowed
forehead. 'You can use it to plot your route. It saves carrying maps,
and prevents you making wrong turns.'

'Oh,' Icarus replied, thinking, but if you don't take any wrong
turns, how would you ever satisfy your curiosity or learn anything?

If W's smile was anything to go by on his return, then all had gone
well. New brake blocks had been fitted, his bottom bracket had been
regreased and was running smoothly, and all twenty one gears were
working rather than fourteen or fifteen.

'Where have you come from?' the mechanic asked. 'Where are you
going?' As Icarus explained, the man wiped his filthy hands on his
mechanic's apron. 'You are going to the conference?'

Icarus nodded. 'In fact, I'm a delegate!'

The man shook his head. 'You are crazy.'

There was only one last dog to go before Icarus and W left Arcadia for good. It was one of the hottest days yet and the sky had turned that exhausted shade of blue reserved for afternoon. The road cut a line across a fertile valley before climbing over the shoulder of the vast bulk of Mount Artemision, whose rugged summit ridge was lined with wind turbines. But more immediately, a huge stray wolf dog was padding possessively along the white dashed lines in the middle of the road ahead. The verge was too rugged to carry W, there were no alternative routes, and it was far too hot to sit and wait, with no shelter.

'How about I try whistling?' Icarus proposed, for want of any better ideas.

'Well, so long as the dog likes your tune,' W replied doubtfully.

Icarus adapted her tune as well as she could to the canine threat:

rotation around a triple axis
 maintaining equilibrium
 easy as that

it isn't what you say:

 our pitching rolling yawing
 in relation to the earth

driving chain-drive diamonds
to the sky

 banking the angles
of cumulus as a pitch on sun

we talk of longitude
 lean into it

 a side-slippage near zero
 a wing camber of ways to say

the earth was smaller blue
at an altitude of airlessness
a brake upon infinity

please take this singe of muslin wings
spruce wood spokes which burn
at boiling point

And in fact it must have been the type of tune which the hippy hobo
dog liked best. He didn't even break his stride as Icarus freewheeled
past, just lazily rotated his head to check them out, nodded casually,
as if to say 'hey dudes,' and kept on lolloping.

Icarus and W
climbed up to the
Kolosourti pass where
the view opened out
on the Argolikos gulf
– the sight of the sea
marking the far side
of the Peloponnese
peninsula causing
Icarus to cry out:

'we're going to make it! We're really going to make it to Athens, W. I
finally now believe it.'

Having taken the hairpin bends of the descent at the high speed
confidence of new brakes, not even the fact that the campsite in Myli
was another figment of the Mappa Mundi's imagination could dent
Icarus and W's smiles. Right then Icarus wasn't even bothered by the
multi-headed Hydra that leapt out of the verge near the dried-out
shores of Lake Lerni to attack her. 'Oh, away with you!' she said,
flapping away its many poisonous heads as if it were a gnat.

If Arcadia had hardly proven a pastoral idyll, then on first appearances, Ancient Greece didn't look very ancient either. The ancient site of Argos hid on the horizon behind a modern façade of petrol stations, advertising hoardings, telegraph wires, and rush hour traffic. And the architecture of the modern village of Mycenae was characterless, even if its ramshackle campsite owner wasn't.

'Welcome, you can pitch anywhere,' the woman said, bursting from thin air like a genie and extending a toothless smile. She was wearing seven scarves and eleven skirts and more colours than three rainbows, and was shivering as if it were the depths of winter. The site, meanwhile, was basic, the toilet block an exercise in kitsch, and the showers lukewarm. Yet the generously spaced pitches were shaded, separated by narrow benches to eat dinner from, and later that evening the woman's husband strung up a line of lights around Icarus's pitch to enable her to route-plan beyond dark.

'Do you know what tomorrow is?' Icarus barely dared to whisper to W through the canvas once she'd snuggled up to sleep.

when wireless forms connect with smoky tops
then this would be a wilderness
400 million years from now

an avatar of a whole new
planet running hand in hand with the trees –
never changing places no matter how fast I run

satellite images integrating allegory –
designed to deceive

the database aesthetic of dynamic
change as the earth lets fly
regenerating the residential side
of the blood that worms

there will be a square which is all forest –
 the leaking roofs
 the broken flooring
 the rotting woodwork

i thought i'd try and find my way
 looking backwards through
the weather glass of signs

when I asked the foresters the influence
of their expression they spoke of many landscapes:

 clocks all set to different times.
 a world of 3D trees and answers
 sensible as dictionaries

i dived beneath the surface
 coral layers marked out in stages
of their own selection –

 brachiopods and sea lilies
 the sounds of crushing shells

the bluest planet rested in the settling pools
reflected in the light

 the highest geometrical ratio of
its increase – thoughts that hurt

i doubted I would ever feel inside the earth
 a passage to a place i used to play
marked out in squares of black and white

Icarus had fallen asleep before W had had the chance to respond, leaving W troubling over the question all night. 'So what is today?' he asked the following morning.

Icarus smiled. 'Dear W, you will be pleased to learn that today is the day we cycle into Athens.'

W's face was a mixture of excitement and also troubled confusion that their well-laid plans were once more being changed. 'But I thought you said it was too far to cycle in a one-er?'

Icarus grinned. Now she was in sniffing distance of Athens, anything suddenly felt possible.

'One hundred and fifteen point two kilometres,' W estimated, looking over Icarus's shoulder at the Mappa Mundi.

'We cycled much further distances in Italy!' Icarus exclaimed, her expression bursting with an enthusiasm in stark contrast to W's increasingly mimsy appearance. His handlebars were drooping lower than a racing bike's. 'What's up, W? You didn't even look this miserable when I let slip that the Peluda had died – way back in the Loire.'

'You still want to get there?' he asked in a timid voice, stripped of his characteristic bravado. 'Considering Zeus's anger and everything? I've witnessed bicycle capital punishment, you know, down the dump. I can't imagine it's any nicer a prospect for you.'

Icarus sat down beside W to talk at his level. 'But I've never done anything like this, W. And even if I don't want to persuade anyone of anything, it's the least I can do to share my experiences. If I don't see it through I'll spend the rest of my time wondering what if. You willing to join me for the last leg?'

'I'm glad of that, Icarus,' W replied, sniffing and blinking away his tears as if they had been a figment of Icarus's imagination. 'I was worried you'd be a little scared and pull the plug on me.'

The moment could easily have become painfully sentimental had it not been for the stray cat, which suddenly appeared from nowhere, tore a huge hole in the side of the tent, and scampered off with as much food as its emaciated body could scatter. If Icarus needed any further impetus to get to Athens that day then homelessness was it.

There was only one last bit of business needing attending to before leaving. It was still early and the ancient site of Mycenae was just opening. The sun, reversing the direction in which it rose and fell, had instigated the bloody downfall of Ancient Mycenae's House of Atreus, providing the basis for Atreus to argue for the reversal of his brother's election as king. Icarus was the site's first visitor that morning and bore no illusions to Kingliness nor any desire in the slightest to reverse the direction of the sun – for fear she would have to then follow it all the way back north west across Europe.

Stray dogs were already sunbathing on the path up to the site while two headless lions guarded the ancient gates above the precise place where a snake slid over Icarus's toes. Icarus weaved slowly through the labyrinthal remains until she arrived at a single olive tree at the uppermost point of the site where she reached into her pocket and removed her weather glass for a final time.

There was something almost ritualistic about the way she refilled the glass with blue water and then slowly reached out to hang it off a mid-height branch. She then reached into her bag and removed her copy of *Through the Looking Glass* and laid it at the base of the tree.

'Thank you,' she said. 'For absolutely everything. But I must leave you here where you might be of some help to other travellers – as mementos of our acceptance of the eastern rise and the western fall of the northern hemisphere sun. May other travellers voyage through you and see what I have seen. May others experience the world from the perspective of the sky. For surely our only remaining hope resides there.'

'You will fly the middle way,' Icarus thought she heard the weather glass reply. 'Not too close to the sea nor too close to the sun.' And the looking glass recited some good luck poetry – for the road:

a weather glass, a sunny sky
lingering onward dreamily
in icarus's eyes

if anyone is filled with fear
then eager eye and willing ear
pleased by a simple tale to hear

long has paled that sunny sky
echoes fade and memories die
autumn frosts have slain july

still it haunts me, phantomwise
climates moving under skies
never seen by waking eyes

if anyone is filled with fear
then eager eye and willing ear
lovingly will nestle near

in arcadia we lie
dreaming as the days go by
dreaming as the summer dies

ever drifting down the stream
lingering in the golden gleam
of life what is it but a dream?

Icarus followed the blue ray of light that the weather glass cast ahead in the direction of Athens. She clasped an outspread fingerful of it as she went and held it to the earth. The sky wasn't blue after all, she thought. It wasn't even reflective, it was see-through.

By the time Icarus left, the first tour buses were arriving, and German tourists were already queuing outside the neighbouring tomb of Agamemnon. All that remained was to safely deliver themselves to Athens in time to face the weather.

Icarus and W set off through rolling countryside, dotted with olive trees, but the landscape became increasingly developed. The Ancient site of Korinth sat on top of a hill near the north east corner of the Peloponnese peninsula, but further on lay the modern city. Across Europe Icarus had done her best to avoid towns, and even on the Mappa Mundi Korinth looked like a navigational nightmare, which Icarus had dreaded all morning. And frankly anything Icarus could have done right then to speed them more quickly and with less effort to Athens was worth a moment's consideration. It was suddenly as if the relief of near arrival had accelerated Icarus's fatigue; fully realised it for the very first time. 'See this road?' she said to W, pointing to a recently constructed motorway that cut a corner off their most immediate route, avoiding the city entirely.

'So cars can travel a more direct route by motorway. What's new?'

'What's new is this,' Icarus replied, pointing to a slip road, beside which a green motorway sign indicated the usual restrictions – no pedestrians, no tractors, no horse-drawn chariots. 'Do you see anything banning bicycles?'

'No, but...'

But before W could even finish his objection they were already rolling along the motorway hard shoulder. 'Vorpal! How about this W?' Icarus cried, spreading her arms as wide as a bird. They had far more room than most single carriageway roads offered bikes, the surface was smoother, and with undoubtedly less traffic. Icarus's heart jumped when a police car passed, but it soon sped off, uninterested. 'If I'd known bikes were allowed on Greek motorways I'd have cycled more of them.'

The motorway was raised above the land, offering a panoramic view. Humanity had built itself into almost every element of the surroundings, from the concrete industrial environs of modern Korinth and its neighbouring petroleum refineries to a bird's eye perspective on the one hundred metre high cleft of the Corinth canal. Icarus drew her breath in with excitement at the architectural marvel, lent W up against a crash barrier and clambered down the embankment, through the barbed wire, to more closely investigate.

'I knew it was unwise from the beginning,' a tramp called out from beneath the motorway bridge arches, waving a bottle towards the canal. His beard was dreadlocked down to his toes, and his tattered clothing bore evidence of styles not fashionable since ancient times. 'I told them ill would befall anyone who tried to build it. Nero dead, Caesar, Caligula assassinated, and look at it now. Shipping? It's barely wide enough these days to let pleasure craft through, let alone commercial boats.' He swigged from his bottle then held out his hand. 'My name's Apollonius of Tyana – famous philosopher. You?'

'My name is Icarus. And I'm a poet. Is there anything you would like me to tell the world? You know, in my next poem?'

'You tell them this, Icarus. If they continue cutting swathes through the sky just like they've carved up the land, they will confront the limitations of their imaginations soon enough.' The philosopher cast his hand towards the canal again. 'A bit like this. Soon the sky will not even prove big enough for aeroplanes, mark my words.'

Having returned to W, Icarus's motorway adventure was inevitably as shortlived as her good behaviour remained in limited supply. 'Well, I didn't say it was legal as such, just that nothing indicated it was illegal,' Icarus said as she balked before some toll booths ahead.

'Oh, *Icarus*. Are you determined to get us into trouble? I'm not sure I like this devil-may-care you. Where's the anxious young woman I set out with?'

When the young Greek tollbooth assistant saw them she froze. 'Adjgbaeioutg zuoxdita aileh adud!' she exclaimed, swishing her uniformly straight long brown hair from side to side.

'Do you speak English?'

'Yes, a little. One minute – you must wait here. You must not go anywhere!' The woman retreated backwards to keep them in her sight, before returning in the company of a manageress with a ferocious hairbun.

'Come with me,' the hairbun ordered, leading them away.

Icarus's imagination ran through the full range of potential consequences but what actually happened didn't even make her list.

'You must leave here, before the traffic police see you,' hairbun said, beckoning them politely through a gate onto the coast road.

Icarus and W needed no second invitation. They were off.

'How about we practice being good again today?' W suggested. 'It would be stupid to get arrested now. No more mischief, ok?'

But it was not to be one of those days. Only a few more miles further on the convoluted towers and tubes of a petrol refinery made quite an aesthetic spectacle on the blue sky. Icarus stopped to take a photo of the lines and angles the building made on the sky but had only taken one snap when:

yelled a security guard, racing towards them. He was traditionally dressed – day old stubble, matching dark hair, shades, a cap. 'What d'you think you're doing?' he yelled in perfect English.

'I was taking a photograph of the tower.'

'But why? Why photograph this?'

Icarus curtsied as she tried to think of an answer which might buy them some time. 'Because I think it's beautiful,' she eventually muttered – the most feeble but truthful account when faced with a security guard intent on trouble. She handed over her demanded passport.

'Do you not know it is illegal to photograph this?'

Icarus shook her head.

'Why are you here? The climate conference? You are not a Turkish terrorist?'

'Certainly not. No connections at all.'

'And you're called Icarus?' Suddenly, with no warning, the man burst into so much laughter that his love handles exploded from his belt, causing his blubber to spill and fall and tumble out over the road.

'Quick!' W cried. 'Before it melts my tyres!'

there was always going to be
a long way to fall which was as good a reason
to live upon a curve as any

the earth just kept on rolling
(we wore it with the offskew
elegance of an egg)

inside the sea over yonder
four elderly heads are ducking for apples
what a nice day! i exclaim

The race (they keep on saying) is about to multiply

Icarus had expected the approach to Athens to be an industrial wasteland. And apart from the Kakia Scala – a ten mile stretch of road clinging to limestone cliffs several hundred metres high – it was. The town of Megara bulged and spread over the surrounding countryside like a disease. And there was scant countryside separating Megara from the next town of Elefsina, which had once been the site of the Eleusian mysteries – annual cult-like ceremonies held to celebrate Persephone's symbolic descent to and subsequent ascent from the underworld. Demeter had threatened to render the land barren if her worship at Eleusis ever ceased, and her threat had been realised. The bay was scattered with abandoned ships, both upright and capsized, while shipyards continued to produce new vessels. And next along there was the largest oil refinery in Greece, commercially emblazoned warehouses…forty percent of the country's industrial output spread across the Eleusian fields like polluted manure.

'Research has shown that the particularly hot climate here is the result of the concentration of industry,' W pointed out. And their own day was similarly about to heat up beyond precedent.

A traffic policeman by the junction into Elefsina had informed Icarus that the motorway into Athens was the only motorway bicycles *were* permitted on in Greece, with a logic even he admitted was twisted. If only they had been banned from it. The luxury of motorways with hard shoulders became but a memory as the rutted surface switched between two and three narrow lanes. The traffic barely slowed down to merge, it simply crammed slightly closer together and drove faster to avoid colliding with itself. Ahead of Icarus and W buses stopped suddenly in the inside lane, without signalling, to pick up passengers waiting on the verge. Cars and lorries and motorcycles sped past – inside and out – and the air spun out of control with fumes in a motorised carnage of which neither of them had seen the like.

'This is bicycle suicide,' W shouted. 'If you'd have asked my advice, I'd have said to take the long way around, but it's too late now!'

Icarus gave them as little as a fifty percent chance of making it off the motorway unscathed. They had even managed to coincide with afternoon rush hour. When she drew into a petrol station everyone stopped what they were doing to watch what this crazy individual and her bicycle might do next. Icarus bought a two litre bottle of water and downed it in one before crossing all her digits and rejoining the *road of death* – as it had locally become known. 'Is Athens never going to arrive?' she shouted, counting down the kilometres, as if their fate depended on the city delivering itself to them. But just when it looked like Athens was travelling as quickly in the other direction as they were travelling towards it, they found themselves in its outskirts, where the traffic suddenly slowed.

Icarus and W climbed the final incline towards town. To their right they passed the botanical gardens, where gardeners delivered an unfortunate selection of plants into this fume-fuelled world. To their left a signpost indicated a campsite.

'We're not stopping?' W asked.

Icarus grinned. 'No fear, W. Tonight we're staying in the conference hotel.' But no matter how much of a relief it was to be within Athens' city boundaries, they hadn't truly made it to Athens until they had seen the Parthenon.

'Look, Icarus, look!'

When Icarus raised her head from the road she first saw the car up ahead, and then a sign for a Ford garage, and then a roadsign indicating the road was about to split in six. But beyond it all, undeniably, was the Acropolis, basking in the late afternoon light. Icarus pulled up on the verge. Two large tears fell down her own face, and then two large tears slipped down W's head tube, and then they both began to sob.

'Oh don't cry!' climate change begged. 'Consider what a great protagonist and bicycle you are! Consider what a long way you've

come! Consider what o'clock it is! Consider anything, only never cry.'

Icarus had lost count of how many impossible things she'd believed at once. A talking climate she could certainly contemplate, but having made it all the way to Athens by bike? 'Thank you W!' she exclaimed. 'Thank you Lucy. Thank you Alice. Thank you climate change. Without any of you I would never have made it here today, believe you me!'

Part 6: The Athenian Climate Summit, 9/9/2010

Good in the room, yet,
we talk, and little payments
are even more rare

 the direct translations
 more or less
 contain themselves

to change

 two degrees

 of this
 consensus.

 If we continue

 The same architecture
 continues

 Bloated, and unreadable

So this was finally 'it'. The end, the beginning, and the present all at once. When they made it into the labyrinth of central Athens, Icarus had one final surprise in store.

'We're staying *there*?' W exclaimed, admiring the shimmering glass frontage of the five star hotel.

Icarus held out the invitation. 'It's the conference accommodation. Look, it says so right here.' However as she followed W's gaze she

struggled to share his admiration. A bit of comfort and luxury would certainly be delightful after five weeks and two days spent galumphing around on a camping mat. But after living off survival rations to here the hotel's opulence was suddenly too much. How many days of cycle-travel could have been afforded for the price of one night's stay? The multi-storey hotel looked down on Athens: an embodiment of luxurious contemplation; its mirrored windows a reflection on humanity's self-love and its surrounding climate to Icarus's eyes.

W had spent the last few minutes preening himself. 'You could at least give me a spit and polish, Icarus. You never know who I might meet. Let's pretend that you're a God and I'm your chariot of fire.'

W's hopes for an appreciative welcome were soon shattered by the hotel doorman, before they'd even crossed the threshold. 'Left luggage,' the characterless man announced authoritatively, wheeling a squealing and writhing W away with the tips of his white gloves.

'But he stays with me, as a regular rule...!'

It was too late, and everyone in the lobby had already begun staring at the peculiar woman calling after her battered bicycle. Yet when Icarus went to check in she was treated no less snootily. 'Passport please,' the receptionist asked, turning up her nose at Icarus as if to say, 'look what the weather just dragged in.' Icarus already imagined this might be the last time the hotel agreed to have an *environmental* gathering to stay, although admittedly every other delegate was looking smarter than her. But she bet none of *them* had

fallen through the atmosphere, undergone a gender metamorphosis and then cycled the breadth of Europe for the privilege.

Certainly, thinking back on it, Icarus wouldn't have said that she *didn't* enjoy her dip in the hotel's rooftop pool. She coped splendidly with the jacuzzi bubbles easing her aching legs. The complementary cocktails she was obliged to consume as she sunbathed in the early evening sun, admiring the view over the Acropolis, was a passable way to contemplate any climate. And Icarus felt only a little bit smug, leaning over the rooftop terrace watching the build-up to the conference begin in earnest in the streets below: singing, shouting, and even fighting between opportunistic local gangs, protesting environmentalists and the police.

STOP CLIMATE CHAOS!

shouted banners in all languages and colours. Far from it, to Icarus it looked like chaos was about to begin. However, later that evening, she did feel rather guilty about the mezze platter she enjoyed in the hotel restaurant, which would have been easily enough for two. As a mark of respect for W – who had been left with any food scraps he could find in her panniers – she didn't leave a crumb.

'But where were all the Greek Gods staying?' she wondered, looking around at the anonymous faces of the other delegates. Surely there had to be *some* characters she might recognise from her past? Or, after all, was this just the final joke on her, and her Satanic presence had been parachuted into a gathering of humanity's plebs? And who better to ask that question than Zeus, Icarus thought, leaping from her feet as she suddenly spotted his security entourage sweep into the lobby in the distance.

In the instance of recognition all sense departed Icarus. 'Zeus!' she cried, sprinting in that direction. But she arrived a second too late as

the lift doors closed on the tip of her nose. Icarus looked for the stairs. Perhaps her ideas had just been lost in atmospheric translation, and Zeus would understand everything once they got the chance to talk things through. Yes, he had undeniably vented his anger in the most unambiguous of ways. But what better time to resolve this than now, before proceedings began? Icarus took the stairs three at a time; by the time she reached the top floor the hotel's altitude had quite taken her breath away, leaving none to spare when she confronted Zeus's security Titans around the first corner.

'What d'you want?' the advancing brutes demanded, banging their clubs in their twenty four inch palms.

'Room service?' Icarus tried, unsuccessfully, before turning on her heels to flee.

It was only when Icarus spread herself out like a lonesome starfish on her king-sized bed later that night that everything finally caught up with her. Icarus, climate change, a talking bicycle, a weather glass, the looking glass, and a sex change for good measure? Her limbs sank into the mattress as if it were made of wet concrete. The 'real world' she had suddenly re-entered felt alien compared to the questic realism that had become her imaginative world as of late. Icarus had barely spent an hour indoors at a time all quest and now the climate-controlled hotel interior pressed in against her head – as if trying to compress her thoughts about climate change into different shapes.

Did she know what tomorrow was? Icarus now asked herself. The potential consequences of delivering her conclusions about climate change to the conference made Icarus balk. And if her own myth really did symbolise humanity's journey with climate change, then what for humanity when their antihero has gone and lost her plot?

beyond the road
 the daily sense of blinking water
awake despite ourselves

 we spent the morning indoors
 workshopping planetary dead ends

 could we climb this one?
 how did the last one begin?

a washed up pier

 the first man and the first woman
are left to grow in the purposeless heat
 constellations of paperweights

 sea ice
 – which should not have been possible

 liquid fossil clocks
 seen from the angle of the sun

our focus held the concentration of anniversaries
 burning years

 take these bits of aeroplane
 traffic cone
 and secondhand whale

 a preference for averages
 risking routines of change

 whose house were we really in?

we decide to build it here before we can
catch hold of anything more wonderful

submerge our globes in little alchemy
 mouthfuls collapsing into tables

doll's head trucks passed by
by music
eyes I thought we had put out

every day is a beautiful day
we hoped
the scale of windows

the more we looked the more it simply
wasn't there

The previous night's climate chaos was nothing compared to the following morning's. 'Have fun?' Icarus asked, collecting W from left luggage.

W pulled a grim smile. 'Not so bad. Made a few friends – suitcases mainly, some mule panniers, a chiton tunic bag or two.'

The hotel lobby was frantic with delegates rushing this way and that, competing over whose mobile phone conversation could look most urgent. Outside, the streets were already overflowing with workers, shoppers and protestors alike. It was several miles from the hotel to the Pnyx, the site of the Athenian democracy, and the procession in that direction had long since begun. Icarus dodged the briefcase corners of a pinstriped businessman who was using his best weapon to get out of there, fast.

'Thwack,' cried the large paper shopping bag of a bouffanted lady, insisting on her right to continue shopping through the mêlée.

'Give us a lift will you?' cried a plucky young chap, with multiple piercings, an orange beanie hat, and a stripy t-shirt.

As if there was any chance of cycling anywhere! W was already getting in the way of everyone, his bar-ends jabbing people in the sides when they least expected. It was still several hours before events began, but already the crowd had formed a surging wave of bodies. Already the ground was littered with rubbish. Already the

volume of noise was pushing the air to breaking point. The protestors were a motley bunch of not only dreadlocks, t-shirts, henna tattoos and a rainbow of banners, but also the occasional suit of the professional campaigner, and a veritable zoo of endangered species: cave beetles, polar bears, and...'Hey, look W, is that not your friend the Peluda, just up ahead, come back to life for the occasion?' Icarus realised her stupidity immediately. W could see nothing but the bottom of the campaigner immediately ahead.

'This is my least favourite climate yet!' he cried from low among the mass of bodies.

'Coffee and a biscuit?' Icarus extracted W from the wave's momentum, where she could better see her trembling friend and the trail of tears winding down his forks. 'Hey, W, are you ok?'

'Just hot and sweaty, Icarus.'

'Well, ok, but if you need to talk...'

When W finally did speak, his voice kept breaking as if the heat was cracking his paint. 'I've waited forever for this, Icarus. Thank you for everything. This quest alone has made my life worth living. I hope you know that?'

It could only have been a matter of time before the issue of Icarus's female form might have to raise its problematic head, but it took two coffees in a nearby open-air café before W could persuade Icarus of this. Before bed the previous night, Icarus had prepared her props: some strips of black lycra she had cut from her cycling shorts to strap around her breasts; three pairs of socks to stuff down her pants; but she was particularly proud of the bag of leg-hair trimmings she'd shaved to make an adolescent beard. Icarus had become accustomed to the way that climate change and the world had re-cut her, but here she was again, recutting, and being recut. 'I hope you've a good

hand at pinning and tying strings?' she said to W. 'Every one of these things has to go on, or in, or under, somehow or other.'

When Icarus returned from the toilets, transformed, the occupants of the neighbouring tables gave her some reassuringly puzzled looks – as if something had changed, and they couldn't quite put their fingers on what. Icarus supposed it had something to do with the fact that she looked no more convincing as a male adolescent than she had made a convincing woman.

the people are changing flavour

we declined masculine
or feminine or neuter at the boundaries
of the grammar rules dictating taste

A is for the end of woman
Zero ended man

they said i was created in use for use

take your choice of my reduced body
i will be naked
for i have left it out for you

you do not have to live here
i am merely passing through

By the time Icarus and W returned to the road, the wave of climate change protestors had overflown the pavement and spilled onto the road. All cars had long since been brought to a standstill. Some samba drummers had climbed onto a van's roof, from where they pounded out the beat of the march until some police brutes bundled them into the back of an unmarked truck. The atmosphere had

become so tense that the whole thing risked going up the next time someone lit a cigarette.

'I'd be finding a back route to the Pnyx if I were you.'

Icarus turned to face a polar bear, addressing her in grammatically perfect English, with a strong Greenlandic accent.

'Your bicycle's only going to get trodden to the ground otherwise,' he added, as if he knew precisely what it felt like to watch your space on earth retreat before your eyes.

Icarus needed no second invitation, and at the next opportunity pushed W into a side alley.

'The underground?' W proposed.

The underground had other thoughts. NO BICYCLES, read a large sign above Omonia tube station, in big unambiguous red lettering in both Greek and English script. 'Shall we?' Icarus asked. 'We've got little left to lose, and just think what we could gain?'

A heavy hand laid itself upon Icarus's shoulder before she made it to the escalators.

'I don't think so, son,' the security guard said, leading them back outside.

Icarus flopped down on a bench like a rag doll, unable to even feel any pleasure at the security guard falling for her disguise. Had they come this far only for W to be turned back for being a *bicycle*?

W's handlebars, meanwhile, were drooping lower than she had ever seen. 'Oh, just leave me here and make your own way,' he said. 'You'll be late otherwise, and at least one of us had better make it. At least *he* fell for your disguise.'

Icarus shook her head. 'No way, W. We're in this together. It would mean nothing without you by my side.'

'But what else are you going to do?'

Icarus had been just about to announce that in fact there was nothing to be done about it, and that perhaps they should head for

the beach today instead, if it hadn't been for the way the sand got stuck in W's sprockets and…

‎♠

'Yo, so you made it?'

When Icarus looked up she came face to face with the cheeky grin of none other than her favourite carbon dioxide particle of all, who was hanging his attitude off the end of the bench. 'Billy! I was wondering what had happened to you,' she lied. 'But what *are* you doing here? Isn't it dangerous with all these protestors in town?'

'No fear I'd miss the party of a civilisation. And I might as well hear straight from the donkeys' mouths what our fate's gonna be.'

Where W's frame had become deflated, it was now tense as he muttered, 'who on earth is *this*? I thought you said your carbon dioxide friends were gentlemen.'

Billy guffawed. 'Me? I thought you'd clocked me better than that Icarus. But come on, let's get going.'

'Go where, precisely?'

'To the Pnyx of course, stupid.'

'But we can't get through – that's the whole point. Why else do you think we'd be sitting here feeling sorry for ourselves.'

'No, I mean *come with me*. I know all the back ways – trust me. I figured I owed you a favour after helping smuggle me into the atmosphere. Quick, we've no time to lose.'

In the circumstances not even W argued as the CO_2 particle led them along this alleyway and that, through houses whose front and back doors had been left open, and even, with a bit of cajoling, through the solid surface of concrete walls. Billy grabbed hold of a passing taxi's wing mirror and Icarus followed suit. Half an hour later they were so close they could see the overgrown greenery of the Pnyx ahead, and feel the pounding of the marchers' feet in a parallel

street. 'No, this way!' Billy cried as the police kettled a breakaway group in their direction. The Pnyx, site of the Eleksia, the ancient Greek democracy, was located on a hill, half a kilometre behind the Acropolis, which already lay below them. By the time they approached the gates Icarus and W were giddy. 'This is as far as I can safely take you, I'm afraid.' Billy hooked his thumbs in the loops of his oxygen and pointed at the ranks of police officers which were swarming the area.

Icarus reached out to shake Billy's hand, and W even conceded to extend a single bar-end. But Billy just gave them the V sign before disappearing into thin air. 'Good luck. You'll be needing it!'

A short distance further on, two long tails of conference delegates queued in line for the Titans' security checks, just as Icarus had anticipated. The queues were already several hundred deep, marshalled by baton-wielding climate police.

'Best wait here a little bit until the queue dies down,' suggested one of two nuns who were regarding the scene from a nearby rock.

But once they'd come that close, Icarus couldn't bear to wait any longer to discover their fate. 'Just one moment,' she said to W, before

launching herself into the mêlée. 'There's only one more thing.' She
dug in her bags and pulled out a pair of cherry red angel wings
studded with diamantes which Billy had slipped in her direction
with a cheeky wink. 'If I've got to pretend to be boy-Icarus, it's the
least you could do to make some effort to be my wings.'

'He looks like he's going to a hen-do, not the most important event
of this civilisation!' one of the nuns cackled, pointing at W wriggling
and writhing ineffectually this way and that.

 ours was a world of uncompleted
 long-acknowledged silences

 damage limitation
 was considered a form of talking

 a weak recognition of existence
 a statement of reluctant intent
 and a shifting baseline

 what price the air?
 whose sky was it anyway?
 what was warming what was warm?

 russia burned
 niger starved
 while pakistan and china
 had slipped into the river
 in the direction of the sea

 – there was no nicer way of putting it

 what is Europe?
 where is Tuvalu?

 self-interest was an unnavigable island
 between oceans

it had already proven the hottest
wettest year on record

a semi-crisis of disconnected proofs
weather every shade of black and white
but grey

what colour obstinacy no-one knew

The scene was an Ancient Greek celebrity spotter's dream come true, and it was being furiously snapped by paparazzi whose climate change photo opportunities had come all at once. Icarus, however, only had eyes for the Titans. Did you see that? I'm sure the Titan just eyeballed me – the one on the left. Look, he just clocked me again. Tell me he didn't W?'

W burbled something indecipherable about not being certain. 'But look, there's Euclid!' He pointed to an old man with electric white hair, who was busy tapping figures into a calculator.

'And W, look! Is that not Plato?'

'And Aristotle too and...'

If Icarus had been momentarily worried the day before that she had been cast down upon a conference for plebs, then now the presence of so many dignitaries terrified her...The first queue was for Gods and heroes, and the second one for Athenian citizenry, providing Icarus her first quandary. In the end they took up an in-between position, as most other either-ors appeared to be doing.

'And there's Aphrodite, at the front,' Icarus exclaimed, drawing in her breath sharply and closing her eyes as she awaited the sound of club against head gristle. She dragged W to one side to avoid the likely trajectory of the Greek Goddess of love as she was tumbled rudely back down the feminine alleyway from which she had come. But when Icarus opened her eyes a minute later, Aphrodite was safely making her way into the Pnyx beyond. Next up was Sappho.

'She hasn't even put on a disguise!'

'But isn't she dapper?' W replied, admiring Sappho's bright green 1920s flapper-style tunic and her dazzling amethyst headband. But again, the Titans just checked Sappho's identity card and allowed her through. Icarus looked around more closely, and, in fact, yes. How hadn't she noticed? There were any number of women in the queues, not only famous ones – including the two nuns from before.

'But of course, it's no longer *Ancient* Greece,' Icarus exclaimed. 'Has Zeus moved with the times?'

'I wouldn't smile too soon about it if I were you.'

The voice that had replied wasn't W, yet the shape of the hand on Icarus's shoulder was familiar.

'Look who we've got here. It's Lady Satan!' Apollo exclaimed when Icarus turned around. 'Would you ever take a look at yourself? Hey Dionysius, hey Ares, come and have a look at this! Pansy Icarus has dressed up for the ball.'

A small crowd of young Gods had soon gathered, and began jostling Icarus this way and that. First Apollo reached out and stripped a side of stubble from Icarus's face, while Ares lunged to remove a sock from Icarus's pants.

'Oooo let me do that,' Dionysius butted in, drunken and càmp as ever.

Apollo had just made a lunge for Icarus's taped breasts when W could stand it no longer.

'Get off her! She's far more man than any of you. Now scram!'

The small crowd froze. 'A talking bicycle? But bicycles can't speak in the real world!' they exclaimed in unison.

'We can when there's anyone worth talking to. In my reality the ability to converse is as natural as a chainset and sprockets.'

Apollo was first to laugh at the talking bicycle with cherry red diamante angel wings, but soon the air was filled with the sound of mockery: HA HE HA HE! Check him out!'

'Stop it, now. I say leave him alone!' Icarus cried. The young Gods had now started to push W around, and his brake cables had already come away. There was nothing for it; what was there to lose? Amongst the mêlée Icarus had been let free, and now, slowly but surely, she lifted her t-shirt from her waist, off her shoulders, over her head, revealing the layers of lycra strapping down her breasts, before she began unwinding the loops in front of the stunned audience. One layer, two layers, three, as Icarus sought to distract attention in the only remaining way possible.

'Icarus, you don't need to do this!' W cried from where he'd been deposited in the gutter.

'Oh yes, I do, W,' Icarus replied. She made little show of dropping the final layer of lycra to the ground, allowing her breasts to unfold where they had been restrained, for all to see. 'Is this what you wanted, Apollo? This is me, She-Icarus. Are you happy now? Why don't you take me, right here, as you will?'

As if the Titans were going to rescind first claim. 'Out of our way!' the skinheads shouted, throwing Ares and Dionysius from their path as if they were feathers, as they bounded through the crowds towards Icarus, whom they threw unceremoniously over their shoulders, before striding back towards the gates to the Pnyx.

'W!' cried Icarus, but all she could hear and see was the cheering and booing of the crowds and the rough sack tunic of the Titan carrying her. Before Icarus knew what was happening, she was beyond the security threshold, and now being heaved down a back alley into the dampest, dark recesses of the Pnyx where the Titans dropped her, surprisingly gently, to the ground to exact their humiliation. Icarus closed her eyes to await all her punishments at once.

'So here you are, delivered safe, just as Zeus instructed,' the first Titan said, causing Icarus to open her eyes wide.

The second Titan laid Icarus's clothes out beside her while averting his gaze. 'Come on, quick, cover up, will you. You're embarrassing me. My wife will never forgive me for looking at another woman's naked flesh.' And on that note, both men nodded respectfully and returned the way they'd come.

♦

In fact the Titans had only retrieved about half of Icarus's clothing, and re-dressed she looked more of a hybrid He-She-Icarus than ever. But at least here she was, in relative safety, which was far more than she presumed of W...Icarus bit her lip worrying which of the consequences he so badly feared was being – right this minute – exacted upon him. And why should *he* suffer for *her* stupidity?. Not that self-flagellation was going to help matters any, Icarus suddenly thought, sitting up straight. The last thing W would have wanted was for her to miss the conference through worrying. According to the crescendo of noise outside proceedings were soon to begin. 'This one's for the team, W' she said, closing her eyes in a futile attempt to conjure some courage for whatever fate Zeus had in store for her.

Icarus followed a tunnel of light towards the outside world, just as she had followed the southerly trajectory of the sun across Europe to here. Every step conjured a different feeling – like every emotional season at once. 'W, are you out there?' she cried, but her question just echoed back to her while some murderous sunshine-loving bats began dive-bombing. By the time Icarus reached the end of the tunnel the light was so bright that it was like she was crossing the threshold of the sun. Meanwhile, inside the sun, inside the Pnyx, the scene was like nothing she had ever seen – a surreal dream so vivid it couldn't have been animated; the history of civilisation incarnate.

Icarus had emerged on a terrace, offering a panoramic view. The Coupe Icare Festival of Flight was providing pre-conference

entertainment; birds hovered above for a sky-eyed view; lizards clung to the sunny sides of rocks; and flowers peeked between the crevices. And then *all those people*. Icarus shrank inside her shyness. How could she ever have *thought* to address such a crowd?

The gathering was spread in the shape of a crescent moon around a single microphone and a podium. The mortals of contemporary Athens stood at the front. Behind them stood the citizenry of Ancient Greece, followed by the heroes of Greek mythology, while at the very back sat the Gods, and, of course right *there* was Zeus, pride of place, on a large throne overlooking everything. He was wearing his best white tunic, and his beard had grown so long that it hung down to his sandals. *Smug bastard,* Icarus muttered under her breath, startling even herself with her bad language. Her surrogate father was regarding proceedings with the look of one five times as rich and five times as clever and *infinitely* more powerful…but right then Icarus was more immediately interested in the man she had just noticed sitting to Zeus's right hand side…

'Dad,' Icarus whispered. *'Daedalus.'* Just as Naucrate had promised, her father was there to save her if all went wrong. *I'm here Dad*, Icarus mouthed. *Five weeks of applying myself to the good!* And as if her father had actually heard her, at that moment Daedalus began whispering in Zeus's ear before they both turned to look in Icarus's direction, causing her to duck instinctively. And when Icarus's curiosity finally encouraged her to raise her head back above the crowds, the two men's attention had already turned elsewhere.

Icarus kicked her own heels. What had that been about? Acting the guilty party was hardly going to help her case. She looked up and around to choose her spot. And where better than *there*, three rows in front, between the shoulders of Sappho and Aphrodite, whose error of gender had denied them entry to the arenas of the Gods.

'Icarus!' Aphrodite exclaimed, giving Icarus the heartfelt hug she had long awaited. 'We had heard all about your – oh, you know…changes and all that. You look so well on it!'

Icarus blinked away her blushes. 'Aphrodite! Sappho! Is this the women's liberation section?' she exclaimed, causing Sappho to throw Icarus a withering look.

'I think you are over-simplifying our cause, Icarus. There's a bit more to the sisterhood than you appear to have yet grasped. But I suppose five weeks isn't long to absorb *all* of the latest waves in feminist thought.'

'But...?' Icarus began, taken aback. It wasn't the best of starts with someone she had depended upon as a potential ally. Was this really the same Sappho she had seen from the ferry? Was her feminist thinking really stuck in the mid-nineteen-eighties as implied?

'And if you wouldn't mind Icarus, just standing a little bit away… if anyone associates me with *you*, I'll *never* get to speak!'

Tears stung Icarus's eyes as she did as instructed, just as the Speaker climbed up to the podium to address the crowds:

"who wants to speak?"

Icarus stared at her shoelaces, gulping back an instinctive, 'not me!'

The protestors outside had begun to jeer and cheer, while inside you could have heard a pin drop. As if to prove it, someone dropped one – the tinkle it made on the ground prompting the gathering back to full voice. It was a good twenty minutes before the Speaker managed to restore order.

Hermes, Messenger of the Gods, was first up. 'The words I speak are those of Zeus.' The crowd inhaled collectively. 'We gather today to consider the future of this planet, the future of mankind, the future of the earth and its changing climate. You could argue that

Zeus might solve the planet's ills with a single bolt of lightning to the sky. But how then would humanity learn from their mistakes?' Hermes spread his arms wide. 'Here today are gathered civilisation's best minds. We await your bidding in this, your final chance to solve the problem of the changing climate. Your final chance to ensure a future for this world. Here, before you, lies the possibility of a stable future for Earth.'

Icarus already felt frustrated. 'He can't just predetermine the agenda like that – *solving* the climate – as if there were no other ways forward!' Sappho reached over to where Icarus now stood and prodded her in the side.

The next speaker sought to update the conference on current day international climate change negotiations and the fallout from the latest disastrous Conference of the Parties. The Greek Prime Minister was the third generation of his family to hold the post. But all he had to offer were some vague generalities about the importance, whatever happened, of ensuring continued economic growth, and not risking the Greek recovery with environmental policies likely to inhibit its already shrinking wellbeing. Icarus groaned, causing Sappho to land a kick in her calves. The Prime Minister then took the liberty of playing various messages that world leaders had recorded for the Athenian democracy gathering.

'But they aren't even Greek!' Icarus wasn't the only delegate to exclaim, before Zeus silenced the protests with an upraised hand.

'The new deal we have before us is an essential beginning,' said the United Nations Secretary General.

'We have come a long way, but we have much further to go,' the American President began. He spoke earnestly, stressing the meaningful contribution that the informal agreement they had recently brokered would make to future climate change negotiation, while dropping some none too subtle hints that the breakdown of

negotiation was all China's fault. Was China not the largest emitter of CO_2 in the world?

'But what about some legally-binding commitments if you mean what you say?' yelled a heckler, as if the recorded message had the right of reply.

The British Prime Minister mentioned recent legislation committing the British government to ambitious emission reductions. The European Union President emphasised how keen Europe was to lead the way. 'We are already committed to reducing greenhouse gas emissions by 20% from 1990 levels by 2020, and will raise this to 30% if a global deal can be found.'

'Same old, same old,' Icarus moaned, turning her head this time towards Aphrodite, whose elbows were more rounded.

The Chinese Premier stressed historical responsibilities for climate change emissions and alluded to the fact that the USA's per capita emissions were four times their own. 'To meet the climate change challenge, the international community must strengthen confidence, build consensus, make vigorous efforts and enhance co-operation.'

The entire Pnyx began laughing at that.

'We can be satisfied that we were able to get our own way,' said the Indian Prime Minister, before reinforcing China's message that it was not fair to stunt the growth of their economy while the western world continued to pollute.

Bolivia fumed about anti-democratic, anti-transparent deals made behind closed doors. 'The previous meeting failed. It's unfortunate for the planet. The fault is with the lack of political will of a few countries led by the US.'

Tuvalu asked the conference if it was about to allow its islands to become extinct?

The leader of the G77 countries reported that the most recent negotiating text was a 'suicide pact' for Africa that would 'maintain the economic dominance of a few countries. The values the most

recent agreement is based on are the very same values in our opinion that funnelled six million people in Europe into furnaces.'

Icarus bowed her head, just like she had in Montoir-sur-Loir, but the most poignant recordings came from Russia and Pakistan, where events continued to deteriorate and whose eyewitness accounts silenced everyone. The Greek Prime Minister pressed 'stop'.

It was time for the Ancient Greeks to have their say. A gathering crescendo met Demosthenes's cameo as he climbed up on the podium step, down, up, back down – causing the cheers to rise and fall. If only the content of his contribution had matched his renowned oratory skills. Icarus was left no clearer by his concluding words what he actually thought should be *done* about climate change. Pericles was diplomatic but as populist as ever. Ariciabes called for oligarchy, and Zeus and his gathering of assembled Gods clapped appreciatively, causing Icarus's ears to steam.

Theseus called for cunning in defeating the labyrinth of climate change. 'We must not allow climate change to impede the onward march of progress. We cannot return to archaic ways. We must slay the minotaurs of climate change and continue – never left nor right but forwards!'

Odysseus metaphorically compared humanity's journey with climate change to his own journey back to Ithaca. Orpheus then sang a song pleading forgiveness from the sky which almost made Icarus cry. Heracles soon brought that up short, however, with his appeals to masculinity and courage in the face of humanity's plight.

The philosophers were next on the bill. Anaximander and his disciple Pythagoras jointly posed humanity the four key Pre-Socratic questions it should ask itself in the face of climate change. 'From where does everything come? From what is everything created? How do we explain the plurality of things found in nature? How might we describe nature mathematically?'

Icarus rubbed her hands, smiled for the first time. If she was allowed to bypass the maths, then this was more like it.

Socrates probed the meaning of the word virtue in the context of climate change in a series of typical Q&A's. 'No-one desires what is bad. And if anyone does something that is truly bad it must be unwillingly or out of ignorance. All virtue is knowledge.'

Plato was inevitably next, calling for the rule of philosophers in the face of climate change and the pursuit of abstract ideals over practical resolutions. 'Good people do not need laws to tell them to act responsibly, while bad people will find a way around the laws,' he added, causing Icarus to blush momentarily. He then embarked on a quick-fire series of quotations from his own oeuvre as if he, of all people, had succumbed to the demands of soundbite politics. 'We can easily forgive a child who is afraid of the dark; the real tragedy of life is when men are afraid of the light; he was a wise man who invented beer; for a man to conquer himself is the first and noblest of victories; love is a serious mental disease…'

Aristotle disagreed with all of the above. 'Such are empty words and poetic metaphors. The question is, what are we going to do?' He proceeded to list all of the climate change mitigation policies he could remember – throwing them up in the air where they could breathe a little bit.

It was a while before anyone got up to speak after Plato and Aristotle for fear of looking stupid.

Archimedes proposed a set of parabolic mirrors, to reflect the sunshine back into the sky and set the sun on fire. Icarus only wished that W could be here to hear it all. What would Archimedes make of *his* bicycle revolution plans? Was there something in them where she had been so dismissive? But Epicurus took a different angle: 'surely climate change reinforces the importance of the simple, self-sufficient life, lived in the absence of pain, and in freedom from fear, in the company of friends?'

It was eventually the turn of the Greek Gods to propose how humanity might proceed. Poseidon reassured everyone that if the worst came to the worst, then his boats were ready. Ares declared all-out war on the climate. 'Technology has got you into this problem, and technology will see you out of it,' Hephaestus argued. Dionysus then staggered up to the podium where he raised a toast to a lovely day spent among good friends. 'Let's drink to climate change!' he slurred, before tripping over his toes where manly Odysseus was forced to catch him. It took Hades to bring the hilarity of Dionysius's high camp to a close by arguing that in the depths of despair one will find hidden wealths. 'You must go to the depths to rise once more.'

It came to the point where the only two male Gods of Olympia left to speak were Apollo and Zeus, but their contributions were being left until the end. Instead, next to climb up onto the podium was Phaeton, who proposed setting the world on fire and letting humanity burn. Phaeton wasn't allowed to finish his speech before the Titans, signalled by Zeus, booted him into the air; he flew a looping arc over the walls of the Pnyx where the protestors mauled him close to death on the other side.

A plucky climate denying heckler from the body of the Ancient Greek populace fared no better. 'If it was so, it might be; and if it were so, it would be; but as it isn't, it ain't. That's climate change for you.' One thwack of a titan boot and out he went.

The lump in Icarus's throat was so large she could barely breathe.

▲

Any Ancient Greek male who wished to speak was duly given the opportunity – in a stream of diatribe and nonsense that to Icarus lasted an eternity – before Hermes reappeared at the podium. 'I speak again on behalf of Zeus, who is delighted to announce that, as

a result of his recent forward-thinking positive discrimination policies, women have for the first time been admitted to the Pnyx, and will now be invited to address the gathering.' Icarus chose her moment well to re-establish more positive relations with Sappho by sharing a look of, *never mind positive discrimination, how about no discrimination at all?*

Aphrodite called for the love of Gaia to be extended around the world. 'If only men were a bit more *caring* for the environment, just like women!'

Sappho looked embarrassed at Aphrodite's contribution. 'With all due respect, to my mind feminism has moved on. But perhaps our learnt behaviours towards both women and the environment might both be reconsidered, and someday change. Perhaps our learnt behaviours *as* men and women might change.'

Icarus cheered, but it quickly died in her throat when she realised that she *alone* was cheering, and everyone had just turned to stare. There were so many eyes directed towards her that it felt like an intense form of acupuncture. Of course, it was Zeus who broke the silence.

'So, look who we have here. Hello Icarus! Have you come to address us? You're looking rather ladylike these days – perhaps this is your moment.'

Icarus shrank into her shoulders.

'Let me tell you about dear Icarus and his wish to become a God!' Zeus continued, before relaying the whole darned story of his wish to be a God and his resultant expulsion from Planet Zeus and his fall through earth and his smuggling exploits and...as if *nothing* in the meantime had changed. Was he trying to *provoke her* into speaking? 'You have now had five weeks to prove your Godliness, Icarus, so come now, speak. Here's your chance to have your say. Will we see a coronation of a new God today, of all days?'

Icarus had turned pale, but Sappho and Aphrodite were already pushing her forwards and before she knew it she had been lifted up off the ground and was being passed forward above everyone's heads towards the podium like a rockstar. Cameras flashed and people cheered. Soon Icarus was so confused she didn't know which way was up and which was down when she was deposited on the podium where Zeus began his interrogation.

'You know your ABC of climate change? Because of course, nobody can rise to the status of a God without the proper examination.'

Icarus nodded, if only to clear her head.

'And you know how the climate is made?'

Icarus muttered a half-hearted 'yes,' under her breath. 'You take some weather and you divide...'

'So you even know your addition, your subtraction, your multiplication and division of climate change? Good gracious, you have come a long way Icarus. Perhaps you would like to share this knowledge with the crowd?'

Icarus was already feeling less the rockstar and more of a laughing sacrifice, strung up for the Athenian crowds to throw carrots at. And where *was* Dad when she most needed him? Nowhere, just as usual, she thought, noting that he was no longer at Zeus's side. Icarus looked to the sky to summon courage. *If only she could remember anything right then – even her name!* The crowds had already begun to cough impatiently as the first carrot thwacked her shoulder. *She wasn't nervous of climate change...after they had been talking so long, what remained to be nervous about? It was simply time for Icarus to answer now* – she turned to face the crowds.

'The time has come,' Icarus began. 'To talk of many things. Of shoes and ships and sealing wax, of cabbages and kings.' Icarus stopped. *No! This* wasn't what she intended. It was as if somebody had got control of her voice and was making her say all manner of

things she didn't intend – and on this occasion the voice wasn't Lucy either. 'I'm sorry, but you see, when I use a term like climate change, it means just what I want it to, neither more nor less. But impenetrability and glory will have nothing to do with it!'

'If you can *see* climate change,' Zeus boomed, 'then you have better eyes than most. And *I* mean by impenetrability that we have had enough of this line of argument. Do continue otherwise.'

Icarus had only just started to get into her flow, but now all manner of jumbled thoughts began falling from her mouth where they had become entangled with weather glass world. 'I didn't say there was nothing better than climate change, but that there was nothing quite like it...if you believe in climate change then it will believe in you...is climate change animal or vegetable or mineral?...the best way to handle climate change is to hand it around first and then cut it up...climate change is nobody's dream...if you let climate change alone then it will let you alone...the prettiest climates are always furthest away...'

'Wait, wait, stop Icarus. *Icarus!*' It was Sappho, who had finally broken her silence to try and calm Icarus down. 'You're going too fast. This is all very well, but whatever do you mean?'

No matter Sappho's good intentions, this question threw Icarus into even more of a panic. What did Icarus mean? Even a joke should have *some* meaning! Icarus held her head in her hands in time to fend off a second carrot hitting her on the ear. Why was it that every time she had the chance to prove herself to the world – to show that she really *could* achieve something – it all went bad weather up? Why was it that when she had something worthwhile to say, she couldn't find the words to express it – or the world wouldn't give her a fair passing chance? What *was* it she had concluded these last few weeks? Where had all those ideas gone? 'Would you like me to read a poem?' she proposed, relying on Lucy's clarity of mind to come to the rescue.

'Oh, it needn't come to poetry!'

'But...!'

'But there is no such word as 'but', Icarus.'

'But please just wait a minute while I compose myself. *Please...!*'

Zeus was having none of it. 'I think you should go now, Icarus. Farewell Icarus. Farewell, my Lucifer. Who next wants to speak?'

Whether Zeus really had meant it as some kind of cruel, ironic joke to quest Icarus to earth in the female form of Satan was not to be established. For just mention of the word Lucifer was all it took to finally prick the bubble of the conference's increasing hysteria. The entire gathering began falling about this way and that like a Mexican Wave on laughing gas. And once the atmosphere had begun to disintegrate, what a noise it made as it began to tumble. Icarus looked about frantically for somebody – *anybody* – to come and speak, to save her from further humiliation. *Daedalus.* 'Dad!' she suddenly cried out loud. But it wasn't her father who answered her pleas, nor the familiar call of the cherubims ready to lift her back to Planet Zeus, but a different multitude of angels, darkening the skies above their heads.

'W!' Icarus cried out as she looked up. Her bicycle friend was currently floating several metres above her head, suspended in mid-air by a pair of cherry-red angel wings. Alongside him flew young Billy, flashing his carbon dioxide cowboy spurs this way and that, just out of reaching distance of the crowd. *W.* Her dearest friend, her saviour, her brains, her sprockets, her *wings*, which he was now outstretching to prepare to address the conference.

'Gods, thinkers, citizens,' he began in her place. 'I come before you today as a changed bicycle. When I began this journey to Athens to address this conference I had a plan. But over the last two and a half thousand miles this plan has changed. I fear that you might not like what I have to say, but bear with me, listen to the end.'

The crowd continued to stare at this talking bicycle with their mouths hanging open.

'I'm a scientist. And a technologist. And a mathematician. And I have a bicycle revolution of unforeseen technological advancement to put to you all today. But we do not only need scientists. We need thinkers, like Aristotle and Plato, Pythagoras and Anaximandus here, to direct my science. While travelling through France I was asked a question which has proven to be the most important question of them all.' W paused for effect, exhibiting oratory skills to rival Demosthenes. '*Why?* Why are we trying to solve our climate? What do we hope to achieve? Why am I inventing a bicycle revolution and what part does it play in my vision of the world?'

A few of the intelligentsia shuffled their feet, and there was some coughing.

'I'm not saying we shouldn't respond to the evidence of our changing climate. We must. But perhaps our climate is too complex to be solved. Perhaps it's hubristic to try. We are participants in this world, not rulers of it. And my current challenge has been working out whether my bicycle revolution has any part to play in this altered understanding of the world.'

The Pnyx had become so quiet you could now hear individual crackles of sunshine breaking like static on the earth's surface.

'On the middle branch of the olive tree at the top of Mycenae you will find a weather glass. I urge every person here to visit Mycenae to view the world through the weather glass, then come back and tell me what you see. For what I experienced through the weather glass was such an entangled, interconnected view of the world that it altered absolutely everything. Far from us being the rulers of the climate, to manipulate as we wish, we emerge from our participation in it. We re-make ourselves in the image of what we are remade.'

Not even death could have been as silent as the Pnyx had become, before a single Athenian spoke, and then another...

'Fatalist!'

'Sceptic!'

'Nihilist!'

'Who does this bicycle think he is? Gatecrasher!'

A few carrots had already been directed in W's direction, but he just flew slightly higher still and kept talking. 'It's time we got beyond the dualistic limitations of Enlightenment science and its presumptions to human mastery. It's time for something truly radical, truly emancipatory. And now let me tell you all about my bicycle revolution.'

The crowd calmed down as W outlined the technological details of his plans. Archimedes even posed the question: 'but will bicycle frames not reflect sunlight better if they can be designed parabolically?'

Icarus took the chance of the temporary calm to scan the crowds once more in search of her Dad, and yes indeed, there he was, pushing through the crowds towards her before the Pnyx could descend into chaos once more. And he had better hurry up, Icarus thought, holding a hand out in his direction.

'I'm proud to say that I address the Pnyx today on behalf of my friend, Icarus, with whom I was tasked to cycle across Europe to here. And I did so in good faith, keen to join the young semi-mortal in discovering her future along the way. But I have learnt that far from discovering her future, the parameters of the quest have quashed it. Will humanity not rise up and see that it's *you*, the general populace, who are being stabilised not the climate, and is Icarus not a case in point? When will humanity free itself from this story of continuity, not change?'

That was the last word W had the chance to say, for by directing attention back on Icarus, climate chaos had finally broken out. A club flew past Icarus's right ear, and a big glob of spit landed in her cleavage. Clubs catapulted through the sky towards W like

boomerangs. The last thing Icarus saw was Daedalus's path being blocked by the Titans while he called out, 'Icarus! Fly the middle way, not too close to the sun, nor too close to the sea!' Already the people in front were climbing up onto the podium…Everything then happened in the course of a split second. Icarus had closed her eyes to blind herself to the frenzied eyes and nails of her attackers, when suddenly she felt her feet lift off the ground. By the time she had reopened her eyes she was already high above the conference, looking down on everyone from above.

'W, are we flying? W, please tell me we are flying?' she cried, causing W, who was flying alongside her, to grin with delight. Icarus looked up. Not only was she flying, but doing so suspended from the spurs of the carbon dioxide gang she had once smuggled into the atmosphere, and heading for the sea faster than the police helicopters could chase them.

Icarus didn't need to ask where they were going: it had to be due south east as usual, across the Aegean Sea to a wing shaped island named for the place where Icarus always fell. *Icaria*. Icarus felt her entire existence rising and falling on the thermals. So she had never been meant to rewrite her fate? She had never been meant to make it to Athens? Stabilise climate change? As if! All Zeus was interested in was maintaining his own oligarchic control over the capitalist climate and its delimited skies. If the fate of humanity remained connected at all to the fate of Icarus, as she had once supposed, then it had just been screwed over once and for ever.

'Look behind you!' W cried.

Icarus smiled as broadly as the sun. The sky above Athens had turned the shade of cherry red bicycle, as if every red bicycle in the world were following in their path – as if W's revolution had just come true.

icarus

i.

It's a warmer world
the closer that you fly
towards the sun

 We're backing into knowledge
 hanging on it
 our wings
 around our necks like clews
 and our noses to the sky

We took the route untravelled
and unravelled it
 strings of daylight tangling
round our fingers just like flax

 What had we started?

 Climbing contours higher
 splitting rungs
 of atmospheric gases

 sculpting skies from uncompleted
 spaces bound in wax

ii.

Just working models
 otherwise applied –

 the reflections
 of the whites of our eyes
 encircling what?

 The heat of globes.
 The way we talk about it.

iii.

I didn't think it would be blue
inside the sun

 I'd brought a saw and a set square
 sliced a geometric corner
 from the edges of its flames

 reassigning claims –
 to what?

Metaphors which open
into dissolution
 The colour of pupils

 Take another breath
 and hold yourself to it

 pin it to the light

(or perhaps it was actually a bit more like this:

Bottled anachronisms: one eye short
of a hard-boiled egg

icarus is depressed by the thought that,
after all, the hero may be another version
of himself, gone elsewhere

by the time that he had solved the mystery
of the disappearing sky he had disappeared
himself

he empties his limbs into another
glass of rye – what else to do when you've
lost the plot line to your life?

his nightmares are armadas, fleets of
caricatures, pseudonyms, mongrel wings

the solar cycle which he sees reflected
in his drink is a scattered shade of green

'now,' he said, 'where was I?'

the symbolists had already done away
with the polar bear and rising seas

before he knew it they'd be abolishing
the globe – as seen from space

after five whiskys icarus was drunker
than the whisky itself

'I might compare whisky to helium,'
he said. 'It elevates the voice as helium
elevates balloons'

His soul was transported to the traveller,
who multiplied the earth by his imagination
with dreams of being guided by the wind.

So let us swim!

When he reached the inner limits of the sun
his heart was a pickled onion, and his eyes
were staring, shaking – oneiric hard-boiled eggs.)

Part 7: Icaria

There were goats and winding dirt track roads,
and an independent people gathered in
against a rugged sea; but most of all
there were songs and dancing;

> *to the lady of the labyrinth*
> *a jar of honey*
> *to the daidaleion oil*
> *to the spit roast carcass of a goat*
> *take this sweetened red-blood wine*

i followed the painted footmarks
of the ancient trails of sun
navigating the mountain spine of my wing-
shaped island in the East Aegean known as Icaria

i.

The œuvre of Daedalus's entire creation
lengthened the period of stasis.

Here

but a tactile exile,
located at the birthplace of ambition;

clauses erased by the wings of departure
to the furthest licences of iniquitous earth.

Beneath the obstructions of certain gravity
were incalculable patterns.

Spatial, seasonal.
Between singular and plural,

I or us.

A lack of omniscience possesses and unpossesses
the depleted air.

Ours had always been an atmosphere of unrelenting change.

The supposed art was ignorance:

digits of imitation,
patterns of asymmetric feathers,
natural novelty without inordinate pain.

We bore no small knowledge of the basics
of taxidermy.
We were life-like professionals.
We were mannequins, mounted on bone.

ii.

A minimum co-option of the long brevity
of the sequence cleaves crevices
in the daily rusticity of the pull of disappearance.

 Now you do not see me, now you never did.

 To practise taxidermy,
 one must be familiar with anatomy,
 sculpture and painting as well as tanning.

Our hands are atoms,
surgically becoming.

The turning floor mediates consumption.

 Shades of grey or blue.
 Unfulfilled requests for globular yellow suns crafted from beeswax.
 A carbonated taste of honey from a pulse of the passing air.

All we've got is more than we could care for

 – attacking our composition for its curved flexibility
 and its true imitation of prayer.

iii.

And then,
Icarus.

Stubbornly ignorant of his particularly repetitive trajectory,
residues only altered by the vagaries of movements,

> auras of fashion,
> capabilities of the plumes of flavour policing
> the ongoing modes of our becoming.

> The most realistic climates for his creations
> were the air-regulated conditions of museums.

> > A mesh cage.

If we might mollify the loose lost canons of our miraculous fathers,
> > then impede the opus.
> > Post-

a certain form of reason.
An uncanny fear of wax. Clay is used to install
glass eyes.

Our ultimate co-existence is imposed like twins
opening the retrospective texts of their entire corpus,
mortality in perpetuity.

> Limbs upon limbs upon limbs.

We were first instructed in the ways of the median birth,
limiting the currency of Icarus to twenty-first century money.

> Take the negative, the affirmative,
> halving the original meaning of the verb 'to be.'

iv.

Were we accidental? The cast of unknown powers of gravity?
The temperature of the unknown growth of adoration leads
to the ultimate spectre necessary for flight:

> Forms are commercially available from a number of suppliers.
> I am, you are.
> Blood as blue as the iris of the moon.

It was the time of year when both of our eyes
were accustomed to leaving the curved wings
of the ensemble for the seizure of the individual stage of life.

> We are equal only to our preconceptions
> of the meaning of tradition.

> We will ignore the innumerable warnings
> of the accommodation of fate.

Between opuses.
Glass eyes.
Telescopic arms.
Planets dislocated from atmosphere.

This can all be established without even opening the body cavity.

> Our genus should
> perhaps be mounted
> upon a background of
> forgotten parenthood.

> The pupil is best known for its
> ability to see into the deepest
> recesses of the dark.

v.

Now our hands tremble with the obscurity demanded by rebirth.

 No iterations,
 repetitions,

 only the ability to raise the bar of penitence in time
 for a commitment to fly above the limits of the sky.

What temerity reproduces the prolonged cast of the lost state of air?

 Horticultural sequences,
 the plurals of sun,
 the damnation of the erudite arts,
 an unfortunate movement of our lips towards the means
 of artificial breath.

 Did you hear the tone of the question?
 What shape to mould from gas?

Our alibis shake.

vi.

We are the harangued forms of fishes.
A pastoral scene revived by the inexorable narration of our lives.

(Invisible imaginings.)

The bodily ether possesses credit between itself,

Here
 There

I am leaving my innocence,
somewhat apart.

vii.

Precisely the same references were fire
to the reluctant parishes
of the delinquent hands of lemurs,
the ghostly masks of infra-orders of species.

To be fecund is a melding of calamity,
a haunting
combined with an audacity to co-opt
the gawdy flights of desire to be our guide.

 The tracks of a calculating Cupid.
 High iterated egos.

 Rapidly approaching the sun and the odours of
vanquished penury.

 Stability was a moment of wings
 we did not even notice.

Please take me to be the tableau you will be.
Nude as a quantity of lacerated islands.

Part 8: Epilogue

I am an environmentalist by profession, by vocation, even, and I might add, of some renown. Since I am an environmentalist, I create environments. And since I create environments, I deal with earth, and sky and oceans. And now one of them has vanished. Literally. An environment I had just begun, about ten pages, fifteen at the most, and in which I had the highest hopes, and now the sky, which I had barely begun to outline, disappears. As I obviously cannot continue without it, I have come to ask you to find it for me. I won't be able to write a word until the mystery is solved and the sky returns. What a fate – that of an environmentalist without skies! Perhaps that is how it will be for all of us, one day. We won't have any more skies. We will become environmentalists in search of skies. The environment will perhaps not be dead, but it won't have skies in it any more. Difficult to imagine, an environment without skies. But isn't all progress, if progress exists, difficult to imagine?

Adapted from *The Flight of Icarus* by Raymond
Queneau, tr. Barbara Wright

The romantic idealist in Icarus felt the same every time she landed on Icaria: yes, *this* will be the time I stay forever, to live out the rest of my days. Predictably, considering the myth with which it was associated, Icaria was no traditional paradise; rather 'the red rock' was a land of rebels, communists, hippies and other undesirables whom the Greek government had shipped out over the centuries. It was such a forgotten outpost of the Greek state that no roads had been paved until the mid-1980s, and even now there were only two surfaced roads across its one-hundred square metre land mass. But

all the better in Icarus's eyes. What's more, if she really had become mortal, then at least she would live well into her nineties here if local population averages were anything to go by. Maybe it was the medicinal qualities of the pungent pine honey which kept the population alive so long. Or the all-night fiestas and energetic local folk dancing fuelled by spit-roast goat and sweet red wine.

Or perhaps it was how warm the rocks were to lie upon when out wandering the waymarked paths through the mountains, Icarus concluded, curling up on a big boulder in the afternoon sun like a snake. On this occasion, after everything that had happened over the last five weeks, Icarus was more grateful than ever for the chance to recuperate, sleep, and to remind her legs of other motions than spinning in circles.

But even now, lying on this big rock, watching birds circle hopefully overhead, when she had more to lose than ever from returning to face the weather on Planet Zeus, Icarus knew that this paradise could only ever be temporary. It was the same every time. Within a couple of weeks Icarus was always restless and plotting her escape from escapism, back into the *real world*. Strangely, considering this was the island in Icarus's name, she had never really felt at home here, had no friends as such, and no one had ever clocked who she really was. But why should they when her original remnants had long since fossilised into the spine of this remote East Aegean island?

And if Icarus was becoming restless after a fortnight, then W was already beside himself. 'What kind of a thanks is *this* for saving your life?' W protested after yet another day left leaning against the wall of Icarus's stone-washed studio apartment.

When the inevitable decree arrived in the post, ordering Icarus to return W to his rightful owner, Lucy, and then report back to duty on Planet Zeus, Icarus was as ready as she was scared. It was anyone's guess what this might now mean: for Icarus, her gender, how she would fare if hers and Lucy's identities were once more

severed as now seemed inevitable. Let alone what might happen to the climate, the rewritten Icarus myth or what punishments might be exacted upon Icarus for going AWOL during her climate quest. Icarus read through the postcard from Planet Zeus a second time:

Icarus come home

before pulling a face as she turned to look at W. Yes, she was ready for the next stage in her mythical adventure and what would be would be. But how would the days and months and years ahead be without the company and support of her newfound friend?

In fact W himself had almost fallen over with excitement when she had relayed the news that they were to be on their way. 'But what are they?' he asked, peering over Icarus's shoulder. '*Plane* tickets? What the devil do we need those for? I was thinking we could cycle the long route back together through the Balkans...'

Icarus gave W's handlebars a gentle squeeze, shook her head and tried to put a positive spin on the situation. 'But you must be looking forward to being reunited with Lucy? I am sure there are lots of adventures she is itching to take you on. And this will certainly *expedite* the journey.'

'I suppose it will be good for her to get her life back,' W conceded, 'provided she sticks by me, you know, instead of preferring that carbon bike on the landing. Do you remember?' There was a weighted pause before W continued. 'But what about you, Icarus? What's going to become of you?' The furrows in W's cables betrayed his struggles to comprehend how *both* Icarus and Lucy might co-exist let alone get along and what implications this might have for the She-Icarus he had come to know and love.

Icarus shrugged as if this was neither here nor there before turning the other way so that W couldn't read her doubts about her ever

making it back to Salford with him. Zeus's lazy cherubims were unlikely to pass up the opportunity to pluck Icarus out of the sky while they flew by; and W was unlikely to be able to rescue her from the confines of the airplane hold while her father would likely be AWOL as ever when it came to answering her calls.

'Or else, of course, once we get back to Salford then you could always continue cycling me and Lucy could cycle the carbon bicycle!' W added, having obviously followed a different trajectory of thought entirely. He was smiling so broadly you'd have been forgiven for imagining he had just invented the sun.

you ask me what I've brought you
from my travels

 and all that I can offer you is this

 CC

two letters
 as an imperfected mirror
of themselves

 slipping through the gaps along a horizontal line

two horseshoes or a broken chainlink
 a pair of spectacles we framed in space

The journey back to Athens was far harder work than the dreamy flight in the other direction had recently been. Icarus's legs weren't what she'd have called happy to find themselves spinning in circles again for the hour cycle to the port along the mountainous island coastline. And the nine hour ferry journey had none of the euphoria attendant upon their escape in the company of a host of carbon

dioxide bandits. And despite its recent distaste for Icarus and W, Athens didn't make it easy for them to leave once they had landed back on the mainland.

'Where's Billy when we need him?' W asked as they were pushed to the back of the taxi rank again as another taxi refused W carriage. One driver did give it a go, but soon changed his mind when he noticed the grease marks W made on his white jeans as he attempted to lift him into the boot. Actually cycling to the airport, meanwhile, was impossible – the only roads in that direction were motorways, and in any case W's pedals had already been removed in preparation for the flight. The underground line to the airport didn't take bikes, and neither did the airport buses.

'I knew we should have cycled home,' W continued to protest. 'It would have been more straightforward than *this.*'

Icarus was inclined to start to agree; the only remaining option was a long sweaty walk across town and then the train – if only the ticket officer hadn't guided them onto a train headed the wrong direction.

'You *are* coming back to Salford with me, aren't you Icarus?' W asked once they had eventually found a train going the right way, as Icarus pushed him through the sliding glass airport doors. 'You're going to come and stay? Promise me! We'll never perfect our poetico-scientific model of climate change if we get separated now.'

'Of course I'm coming back with you,' Icarus replied, biting her lip. 'Do you think I could abandon you after everything?' She blinked back her tears. To admit her doubts and fears to W would involve having to truly confront them herself. And perhaps their separation was just how their fate had to be. It did feel like a bit of a betrayal somehow but it wasn't as if she could do anything about it and right now she lacked the energy to deal with the emotional upshot of being honest, upfront. Instead of confiding in W, therefore, she looked straight ahead. The airport concourse was vast, characterless

both everywhere and nowhere, she supposed, then this was its nowhere, no-place, nothing much at all.

♦

Fortunately Icarus and W had left plenty of time, for once they had reached the airport, things were only about to get harder still. 'You don't need a ticket for bicycles – you just go and check-in,' the young man at the Aegean airlines ticket desk said, waving Icarus away to the other side of the terminal after she had been queuing for half an hour for this information to be imparted. At least the queue at the check-in desk was shorter, presumably because the staff there were even more unhelpful.

'Next!' cried the glamorous young check-in assistant who had already flirted with one handsome passenger, upgraded a wealthy looking passenger and adopted the most patronising of charitable manners for a refugee who had turned up without a passport. When she turned her eyes upon Icarus and W, however, it was with thinly disguised contempt; Icarus held out her passport for inspection and the woman brushed it away dismissively.

'Bicycles need to be in boxes,' she began. 'We won't accept it unless it's in a box.'

Icarus took a start. 'But I called the airline in advance and was told that all I had to do was remove the pedals and deflate the tyres.'

'Well whoever you spoke to was wrong. Company policy is company policy. Bikes go in boxes.'

'But it's hardly my fault if one of your colleagues was wrong!'

'Next!' The woman was already peering over Icarus's shoulder at a middle-aged man with a golf bag which Icarus was in no doubt would be transported by the airline with ease.

'Can I speak to your manager please?' Icarus asked, with a middle-aged haughtiness which didn't become her.

'Of course.' The woman rose and walked with a slow swagger in the direction of her supervisor, to whom she badmouthed Icarus for a good five minutes. The supervisor nodded, looked in Icarus's direction, shook her head sympathetically, and followed the woman back to the desk. The supervisor, like most women of authority in Greece, had dyed blonde bouffant hair which had been hairsprayed so intensely that it arrived several paces behind her and risked falling off her scalp entirely if her expression changed. But this woman's face was set in a frown.

'Only bicycles in boxes,' she repeated.

'But if I'd known this I'd have found a box. Are you really saying that I can't fly home? Are you saying that I must leave my bicycle here? What *do* you propose?'

Such a question had clearly not occurred to the supervisor previously. Now that it had been posed, her over-energetic hairdo could clearly just imagine the security furore that would unravel if Icarus abandoned the bicycle right there...as if Icarus had any intention of *that!*

The woman looked around the sterile terminal behind Icarus as if a box might suddenly fall from the sky. 'Why don't you get your bike wrapped?' the woman finally suggested, pointing a few hundred metres down the terminal.

W was far from sure of this idea as Icarus pushed him away towards the cling film wrapping point. 'That's even worse than wearing diamante wings. How will I breathe?...come on Icarus. It will only take us about six or seven weeks to cycle the Balkan route home. It's not too late.'

The man at the wrapping point had his back turned to Icarus as she approached. He was slightly built for someone with such a manual job but was performing the wrapping of perfectly adequate suitcases with the gusto of a magician performing a conjuring trick, causing

his explosion of curly hair to spring this way and that simultaneously.

'He looks just like…' Icarus began, just as the man turned round.

'Icarus!' he said, softly, looking up but not quite able to meet Icarus's gaze.

'Daedalus,' Icarus replied. 'Dad! What are you doing here? I mean, it's good to see you, but…' They were the first words Icarus had spoken to him for months. She dropped W at her side and embraced her father, who patted her shoulder blades awkwardly in return.

'I hoped I'd see you, you know, before you left,' Daedalus stuttered once Icarus had released him.

Icarus stepped back to take stock before suddenly blurting out, as if scared that the moment might be stolen from her – 'I've been wanting to say for weeks now…I mean. I'm sorry Dad. I've been a hopeless teenager, but that's in the past. I'm grown up, look!' In her excitement Icarus had almost forgotten *quite* how much she had changed since landing in Salford.

Now Daedalus blushed and didn't know where to look. 'But, of course, it makes no difference any which way you are, Icarus,' he finally replied. 'I, I wouldn't say I *understand* you, but you're still my son. I mean my daughter. I mean, I still…'

Icarus's eyes opened wide as she waited for her father to try and stammer a word that had never fallen from his lips, but Icarus herself was forced to break the silence. 'You mean you don't understand everything I've come to think about climate change? Let me explain!'

'No, no, I get that. And ok, so I disagree. I just…It's ok, Icarus. I guess we're just different aren't we? But you're still my son, I mean my daughter, I mean…Icarus, hello…' On that inconclusive note Daedalus finally raised the courage to meet Icarus's expectant gaze for the first time.

Icarus held it as best she could, wondering how so much intelligence could struggle to find expression for a single, simple word. But did it really matter when it was in his eyes? Was it not there in his persuading the usual baggage wrap employee to take some leave, to wait for Icarus, in case she came? Was it not identifiable in his leaving the middle path to wish Icarus on her way? Was it not now there in the gentle way he reached out to W, her friend. 'Dad, I need to introduce you to someone,' Icarus said, lifting W off the concourse and pushing him forwards. 'Please meet my very own personal scientycle, Wings.'

W's head tube swelled with pride. 'Sir, sir, I'm delighted to meet you...you know I've read all of your books, and...indeed, I don't think that you have a bigger fan than me.'

It was suddenly as if someone had turned the awkwardness dial to zero as Daedalus and W embarked upon the kind of technological exchange that made Icarus's head wobble.

'And, of course you like my ideas too?' Icarus suddenly interrupted. 'Even if you disagree with them....*Dad?*'

'You really have grown up, haven't you Icarus?' Daedalus replied, obliquely, turning back to Icarus with a look that seemed both saddened and relieved to witness his son, his daughter, find their own path through life. He scratched his curls. 'It's good to see you, Icarus. I'm sorry I've not always been here for you, along the way. But Naucrate wrote to me and said...'

Icarus was never to find out what his mother had written, for the tannoy announcement had just made the first call for boarding, prompting Daedalus into practical action.

'But I'm afraid your bicycle will *never* fit on that!' Daedalus pointed to the revolving cling film wrapping stand. Indeed, when Daedalus tried, it was clear that there was no way – sideways, frontways, backways. 'You could always leave him here. I am sure I could find a home for him.'

After everything that had happened over the last few weeks, it was finally too much. A waterfall of tears suddenly sprung from Icarus's eyes – heavy enough to rival any Greek storm. 'Will Athens ever allow me to leave? It's all I ask – just help me to go, Dad, only this!'

'Please just stop that will you, Icarus,' Daedalus said. 'You are embarrassing me. Consider how far you have come. Consider what o'clock it is. Only never cry…we will find a solution. I promise.' Barely had Daedalus finished pleading than he had already stopped a rubbish operative and commandeered all available cardboard – toilet roll boxes mainly – from his trolley. W inhaled deeply as if this was the final breath of air he would ever take. Next Daedalus used up an entire roll of travel tape wrapping W beyond recognition – as close in appearance to a box of toilet paper as a fully framed bicycle ever would be – before lifting W onto his shoulder and beckoning to Icarus to follow.

The check-in woman began blushing furiously upon their approach. 'It's just…'

It was just that a Greek man with a bicycle over his shoulder was far less easy to bully than an English speaking young woman, Icarus was soon to realise.

Daedalus levered W off his shoulder gently and held him out for the woman to see.

'Of course,' she said. 'Look. A bicycle box.'

Daedalus nodded and turned to Icarus for the final time. 'I will be seeing you, Icarus. I know, we need to talk. Maybe I will like your ideas when we get the chance to work them through.' And on that note Daedalus sloped his inept fatherhood back across the concourse before Icarus could become emotional once more or she had the chance to properly say farewell.

The check-in lady, meanwhile, remained as emotionally sympathetic towards them as Humpty Dumpty. 'It costs eighty euros for a bicycle box,' she said, holding out her upturned palm.

'That's enough to feed and accommodate us for three whole days of cycling!' W protested, muffled through the cardboard. But right now there was nothing for it.

'You will need to sign this disclaimer, just in case anything happens to your bicycle,' the woman added.

Right then, Icarus would have done anything to just be out of there. 'But you have given me the boarding cards for the wrong flight,' she pointed out, fortunately checking the paperwork before leaving the desk.

The woman snatched the cards from Icarus's hands, and sighed heavily as she was forced to print out new cards, for the right flight and everything.

Icarus was glad to have to carry W the last few hundred metres to the oversized luggage belt. She cradled her friend's jutting angles against her jutting collar bone, whistling as she went:

> I love my bicycle with a W
> because he is Wise.
> I hate him with a W
> because he is Worrisome.
> I feed him on Wine and Weather.
> His name is Wings, and he lives…

'He lives with *you*,' interrupted a muffled voice. 'They're not going to separate us, are they Icarus?'

'Of course they won't W. We're best friends.' Icarus in fact possessed not an ounce of hope that she might persuade the cherubims to kidnap W along with her and return them *both* to Planet Zeus. And even less that she would be revisiting Salford in a

few hours' time. She stopped and lay W down beside her. 'Just one moment, I need to check that I've got everything.'

In fact Icarus had reached into her hand luggage to remove her writing pad, which she now flicked through for the final time: the flummoxed beginning to their journey, the craftwork middle, the ill-fated flight, and the inevitable fall. And not in fact strange at all that every single poem was about the weather in some way. But there was little time to become sentimental about the journey now as the tannoy made the final boarding call. Icarus peeled back a layer of tape from W's side and slipped the notepad between the slit she had made in the wrapping. 'Just tidying you up a little bit,' she explained, giving W's side a gentle pat where she had inserted her poems and notes and thoughts. Was Lucy not the writer hereabouts, after all, and likely to do a far better job of writing up and sharing the story of the quest than Icarus would ever be able?

When they reached the oversized luggage point, Icarus had hoped for a bit longer with W before she handed her friend back to the world. At least Icarus had come to *know* Lucy in an incomparable kind of a way. She had faith that her alter ego would continue where Icarus had left off and would treat W well. *Wasn't that so, Lucy?* Icarus asked, already aware that Lucy's bodily presence was slipping away. You will be overwhelmed with love for W when you see him again, Icarus implored, and you *won't* be tempted by the guile of the shiny bicycle on the landing. It's the well-worn, *well-loved* things in life that are the most important, *right?*

'Take some pictures of the view won't you – from the aeroplane windows? To show me when we get back to Salford?' W interrupted.

The luggage attendant was already reaching out to take him from Icarus's hands: to whisk onto the belt and away. Icarus held him tight to her shoulder for those last few moments. 'Thank you for everything, W. You're my best friend ever.'

'Thank *you*, Icarus. See you soon. I hope you have a good flight.'

'W! *Wings!* Farewell, for now, until we meet again.'

The luggage attendant had now rudely grabbed W from Icarus's shoulder and laid him onto the moving conveyor belt. His bike frame was already pushing through the plastic curtains into the x-ray compartment, and away, away, away...

Icarus looked around, wondering why she suddenly found herself alone. She dug her hands deep into her pockets and tried to clench her fists when her left hand closed upon something. Icarus traced its contours – a round, flat metallic disc of some form – which she now held out in front of her. It was the badge from the front of Wings's head tube, inscribed with the letter W. Icarus blinked back her tears and pulled her crumpled boarding card out of her other pocket as she made her way towards the departure lounge.

There were no destinations, she thought. And there were no ends. Just another flight to another place, and onwards, wherever her curiosity might take her, and she would take this reminder of her trusty bicycle with her, all the way. No matter how many times she had fallen during this quest, the world kept going, on and on and....why if Icarus did ever fall again, which there was no chance of, but if she did?